The Art *of* Haiku

The Art *of* Haiku

*Its History through Poems
and Paintings by Japanese Masters*

Stephen Addiss

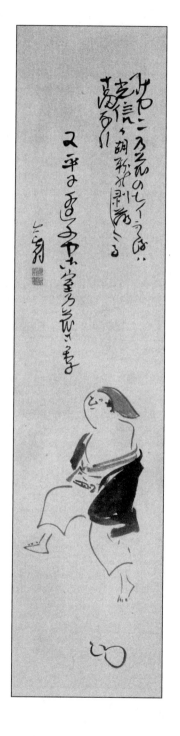

SHAMBHALA

SHAMBHALA PUBLICATIONS, INC.
2129 13th Street
Boulder, Colorado 80302
www.shambhala.com

Cover art: Ki Baitei (1734–1810), *Thirty Figures with Haiku*
(detail). The Clark Center for Japanese Art and Culture.
Back cover art: Inoue Shirō (1742–1812), *Cuckoo*.
Cover design: Audrey Yoshiko Seo
Interior design: Daniel Urban-Brown

9 8 7 6 5 4 3 2 1

First paperback edition

Printed in the United States of America

Shambhala Publications makes every effort to print on
acid-free, recycled paper.
Shambhala Publications is distributed worldwide by
Penguin Random House, Inc., and its subsidiaries.

LIBRARY OF CONGRESS CATALOGING-IN-PUBLICATION DATA

Addiss, Stephen, 1935–
The art of haiku: its history through poems and paintings by
Japanese masters / Stephen Addiss.—1st ed.
p. cm.
Includes bibliographical references and index.
ISBN 978-1-59030-886-8 (hardcover: acid-free paper)
ISBN 978-1-64547-121-9 (paperback)
1. Haiku—History and criticism. 2. Art and literature—
Japan. I. Title.
PL729.A34 2012
809.1'41—dc23
2011046656

To Audrey Yoshiko Seo

Contents

Preface ix

Acknowledgments xi

Introduction 1

1. Background: The Tanka (Waka) Tradition 15

2. Renga, Hokku, Haikai, and Haiga 45

3. Bashō 79

4. Followers of Bashō 127

5. Senryu and Zen 153

6. Buson 179

7. Issa and the Early Nineteenth Century 221

8. Shiki and the Modern Age 267

Appendix: Translating Haiku 311

Notes 314

Glossary 325

Selected Bibliography 326

Index 334

Preface

Unless otherwise noted, the translations of the 997 poems in this book are by the author, who bears responsibility for any mistakes or misinterpretations, while acknowledging that haiku often contain more than one meaning. The appendix offers some comments on the difficulties of translating from Japanese to English, and readers are welcome to make their own versions of the poems using the Japanese romanizations supplied with each tanka and haiku.

Also, in this history of haiku and *haiga,* the ages of poets are given in Japanese style; for example, when Saigyō is described as age thirty, we would consider him twenty-nine.

Acknowledgments

First I must thank Audrey Yoshiko Seo, whose comments, advice, and encouragement have been vital. I would also like to thank Fumiko and Akira Yamamoto, with whom I have worked on previous haiku books, and who continue to be a source of information and wisdom. My great appreciation also goes to Norman Waddell, Joe Seubert, Peter Ujlaki, and my editor, Jennifer Urban-Brown, Ben Gleason, and the entire Shambhala staff.

I must also acknowledge my admiration for those whose work has been so outstanding in the study of traditional Japanese poetry, especially R. H. Blyth, whose many volumes about haiku and senryu fully opened the field to all of us in the West. In addition, I would like to cite Robert H. Brower, Steven Carter, Edwin Cranston, William R. LaFleur, Howard Hibbett, Donald Keene, Earl Miner, Joshua S. Mostow, J. Thomas Rimer, and Arthur Waley for their fine publications on tanka and renga. For exceptional studies of haiku and haiga, I especially admire Robert Aitken, Sam Hamill, David G. Lanoue, Okada Rihei, Sato Hiroaki, Shirane Haruo, John Stevenson, Ueda Makoto, and Burton Watson, among many others. Publications by these scholars and poet-translators are listed in the bibliography, and are highly recommended.

Next I must express my gratitude to all those museums and private collectors who have allowed their works to be published here; their fine haiga deserve to be better known and more fully appreciated in the Western world.

The Art *of* Haiku

Introduction

THIS BOOK WILL TRACE the history of Japanese haiku, including the poetic traditions from which it was born, primarily through the work of leading masters such as Bashō, Buson, Issa, and Shiki, along with a number of other fine poets. Although they are less well-known, haiku calligraphy and haiku-paintings (haiga) of the masters will also be illustrated and discussed as vital elements in the art of haiku. Theory and criticism will be minimized in favor of presenting the works themselves, which were composed to create a spontaneous interconnection with their readers and viewers, who play a vital part in the expressive process.

What Are Haiku?

Although today haiku may be the best-known form of poetry in the world, there is still confusion as to how to define them. Many people would describe haiku as a three-line poem of 5–7–5 syllables, but this does not penetrate more than the surface of this remarkable form of poetry. Rather than tight definitions, it might be more useful to discuss the guidelines that most haiku follow.

Haiku in Japan are generally written or printed in a single column. Nevertheless, until the twentieth century, most traditional Japanese examples fall into 5–7–5 syllable patterns, although this was stretched and even broken by some of the great masters when it suited their purpose.[1] In the past one hundred years, Japanese haiku poets have been divided between those who basically follow 5–7–5, and those who do not. Furthermore, haiku poets in other

languages often ignore this guideline. For example, the great majority of fine haiku in English have fewer than seventeen syllables because English is more compact than Japanese, and the same is true of haiku in other languages as well (see the appendix for more information on syllable counts in Japanese and English).

If haiku do not always depend upon a fixed syllable pattern, what are their most important characteristics? One is closeness to nature, which supplies most of the images that the poems rely upon to convey their meanings. This usually involves concrete observations expressed briefly and clearly through the use of everyday language and a syntax that is natural rather than "poetic." Since in Japanese language the verb is usually at the end of the sentence, this sometimes involves the translator with changes in word order, but the guidelines remain the same. Here is a view of nature by Bashō that finds the extraordinary in the ordinary:

fuyu niwa ya	garden in winter—
tsuki mo ito naru	the moon also becomes a thread
mushi no gin	in the insect's song

The second characteristic of haiku are references to a particular season; these references are called *kigo*. In Japanese, the great majority of traditional haiku indicate spring, summer, autumn, or winter, either directly (as in the haiku above) or through images that suggest which season is being presented. Some of these references may seem arbitrary, but they are firmly fixed into haiku history. To give just a few of many possible examples, frogs, swallows, warblers, the hazy moon, late frost, and plum- or cherry-blossoms are all indicators of spring, while for summer there are short nights, herons, toads, lilies, duckweed, and hail. Fall includes the harvest moon, lightning, dew, deer, grasshoppers, dragonflies, and persimmons, while winter is indicated by snow, frost, ice, owls, ducks, fallen leaves, and bare trees.[2] Therefore a Japanese haiku that mentions a frog is understood as a

spring poem, while one including a heron is understood as taking place in summer. Since the season adds to the mood and meaning of the poem, these references are significant.

Third, and most important, haiku suggest rather than define their meanings, leaving much of the process up to the reader or listener. In effect, the audience joins the writer in completing the poem, and since most haiku have more than one possible meaning, they tend not to have "correct" or solitary interpretations. Here the brevity of the form is helpful; the fewer the words, the more potential for multiple implications. As we shall see, the earlier poetic form called tanka (five-line poems with 5–7–5–7–7 syllable count) tended to be more explicit, while haiku allow readers to become partners to the poet by personally responding to the images. Of course, all art is an experience rather than an object—the poem, music, or painting is merely the instigator of that experience—but in haiku this interactive aspect is especially important. Too much information would be limiting; like the inside of a glass or cup, it is the empty space that is most valuable. In haiku these spaces can take the form of grammatical ellipses, so one may often find incomplete sentences, which allow meanings to emerge rather than being insisted upon.

For the same reason, most haiku are not directly subjective. Instead, an objective description of nature, often with a contrasting element, can allow readers more opportunities to engage with the poem, perhaps supplying their own subjective experiences. The description may contain an element of surprise, mystery, or humor, but it is usually based on fresh, specific imagery with an intense focus. Yet a fine haiku is seldom purely objective, since it has to resonate with human experience. It may give the appearance of being spontaneous, and perhaps it was, but poets like Bashō and Santōka also considered and sometimes altered their verses over a period of time. The purpose of haiku was to use the mundane while exceeding the mundane, to discover a moment of oneness in the diverse or to discern multiplicity in the singular. Haiku can find an inner truth from an outward phenomenon, and ultimately use words to go beyond words.

hatsu aki ya	early autumn—
umi mo aota no	the sea and rice fields
hito midori	a single green

Bashō's haiku seems like pure observation, but it also allows readers to share the experience of an autumn day, as well as the feeling of unity in nature and with nature. However, it does not say so too directly. Haiku present images rather than ideas; they seldom have conclusions, moral lessons, or direct statements of emotions—these may be implied, but the more open haiku are to personal intuition and empathy, the stronger they become as poems.

Another way to view haiku is through the combination of the momentary and the timeless, the blending of human perception and the universal pulse of nature. Like the "just this" of Zen, haiku masters stress the current moment in a state of focused perception, but that individual moment is also part of a greater world that does not begin or end. Each happening can be seen as unique, but also as connected with everything else. The following haiku by Bashō manages to express the former while somehow implying the latter:

kane kiete	the temple bell fading,
hana no ka wa tsuku	the scent of flowers comes forth—
yūbe kana	evening

Haiku Structures

If haiku are generally written in a single column in Japanese, why are they usually translated into three lines? A good question, to which there are several possible answers. Primarily, it is because the three-part syllable division in Japanese haiku becomes more clear in English when the lines are divided. In addition, traditional haiku often include pause marks called *kireji* (cutting words) that help to mark rhythmic divisions. For example,

at the end of the first or second segments there may be the extra syllable *ya*, at most a gentle untranslatable "ah," indicating a rhythmic pause, or sometimes foreshadowing a change of theme or meaning. In contrast, the ending *kana* gives a sense of completeness, or "Isn't it so?" One might see these cutting words primarily as sonic punctuations or intensifiers of mood and meaning, as in these two examples by Bashō:

akebono ya	break of day—
kiri ni uzumaku	swirling though the fog
kane no koe	the voice of the bell
hyakunen no	looking a hundred years old
keshiki wo niwa no	this garden's
ochiba kana	fallen leaves

Neither *ya* in the first poem nor *kana* in the second have a distinct meaning, but in the first haiku *ya* creates a pause, and in the second *kana* fills out the rhythm with a feeling of conclusion. Other cutting words include *yo* and *zo*, both of which emphasize the previous word or words. Since *kireji* seldom have meanings of their own, they are primarily included to contribute their rhythms and sounds; therefore, one may consider many Japanese haiku as having fewer than seventeen active syllables.

In practice, most haiku have two parts, so that either the first two lines or the last two lines are one unit, and the first line or the last line is another unit. In both poems given above, it was one plus two, while in the following five haiku by Bashō, it is the reverse:

aoyagi no	green willow
doro ni shidaruru	drooping into the mud—
shiohi kana	low tide

saki midasu	in the confusion
mono no naka yori	of peach trees blooming—
hatsu-zakura	the first cherry-blossoms

nan no ki no	from which flowering tree
hana to wa shirazu	I don't know—
nioi kana	but the fragrance!

Some haiku that are two lines plus one might be considered "riddle poems," in the sense that the first two lines set up an implied question—What is this?—and the final line gives a (sometimes surprising) answer.

ochizama ni	while falling
mizu koboshikeri	it spills its water—
hanatsubaki	a camellia

ōkaze no	still scarlet
ashita mo akashi	the day after the storm—
tōgarashi	peppers

At other times, the third line is a seemingly unconnected image that can allow us to make our own interpretations, as in this haiku by Ransetsu:

matsumushi no	the buzz of the
rin tomo iwazu	pine cricket is silent—
kurochawan	black tea bowl

Does this take place during a tea ceremony? Is the poet simply looking at a bowl that suggests that night is deepening? Or are there other meanings altogether? This is up to us to consider, but it may be that Ransetsu himself wanted multiple interpretations.

To make the situation more complicated, there are some haiku that divide into two relatively equal segments by having the cutting word *ya* in the middle of the second line, such as this poem by Buson, which could be rendered two different ways, 5–7–5 and 8–9:

uguisu no	the warbler
naku ya chiisaki	sings with its small
kuchi aite	mouth wide open

| *uguisu no naku ya* | the warbler sings— |
| *chiisaki kuchi aite* | with its small mouth wide open |

Other haiku seem to be more continuous over the three sections, although readers may still feel some divisions within them. Here are two examples from Bashō:

yase nagara	although very skinny
wari naki kiku no	somehow the chrysanthemum
tsubomi kana	is in bud

suzume-goto	baby sparrows
koe nakikawasu	are echoed by
nezumi no su	mice in their nest

Finally, there are some haiku that seem to be composed of three separate lines, although of course one can envision connections between them. Here is an example by Buson:

amadera ya	women's temple—
yoki kaya taruru	mosquito nets hanging—
yoitsukiyo	moonlit evening

Haiku Sounds and Rhythms

Like other forms of Japanese poetry, haiku do not use rhyme, but they do sometimes feature repetition of words or sounds to create a particular rhythm and music, such as in this poem by Bashō:

hototogisu	the cuckoo
naki naki tobu zo	calling, calling, flying—
isogashiki	how busy!

Here Bashō's first word, *hototogisu* (cuckoo) is itself somewhat onomatopoetic, since the sound suggests the bird's call, while the repetition of *naki naki* (calling, calling) adds to the rhythm of repeated sounds. Further, the final word has three "i" vowels, somewhat in parallel with the three "o" vowels in the first line. There seems to be no way to retain this music in translation, but it is an important element in the original poem. However, readers can sound this poem out for themselves: vowel sounds in Japanese are similar to those in Italian—*a* as in "spa"; *i* as in "see"; *u* as in "too"; *e* as in "egg"; and *o* as in "so."

Another Bashō haiku begins each segment with an "oo" sound, which also ends the poem. There is also a significant repetition of the "ah" sound in *utagau na, hana, ura,* and *haru.*

utagau na	have no doubt—
ushio no hana mo	tides have their own flowers
ura no haru	in spring inlets

The next three Bashō poems also feature the "ah" sound, suggesting flowering, sunlight, or heat, followed by a fourth poem that emphasizes the "o" sound for the cuckoo.

asagao wa	a morning glory
sakamori shiranu	not knowing of our drinking
sakari kana	blooms
ara tōto	how solemn—
aoba wakaba no	green leaves, young leaves
hi no hikari	in sunlight
aka-aka to	red, red
hi wa tsurenaku mo	the pitiless sun, and yet—
aki no kaze	the autumn breeze
no wo yoko ni	crossing the fields,
uma hikimuke yo	"lead my horse to that side"—
hototogisu	the cuckoo

A powerful haiku by a woman poet who became a nun, Den Sute-jo (see pages 137–38), also emphasizes the sound "ah" for heat; this sound appears in ten of the seventeen syllables.

hada kakusu	skin concealed
onna no hada no	but a woman's skin's
atsusa kana	heat!

Haiku Uses of the Past

Although one of the most important features of haiku is observation of the present moment, poets have occasionally referred to the past, such as mentioning masters from earlier ages whom they particularly adulated. For example, Bashō especially admired the monk-poet Saigyō (see page 34), whose wandering lifestyle Bashō praised and adopted. Buson and Issa looked up to Bashō as well as Saigyō—in fact Buson was one of the leaders in a "back to Bashō" movement at a time when he felt that haiku were

losing the spirit of the great master. Shiki especially praised Buson, whose reputation as a major poet he helped to restore. Sometimes these poets were included directly in haiku:

imo arau onna	a woman washes potatoes—
Saigyō naraba	if I were Saigyō
uta yoman	I'd write a tanka
—BASHŌ	

Saigyō no	just like Saigyō
yō ni suwatte	he sits and chants—
naku kawazu	the frog
—ISSA	

okinaki ya	Bashō's death day—
naniyara shaberu	what are you discussing,
kado suzume	sparrows by my gate?
—ISSA	

There may also be references to images or phrases from the past, such as *furu ike* (old pond), that bring forth the spirit of an admired predecessor. In one case, a verb we might not expect in haiku, *haku/haite* (belch, vomit), appears in the haiku of a succession of poets.

tsuki no ku wo	after belching out
haite herasan	a verse on the moon
gama no hara	the toad's belly shrinks
—BUSON	

kumo wo haku	his mouth ready
kuchitsuki shitari	to belch out a cloud—
hikigaeru	the toad
—ISSA	

yoiyama ya	early evening—
tsuki wo hakidasu	belching out the moon
gama no kuchi	the mouth of the toad
—SHIKI	

The references to past poets can be subtle, and it is worth keeping in mind that not every element in every haiku is based only on direct observation. Frequently, observation and past literature were combined, as in a haiku by Buson that mentions an eleventh-century collection of Chinese and Japanese poetry (discussed on page 29).

kaji no ha wo	a mulberry leaf
Rōei-shū no	serves as a bookmark
shiori kana	in the *Rōei-shū*[3]

Beginning with Bashō, however, references to the past were generally curtailed in comparison to the clever haiku that preceded him, and the most important element was the "here and now" on its own terms. In this regard, there has been some dispute about the role of the imagination in haiku composition. Shiki believed in "painting from life" (*shasei*) in his poetry, but he praised Buson particularly for his use of imagination. This has an interesting connection with memory, since putting a perception or an observation into words is already an act of memory taking place after the event, even if it is just a split second later. Imagination has roots in memory as well, so the situation is certainly complex. Perhaps it is enough to realize that words and images have associations that can add to (or sometimes distract from) the meaning of a haiku.

Some literary connections, whether from tanka, haiku, or other sources, may be lost to us—and certainly no one in Japan could catch every possible reference. However, a fine poem exists perfectly well on its own, and masters were able to use occasional associations without losing the force of their original perceptions. It is therefore the combination of direct perception and the mind of the poet, including memory, personality, and experience, that leads to the finished poem. Many people have heard the sound of a frog jumping into the water, but it was Bashō who transformed this moment into an evocative haiku:

> *furu ike ya*　　　　old pond—
> *kawazu tobikomu*　　a frog jumps in
> *mizu no oto*　　　　the sound of water
>
> —1686

Haiku Painting (Haiga)

If haiku is a worldwide phenomenon, *haiga* (haiku painting) is almost unknown. Yet the major masters all created haiga, as well as haiku calligraphy, and their words and images frequently add substantial meanings to each other.

One reason that haiga have often been painted by Japanese poets is that the tools are the same as in writing—brush, ink, and paper or silk, with the occasional addition of colors. Poets with great talent in painting like Buson created haiga, but so did those with modest skills like Issa, and both their haiga are esteemed by viewers. In fact, too much technique can be as much a liability as too little, since sincerity and suggestion are more important than obvious mastery and specificity. Therefore not only is the medium the same, but the aesthetics of haiku and haiga are also similar. Brevity, directness, naturalness, simplicity, and allowing the viewer to participate are the most important qualities. True haiga does not invite comments like "What a great painting!" as much as "How delightfully the painting and poem in-

teract!" In fact, the only specific definition of haiga is an image plus a haiku, but over time a special haiga style of painting developed that emphasized the casual, relaxed, and understated.

Japanese haiga, the word-image relationships, developed into three main patterns. The first is the most simple: an informal portrait of a poet with one of his or her haiku (see Buson's depiction of Chigetsu in plate 6-2). This follows an earlier Japanese tradition of portraits of aristocratic tanka masters, but now the colors (if any) are muted, the brushwork is less sharp and precise, and the mood is no longer decorous; indeed, some haiku portraits seem close to caricature.

The second (and most common) interaction in haiga is supportive: one of the images is represented in both words and painting. If the poem mentions the moon, the moon also appears visually. However, in a good haiga the painting does not merely illustrate the haiku, and the poem does not simply explain the painting; they both add to the total effect of the work, reinforcing but also contributing to each other. There are several examples of this kind of multilayered support in the haiga reproduced in this book, and reader-viewers can discover how each art contributes to the expression of the other, even when they seem to be signifying the same thing.

The third form of text-image relationship in haiga is the most intriguing: the words and the painting do not seem to have any direct connection at all. Of course, this can occur in words alone, as in some haiku where the images do not seem to readily connect, but it is even more apparent in certain haiga. This will be discussed later with specific examples, such as the Issa painting of a hut in plate 7-1, but in general the result is to add further meanings to both poem and image, setting up a special resonance that expands the total range of expression.

More common than haiga is haiku calligraphy, since many poets were asked for written versions of favorite poems. Because it is believed in East Asia that all calligraphy is a direct representation of the inner character and spirit of the calligrapher, the modest writing of Bashō, the more full-bodied brushwork of Buson, and the gentle script of Issa all well represent their personalities.

Haiga combines not two arts but three: poetry, painting, and calligraphy, and their interactions are always fascinating. It is not merely meanings and styles, but how they are visually combined in space that gives haiga its special flavor (again, see the description of Buson's Chigetsu portrait on pages 207–8). While the literati in both China and Japan generally placed their calligraphic inscriptions so they were separate from the painting, usually on the top of the scrolls, in haiga these inscriptions are often combined in much more interconnected and intimate ways. The poem swirls around the image, balances it asymmetrically, points to it, or any other combination that varies from work to work. The calligraphy of the poem may even be divided into two different parts of the painting, as in the final haiga of the book by Buntō (Plate 8-11).

Summing up the many fascinations of haiga, they often reside especially in the interactions of the different arts of which they are composed. Haiku are marvelous by themselves, but the interpenetration of the different arts is what gives haiga their unique appeal. Since all the master haiku poets must have felt this potential when creating their own haiga, this special form of verbal-visual art deserves to become much better known in the future.

1

Background
The Tanka (Waka) Tradition

ITHIN THE LONG AND illustrious Japanese poetic tradition, the origins of haiku can be seen both as part of a historical progression and as a revolution in aesthetics. To understand these two aspects of haiku, it can be helpful to investigate earlier Japanese cultural history.

This island nation undoubtedly had a strong poetic tradition in its prehistoric days, strongly connected to its ceremony, dance, chant, and song. The first two books compiled in Japan, the *Kojiki* (Record of Ancient Matters, 712) and the *Nihonshoki* (Chronicles of Japan, 720) contain 113 and 131 poems respectively, some of which certainly came from much earlier times.[1] The rhythmic repetition of words and occasional extra vocalizing syllables in many of these verses reinforce the belief that they began as songs. For example, there is an insistent repetition of the word *yaegaki* (eight-sided balustrade) in the very first poem in the *Kojiki,* which is a celebration by a divine bridegroom of his wedding and new railing.

Yakumo tatsu	Where eight clouds arise
Izumo yaegaki	in Izumo, an eight-sided balustrade
tsumagomi ni	to receive my wife,
yaegaki tsukuru	an eight-sided balustrade I've built,
sono yaegaki wo	oh, this eight-sided balustrade!

The 5–7–5–7–7 syllable count of this five-line poem distinguishes it as a tanka (short song), also known as a *waka* (Japanese song) and an *uta*

(song). Its asymmetrical formula is quite different from most traditional Chinese poetry, which features evenly balanced lines arranged in parallel couplets, quatrains, and so on. Chinese *jintishi* (regulated verse) also depends on rhyme and on repeating patterns of tonal inflections, which are both missing from Japanese poetry. Instead, in most tanka there is a structure based on syllables, with a strong emphasis upon the evocation of human feelings, whether expressed directly or indirectly. In addition, many tanka feature "pillow words," which were standard epithets. An example is the first line of the previous poem, which became a standard phrase for the sacred site of Izumo.

Although the tanka's thirty-one-syllable form is brief compared with early *chōka* (long songs), tanka became and remained by far the most popular kind of poetry during Japan's Nara and Heian periods (646–1185), when the court was the fountainhead of refined Japanese culture.

The *Man'yōshū*

The earliest anthology of Japanese poems, the *Man'yōshū* (Collection of Ten Thousand Leaves or Collection of Ten Thousand Generations),[2] was compiled between 686 and 784. Its last datable poem is from 759, but many of its 4,516 verses are much earlier, and include folk songs, chants, elegies, and dialogue poems. Nevertheless, perhaps nine-tenths of *Man'yōshū* poems are in the tanka tradition.

Although other collections of poetry at times became more popular, the spirit of the *Man'yōshū* has remained an important element in Japanese culture for more than twelve hundred years. In the Edo period (1615–1868), the text was significantly revived and exalted by Kokugaku (National Learning) scholars; the first two complete commentaries on the *Man'yōshū* were completed in 1690. This was just the time when haiku were becoming popular, so it may be useful to examine a number of tanka from this seminal collection.

Many poems from the *Man'yōshū* appear as direct impressions of nature, whether of famous beauty spots or more intimate settings.

Kari ga ne wo	When I first hear
kikitsuru nahe ni	the calls of wild geese
Takamatsu no	at Takamatsu
no no e no kusa so	grasses on the moors
irozukinikeru	begin to redden their color

—ANONYMOUS

Waga sono ni	In my garden
ume no hana chiru	plum blossoms fall—
hisakata no	or is it not rain
ame yori yuki no	but snow, cast down
nagare kuru ka mo	from the sky?

—ŌTOMO NO TABITO (665–731)

The charming confusion as to whether it is snow or plum blossoms that are falling, which originally came from Chinese poetry, became a familiar trope in courtly tanka, and *mitate* (taking one thing for another) proved to have a long history in Japanese culture.

Even in what seem to be pure nature poems, there may be hints of human feelings, usually romantic—more than half of *Man'yōshū* poems are directly or indirectly about love. For example, in the first of the two poems above, the word *iro* in the final line can refer to passion as well as color, and the repetition *no no no e no* gives a rich, dark tonality to the tanka.

The moon has long been a familiar image in Japanese poetry, its meaning ranging from purity to a background for love or longing. The first of the following three *Man'yōshū* poems seems to be a direct observation of nature, if not of human passion, while the following two indirectly suggest the feelings of a lover waiting for the beloved.

Ochitagichi	Plunging and foaming
nagaruru mizu no	the flowing waters
iwa ni fure	strike the reefs,
yodomeru yodo ni	then settle in pools where
tsuki no kage miyu	reflections of the moon can be seen

—ANONYMOUS

Nubatama no	The sky is dark
yogiri no tachite	as black beads
oboboshiku	in the fog—
tereru tsukiyo no	but what sadness there is
mireba kanashisa	in viewing the waning moon

—LADY ŌTOMO OF SAKANOUE (C. 695–C. 750)

Yama no ha ni	On the mountain crest
isayou tsuki wo	will the waning moon
idemu ka to	finally appear?
machitsutsu oru ni	As I wait and wait
yo so fukenikeru	night deepens

—ANONYMOUS

In contrast to many poems that use familiar images, other tanka in the *Man'yōshū* are unique, for example comparing nonsexual nights with bamboo, or a difficult lover with a bracelet.

Waga seko wo	I thought my lover
izuku yukame to	would never leave me
saki take no	so like split bamboo
sogahi ni neshiku	we slept back-to-back—
ima shi kuyashimo	how I regret it now!

—ANONYMOUS

The Art of Haiku

Tama naraba	If you were beads
te ni mo makamu wo	I'd wind you around my wrist—
utsusemi no	but in this mundane world
yo no hito nareba	since you are a man
te ni makigatashi	you are difficult to turn

—ELDER MAIDEN OF THE ŌTOMO CLAN (N.D.)

Two other tanka from this collection express the reluctance of a woman to have her love affair become known. The first does so metaphorically through the color crimson, which hints at passion. In the second tanka, since a marriage could be assumed to take place when a lover stayed past dawn, the sentiment is ambiguous—how much does she really want her husband to leave?

Kurenai no	If I wear
fukasome no kinu wo	an under-robe
shita ni kiba	of deeply dyed crimson
hito no miraku ni	when people look at me
nioiidemu ka mo	would they see just a trace?

—ANONYMOUS

Waga kado ni	At my gate
chitori shibanaku	a thousand birds call out
oki yo oki yo	"Get up! Get up!"
waga hitoyozuma	Oh husband of a single night,
hito ni shirayu na	don't let people know!

—ANONYMOUS

Not all tanka in the *Man'yōshū* are individual poems. In courtly Japan, noblemen and noblewomen were expected to write elegant verses to each other on a moment's notice, and tanka poetry became the most admired form of elegant communication between the sexes. The following pair of

tanka was sent back and forth between a nobleman and his young wife. This style of paired courtship or love poems was to become increasingly popular, and became known as *zōtōka* (exchanged poems).

Takeba nure Tied up, it loosens,
takaneba nagaki untied, it's too long
 imo ga komi my love's hair—
kono koro minu ni nowadays I can't see it—
kakiretsuramu ka has she combed it together?

 —MIKATA NO SAMI (ACTIVE C. 700)

Hito wa mina Everyone now says
ima wa nagashi to my hair is too long
 take to iedo and I should tie it up—
kimi ga mishi kami but the hair you gazed upon
midaretari to mo I'll leave in tangles[3]

 —THE DAUGHTER OF OMI IKUHA (N.D.)

Finally, a few of the poems in the *Man'yōshū* have a more philosophical bent; here are three that go beyond the usual theme of romantic love. The first suggests an elderly person who is searching for the Way (*michi*), known as the Tao in China, which can represent both a physical path and a more spiritual journey. The second is also by an elderly nobleman, now regretting that he may no longer be able to return to his home and position at court. The third poem goes beyond death to future life. Although being reborn in an animal state was usually considered unfortunate, this tanka seems to reveal a much more hedonistic approach to life that presages the "floating world" of pleasures that became celebrated a thousand years later.

The Art of Haiku

Utsusemi wa	The husk of my body
kazu naki mi nari	counts for nothing
yama kawa no	I just view the brightness
sayakeki mitsutsu	of mountains and rivers
michi wo tazunena	as I search for the Way

—ŌTOMO NO YAKAMOCHI (C. 718–85)

Waga sakari	The blossoming of my life
mata ochime ya mo	again fades—
hotohoto ni	it's almost certain
Nara no miyako wo	that the capital of Nara
mizuka nariyamu	I shall not see again

—ŌTOMO NO YOTSUNA (ACTIVE 1730s–40s)

Kono yo ni shi	If I enjoy myself
tanoshiku araba	in this world,
komu yo ni wa	in the next
mushi ni tori ni mo	I'll just become
ware wa narinamu	a bug or a bird

—ŌTOMO NO YAKAMOCHI

The *Kokinshū*

Poetry collections became increasingly popular in courtly Japan. Around the year 905, Emperor Daigo (reigned 897–930) commissioned several noblemen to compile the *Kokin-wakashū* (Old and New Waka Collection, usually shortened to *Kokinshū*) as a "modern" successor to the *Man'yōshū*. This first imperial anthology was completed between 915 and 920 and contained twenty books, of which seven were devoted to the seasons, always important in Japanese aesthetics, and five more to love poems. The tone of the anthology is considered refined and subjective, with more emphasis upon the poets' feelings than on nature, which poets often used as metaphors.

One of the poet-compilers, Ki no Tsurayuki (c. 872–945), composed an introduction to the *Kokinshū* that has remained one of the most influential descriptions of Japanese verse ever written, especially its opening lines.

Poetry in Japan begins with the human heart as its seed and myriad words as its leaves. It arises when people are inspired by what they see and hear to give voice to the feelings that come forth from the multitude of events in their lives. The singing of warblers in the blossoms, the voices of frogs in the ponds, these all teach us that every creature on earth sings. It is this song that effortlessly moves heaven and earth, evokes emotions from invisible gods and spirits, harmonizes the relations of men and women, and makes serene the hearts of brave warriors.[4]

Tsurayuki not only wrote this preface, but was also the single largest contributor to the *Kokinshū,* with no less than 202 of his poems included. Some of his tanka are basically variations on familiar romantic themes, but Tsurayuki also contributed a poem on transience, a Buddhist concept that by this time was firmly established in Japan. The occasion was the death of his nephew Ki no Tomonori (c. 850–c. 904), who had collaborated on the anthology but died before it was completed.

Asu shiranu	Although I realize
waga mi to omoedo	we can't know even our own body
kurenu ma no	tomorrow—
kefu wa hito koso	today, even before sunset,
kanashikarikere	is already sad

Some *Kokinshū* poems are direct observations of nature, although one may always suspect a second meaning. In the next poem, for example, since *iro* means both "color" and "passion," the poem might have been sent by a lover as an avowal of constancy, especially since *aki* can mean not only au-

tumn but also weariness or satiety. Such puns and related words (*engo*) were very important within the seeming simplicity of many tanka.

Kusa mo ki mo	Although grasses and trees
iro kawaredomo	both change their colors
watatsuumi no	on the flower-waves
nami no hana ni zo	of the great ocean
aki nakarikeru	there is no autumn

—BUNYA YASUHIDE (NINTH CENTURY)

Noblewomen were important poets in the *Kokinshū*, becoming even more significant than in the *Man'yōshū*. Perhaps the most famous was the talented beauty Ono no Komachi (834–80). By the eleventh century, legends had grown around her name, such as when she required a suitor to stand outside her house for one hundred nights, whatever the weather. On the ninety-ninth evening, he died.

Eventually, Komachi's beauty faded, and she is said to have wandered around in rags before her death, after which her skull ended up lying in a field. While these tales are highly suspect, they did add to her notoriety. One of her most celebrated tanka is difficult to translate, since once again the word *iro* has the meanings of both "color" and "passion."

Iro miede	Its colors fading
utsurou mono wa	with no outward sign
yo no naka no	in this world—
hito no kokoro no	the flower
hana ni zo arikeru	of the human heart

A poet of a generation later, Lady Ise (c. 875–c. 938), also contributed passionate poems to the *Kokinshū*. According to her headnote, this tanka was written while seeing the stubble being burned in the fields, which occurred at the same time she was grieving over a love affair.

Fuyugare no	If I feel
nobe to wagami wo	my body is burned
omoiseba	like the desolate
moete mo haru wo	winter fields—yet
mata mashimono wo	the spring may come again

The *Kokinshū* is often considered more elegant and refined than the *Man'yōshū,* and certainly tanka had been thoroughly developed during the several centuries between the two texts. Nevertheless some of the later collection's love poems are still quite direct, such as these two anonymous verses that suggest that secrecy was an important element in romance. The first poem also has a nice example of personification, another familiar tanka device.

Waga koi wo	Can anyone
hito shirurame ya	know of our love?
shikitae no	If it could be known,
makura nomi koso	it would only be
shiraba shirurame	by our silk pillow

Shinonome no	When the first
hogara-hogara to	flickering lights of dawn
ake yukeba	appear
ono ga kinuginu	we help each other put on
naru zo kanashiki	our clothes—how sad!

Poetry in *The Tale of Genji*

Tanka poetry was a major feature of Japan's (and perhaps the world's) first novel, *The Tale of Genji* by Lady Murasaki, who was born about 973, and died either in 1014 or between 1025 and 1031. The fact that women were discouraged from learning Chinese gave them something of an advantage

when writing prose in Japanese, which many men disdained, and this long narrative remains one of the most celebrated novels by writers of either sex. Although it was written in the early eleventh century, it suggests a period perhaps a century earlier. The principle theme here is romantic love, emphasizing its extraordinary importance in a courtly society where most other elements of life were prescribed and essentially unchanging.

Prince Genji himself is presented as an outstanding poet, as are most of the court noblemen and women that he knows. This gives Murasaki the opportunity to compose many tanka as a means of expressing deep emotions that go beyond prose descriptions. A typical poem sent by a courting courtier includes the word *iro,* which, as noted before, means both "color" and "passion."

Omou tomo	You cannot know
kimi wa shiraji na	my deepest feeling—
wakikakaeri	like the water
iwa moru mizu ni	that seethes over rocks
iro shi mieneba	its color can't be seen

One feature of the tanka in *The Tale of Genji* is how often they were created as *zōtōka,* therefore becoming a form of two-way communication. The novel contains many such pairs of poems being sent back and forth between lovers or would-be lovers, and sometimes they are described as being composed on the spot. One example was written by Genji for his wife, from whom he must part, with her murmured poetic reply. They both play with the charming conceit that his mirror can retain her image over time.

Mi wa kakute	Although we cannot
sasuraenu tomo	travel together
kimi ga atari	you will be near
saranu kagami no	since your image will never
kage wa hanareji	leave this mirror

Wakare tomo	Although we part
kage dani tomaru	if my image remains
mono naraba	when you look
kagami wo mite mo	into this mirror
nagusame te mashi	it will comfort you

Genji thereupon sends a series of letters to his wife from a temple in Uji. One of these includes poem of concern for her, to which she again responds seemingly reassuringly, but with the undertone that colors (passions) are mutable in this dewdrop world.

Asajiu no	Like dewdrops
tsuyu no yadori ni	clinging to reeds
kimi wo okite	you face the storm
yomo no arashi zo	that comes from all directions
shizugokoro naki	and my heart is unquiet

Kaze fukeba	When the wind blows
mazu zo midaruru	there is confusion at first
iro kawaru	but as colors change
asaji ga tsuyu ni	the dew remains on the reeds
kakaru sasagani	just as it hangs on spiderwebs

Summing up the tanka in *The Tale of Genji,* it is clear that in courtly Japan they expressed more than what could be directly stated, and therefore were of great importance in revealing, or hinting at, inner feelings. These tanka served as a way for people to relate to each other through using natural imagery to express their love, or in some cases, their rejection of love. Of course, to some extent this was an elegant game, but in many cases one may find genuine emotions underneath the cultural patterns. The novel also makes clear that these emotions were transient, as expressed in a pair of tanka that

were exchanged between Genji and a court lady. The primary image is, appropriately, a flower that only blooms in the morning.

Mishi ori no	I can't forget
tsuyu wasurarenu	that time when dew fell
asagao no	on morning glories—
hana no sakari wa	are the flowers
sugi ya shinuran	now past their bloom?

Aki hatate	As autumn ends,
kiri no magaki ni	entangled in the mist
musubo-ore	by the bamboo fence
aru ka naki ka ni	are they or are they not
utsuru asagao	fading morning glories?

In a supremely elegant society that seemed given almost entirely over to ceremonies and pleasures, it is telling that sadness and regret ultimately become the outstanding emotions in the entire novel, as well as in its tanka. Perhaps this was because the Buddhist notion of transience had penetrated deeply into Japanese sensibilities by this time, or perhaps unabashed hedonism necessarily leads to loss and sorrow in any society.

The Pillow Book of Sei Shōnagon

While *The Tale of Genji* is a remarkable novel about courtiers, there is a nonfiction and considerably less romantic book of equal interest that presents the life and times of nobles at about the same period. The noblewoman Sei Shōnagon (c. 966–1017) kept a remarkable "pillow book" as a form of diary during the 990s until 1002. It contains a great deal of information presented in her unique style, combining descriptions of events at court, gossip, personal musings (often acerbic), and lists of all kinds.

Some of Sei Shōnagon's comments on the importance of poetry can help flesh out the record left by the tanka themselves, and give them more context. First, the expectation that court ladies as well as noblemen should be able to write verses on any suitable occasion caused a certain amount of tension. One story in the *Pillow Book* tells of court ladies returning to the empress after an excursion to hear the call of the *hototogisu* (cuckoo).

> "And now," said her Majesty, "where are they—your poems?" We explained that we had not written any. "Really?" she said. "That is most unfortunate. The gentlemen at court are sure to hear of your expedition. How are you going to explain that you haven't got a single interesting poem to show for it? You should have dashed something off on the spur of the moment while you were listening to the *hototogisu*. Because you wanted to make too much of it all, you let your inspiration vanish. I'm surprised at you!"[5]

Apparently, not only were courtiers expected to be able to write tanka on almost any occasion, they were also expected to know the classics thoroughly. In particular, we learn that the *Kokinshū* was highly esteemed in Sei Shōnagon's day, and everyone at court was expected to know it well.

> The Empress placed a notebook of *Kokinshū* poems before her and started reading out the first three lines of each one, asking us to supply the remainder. Among them were several famous poems that we had in our minds day and night; yet for some strange reason we were often unable to fill in the missing lines. . . . "Those of you," said the Empress, "who had taken the trouble to copy out the *Kokinshū* several times would have been able to complete every single poem I have read."[6]

In addition, the *Pillow Book* has several sections in which poems are sent with the expectation of receiving a tanka of high quality in response, and the quality of both poems had a great deal to do with one's prestige at court. Skill

at poetry, along with fine calligraphy and refined manners, could lead not only to romance but could also provide access to the emperor and empress.

Other Tanka Anthologies

Among the anthologies that followed the *Kokinshū,* several gained great popularity, each with its own particular structure. One of these was the *Wakan Rōei-shū* (Japanese and Chinese Poems to Sing), a compilation of poems in both languages that was completed about the year 1013, about the same time that *The Tale of Genji* was being written. As well as 216 Japanese tanka, it includes 588 Chinese couplets written by thirty Chinese and fifty Japanese masters. Perhaps it was the Japanese preference for brevity that led to selecting couplets from Chinese verses, rather than including the entire poems. By this time, many noblemen and high-ranking monks were adept at writing in Chinese, but since women were not supposed to learn that language they were added only to the tanka sections. Like most anthologies, the *Wakan Rōei-shū* also presented work from previous publications, and included a dozen poems from the *Man'yōshū* as well as more than fifty that had also been anthologized in the *Kokinshū.*

Because the Japanese poems in the *Wakan Rōei-shū* generally follow trends set earlier, we will offer only two examples here. The first anonymous tanka may seem similar to the well-known question in the West: "If a tree falls in the woods with no one to hear it, does it make a sound?" The second tanka, by the ubiquitous Ki no Tsurayuki (who had more than twenty poems in this compilation), utilizes its title image to hint at emotion rather than stating it directly.

Ashibiki no	In the mountains
yama gakure naru	so wearying to climb,
hototogisu	does the cuckoo,
kiku hito mo naki	with no one to listen,
ne wo ya nakuramu	sing its song?

The Cry of the Crane[7]

Wasurete mo	Its mournful cry
aru beki mono wo	in the reed plains
ashihara ni	calls to mind
omoi izuru no	something much better
naku zo kanashiki	to forget

Another anthology that proved even more successful through the centuries was the *Hyakunin isshū* (One Hundred Poems by One Hundred Poets), which was put together in the 1230s by Fujiwara no Teika (1162–1241) from more than five centuries of Japanese poetry. As noted earlier, the *Man'yōshū* was revived by scholars during the Edo period, but during that time the *Hyakunin isshū* became more widely popular among many levels of society, in part through a card game in which players had to match the first three lines of a poem with the final two (much like the court ladies noted earlier). In addition, the poems were featured in illustrated books, wood-block prints, and even clothing and home furnishings.[8] Some of these tanka had been anthologized earlier, and for most Japanese they became the canon of classical poetry, certainly well-known to most (if not all) haiku poets half a millennium later.

Since the *Hyakunin isshū* is organized in roughly chronological order, a sample of tanka from this anthology can provide a brief review of Japanese poetry up to the early thirteenth century. An even more significant feature of the anthology is how certain main themes vary within the same time period as well as over the centuries. Borrowing from an earlier poem (*honkadori*) was quite acceptable, and to some extent these traditional themes are "performed" by poets much like classical musicians perform Mozart and Beethoven in the West.

To see how the same poet varies a theme, the ninth of the hundred poems is by Ono no Komachi, and relates to her evocative tanka translated earlier (see page 23).

Hana no iro wa	Flower colors
utsurinikeri na	have faded in vain
itazura ni	as I pass
wagami yo ni furu	through this world
nagame seshi ma ni	like slowly falling rain

Now the flower has faded, and the poetess seems resigned to her fate. While the previous poem is more purely descriptive, at least on the surface, this tanka is more personal because she refers specifically to herself (and, by inference, her emotions) falling like the rain.

The nineteenth poem chosen for this collection is by Lady Ise.

Naniwa-gata	Are you saying
mijikaki ashi no	we will go through this world
fushi no ma mo	not meeting for even
awade kono yo wo	as small a time as the tiny spaces
sugishiteyo to ya	in the nodes of Naniwa reeds?

Several tanka in the *Hyakunin isshū* utilize the familiar theme of waiting at night for a lover to come, often in vain. We can compare four poems on this theme, the second and fourth of which are by women. Sharp-eyed readers may note that the final two lines of the first poem have eight Japanese syllables instead of seven. This is called *ji-amari* (extra characters) and it appears in tanka occasionally, perhaps to show emotion breaking the bounds of convention.[9]

Ima komu to	Only because
iishi bakari ni	you said you would come
naga tsuki no	have I waited
ariake no tsuki wo	in this long month
machi idetsuru kana	for the moon to appear at dawn

— THE MONK SOSEI HŌSHI (N.D., POEM 21)

Tsuki mireba	As I view the moon
chiji ni mono koso	I feel the sadness
kanashikere	of all things—
wagami hitotsu no	this autumn is not
aki ni wa arenedo	for me alone

—ŌE NO CHISATO (FLOURISHED 889–923, POEM 23)

Ariake no	More than seeing
tsurenaku mieshi	the pitiless dawn moon
wakare yori	as we part
akatsuki bakari	is the loneliness
uki mono wa nashi	at break of day

—MIBU NO TADAMINE (BORN C. 850, POEM 30)

Yasurawa de	Instead of
nenamashi mono wo	going off to sleep
sayo fukete	as night deepens
katabuku made no	I watch the moon
tsuki wo mishi kana	until it finally sets

—ATTRIBUTED TO AKAZOME EMON (956–1041, POEM 59)

The first of these tanka is straightforward: the poet waits all night, but the lover does not come as promised. The second is more general, with its discovery that autumn sadness is something that others may share. In the third poem the lovers have been together, but after one leaves, the sense of loneliness is perhaps even greater. The fourth tanka is more like the first, but now the absence of the lover is entirely suggested by implication.

Several other themes find multiple expression in the poems chosen for the *Hyakunin isshū*, including the passing of time. This is usually nostalgic and melancholic as the poet recalls his original home, where he felt happy and secure compared with the present-day vicissitudes of living and loving in the capital.

Hitowa isa	One can never
kokoro mo shirazu	know people's hearts—
furusato wa	but in my old village
hana zo mukashi no	the plum blossoms still emit
ka ni hihojikeru	the scent of the past

—KI NO TSURAYUKI (POEM 35)

Ai mite no	Compared to
nochi no kokoro ni	my feelings after
kurabureba	we met—
mukashi wa mono wo	in the old days
omowazarikeri	I had no worries at all

—FUJIWARA NO ATSUTADA (906–43, POEM 43)

Another tanka in the *Hyakunin isshū* is a variation on the pair of poems about tangled hair that we saw before in the *Man'yōshū* (see page 20):

Nagakaramu	How long it will be
kokoro mo shirazu	my heart cannot know—
kuro kami no	my black hair
midarete kesa wa	is tangled this morning
mono wo koso omoe	just like my inner feelings

—TAIKENMON-IN NO HORIKAWA (N.D., POEM 80)

Are all the tanka in this anthology about human feelings? Certainly the frequent use of the noun *kokoro* (heart, mind), and the verb *omou* (to think, care, feel, love) indicates how often tanka express human passions, whether directly or by implication. There are exceptions, however, such as this nature poem by the Buddhist monk Jakuren (1139–1202, poem 87).

Murasame no	While dew-like drops
tsuyu no mada hinu	from the passing shower still remain
make no ha ni	on the black pine needles—
kiri tachi-noboru	the mist is already rising
aki no yūgure	this autumn evening

Saigyō Hōshi

The greatest of all tanka monk-poets was Saigyō Hōshi (1118–90), and his influence was to become significant in haiku poetry through the great appreciation of Bashō and Buson. They admired not only his poetry but also his life, which to some extent they copied, Bashō in particular.

Saigyō was born in Kyoto to a military branch of the vast Fujiwara clan. At the age of eighteen, he was given a position as a captain of the imperial guard that served the retired emperor Toba, but five years later he took Buddhist orders in the Shingon (True Word) esoteric sect. There is considerable speculation as to why Saigyō gave up a position at court for a considerably more difficult life as a monk. Some clues emerge from his own writings, but they have to be considered carefully since it was common for poets to take another voice, such as a male or female lover, when writing tanka. Nevertheless, a few of his poems suggest unhappiness in love.

Nakanaka ni	When she says
omoi shiru chō	"I know how you're feeling,"
koto no ha wa	how much more hateful
towanu ni sugite	than not saying
urameshiki kana	anything at all

Other writings may be more reliable in giving his thoughts, such as a poem composed when he was, according to his headnote, "coming to a decision about leaving the worldly life." Since the first word *sora* can mean

"sky" as well as "empty," the poem could be interpreted as a heart-mind (*kokoro*) that becomes like mist vanishing into the sky.

Sora ni naru	The heart-mind
kokoro wa haru no	that becomes empty
kasumi nite	is like the spring mist,
yo ni araji tomo	feeling that it too
omoitatsu kana	may leave this world

This indicates a Buddhist sense of transience, and considering how essentially unstable Japanese society was at that time, Saigyō may well have been aware of the ephemeral nature of the world around him. For example, in 1140 warrior-monks from Enryaku-ji burned the temple Miidera; tensions at court were also very high, and civil warfare was not far in the future. In any event, Saigyō wrote a tanka preceded by "When I petitioned Retired Emperor Toba for permission to leave secular life."

Oshimu tote	Why hold as precious
oshimarenubeki	what should not be valued
kono yo kawa	in this world?
mi wo sutete koso	The self we throw away
mi wo mo tasukeme	is also the self we rescue

Although Saigyō's Buddhist vocation was certainly sincere, most decisions in life have more than one cause. For those who prefer a more specifically personal reason for his decision, there is a tanka written after he became a monk.

Nanigoto ni	What was it
tsukete ka yo wo ba	that led me to despise
itowamashi	this world?
ukarishi hito zo	a hateful person
kyō wa ureshiki	whom I now know as kind

Saigyō did not live at a large temple, but preferred a quiet hermitage of his own. At first he stayed near Kyoto, but soon discovered that he wasn't able to find the solitude he sought.

Sutetaredo	Although I've thrown away
kakurete sumanu	the world to dwell
hito ni nareba	in seclusion,
nao yo ni aru ni	it's still like
nitaru narikeri	living in society

Once he moved away to a small hermitage in the mountains, however, Saigyō was able to accept and enjoy his solitude. He could also look back at his former life with aplomb.

Tou hito mo	Without the people
omoitaetaru	I had hoped would visit
yamazato no	my mountain hut
sabishisa nakuba	now I wouldn't give up
sumi ukaramashi	my loneliness

In 1147, as he reached the age of thirty by Japanese count, Saigyō began one of his most extensive travels, trekking northeast to Mutsu. This kind of lengthy journeying, which he was to repeat several times throughout his life, enabled him to experience nature more fully as part of his religious practice. Although Saigyō did not always make clear where his tanka were composed, many of his finest were probably written on the road. One of his most intense poems describes the wind dispelling illusion.

Mi ni tsukite	How can we quell
moyuru omoi no	the burning thoughts
kiemashi ya	that inflame the body?
suzushiki kaze no	Only by encountering
augazariseba	the cooling wind

Meanwhile, life in the Japanese capital was becoming more and more contentious. In 1156, the former emperor Toba died; he had been the true ruler of Japan despite his supposedly retired status. This led to battles of succession, and there was the first overt violence in Kyoto and also the first executions there for several hundred years. Three years later, more fighting took place, and for the next two decades there was increasing martial tension. Saigyō was distressed by the events, and they must have reinforced his decision to become and remain a monk.

Continuing his journeying, Saigyō's visit to the island of Shikoku in 1168 led to this poem about the moon, which he admired from the mountains of Sanuki near the inland sea.

Kumori naki	When viewing
yama nite umi no	the moon in the inland sea
tsuki mireba	the vanishing
shima zo kōri no	islands of ice are like
taema narikeru	mountains without clouds

Another powerful poem about the moon takes the reader directly into a chilly pine forest.

Yama fukaki	Deep in the mountains
maki no ha wakuru	the moon shining through
tsukikage wa	needles of the black pines
hageshiki mono no	has a violent
sugoki narikeri	and frightening power

Perhaps most significant of all Saigyō's many and varied tanka about the moon is one that describes it as a focus of enlightened meditation. In a headnote, Saigyō says that this moment came while "Studying the *Lotus Sutra*, deeply entering meditation, and seeing Buddhahood on all sides."

Fukaki yama ni	In the deep mountains
kokoro no tsuki shi	when dwelling in the moon
suminureba	of the heart-mind
kagami ni yomo no	in this mirror I see
satori wo zo miru	satori in every direction

Clearly, it was nature that both lightened and enlightened Saigyō's heart, and he compared the Chinese-derived philosophy of the Way (Tao) to Buddhist enlightenment.

Iwama tojishi	Today the ice
kōri mo kesa wa	clutched by the rocks
tokesomete	is melting away
koke no shitamizu	and the water under the moss
michi motomuran	also seeks the Way

Despite his love of nature, Saigyō was very aware in his poetry of the disasters then befalling Japan. In particular, he wrote a few powerful tanka about the civil war that became extremely violent from 1180 until 1185; it was this warfare that led to the end of a long period of domination by the nobility in favor of a new samurai era. To make matters worse, there was a famine in 1183–83 and an earthquake in 1185 shortly after a climatic battle, all taken as signs that the old order no longer had the protection of the gods. One of the most compelling of Saigyō's poems includes an explanatory headnote.

It has become a time of constant warfare throughout the country. To the west, east, north, and south, there is nowhere without battles. The

number of those being killed has climbed until it has reached a huge number, almost beyond belief—but for what reason is the war being fought? This is truly tragic.

Shiide no yama	Marching through
koyuru taema wa	the mountains
araji kashi	without cease,
nakunaru hito no	the men who will die
kazu tsuzukitsutsu	continue on and on

The final word *tsuzukitsutsu* (continues and continues) is marvelously appropriate in sound, and when one adds the second syllable of the previous word, the effect is like a machine gun spitting out the syllables *zu-tsu-zu-ki-tsu-tsu*.

Within his wide range of subjects, one of the most significant aspects of Saigyō's tanka is how many are specifically Buddhist, to the extent that he has been called "Japan's foremost Buddhist poet."[10] This is in part because he takes a variety of approaches. For example, in one tanka he offers an ironic comment on different levels of reincarnation. In another poem about the hell of constantly climbing trees toward sensual women, only to find the branches are sword blades, he also remembers his own youth.

Ukegataki	Floating up again
hito no sugata ni	into human form
ukamiide	is difficult
korizu ya dare mo	but sinking down
mata shizumubeki	is something anyone can do

Konomi mishi	The swords
tsurugi no eda ni	I used to gaze on fondly
nobore tote	are now branches
shimoto no hishi wo	that must be climbed
mi ni tatsuru kana	by bodies being whipped

More often, however, Saigyō reflects more deeply on the paradoxes of Buddhism, such as the belief that being a Buddhist depends on the historical Buddha Shakyamuni who preached on Vulture Peak, rather than each person finding their own inner buddha. In addition, Saigyō muses on how the true seeker must release even the seeking, and return to the world. Finally, he contemplates the nature of reality.

Washinoyama	People who see
tsuki wo irinu to	only the moon rising
miru hito wa	over Vulture Peak
kuraki ni mayou	are deluded by
kokoro narikeri	the darkness in their hearts

Madoikite	Confusing—
satori ubeku mo	satori can never
nakaritsuru	be attained
kokoro wo shiru wa	by the mind that knows
kokoro narikeri	it is mind

Yo wo sutsuru	Does the person
hito wa makoto ni	who abandons the world
sutsuru ka mo	really give it up?
sutenu hito koso	The person who doesn't renounce it
sutsuru narikere	is the only one to let it go

Utsutsu wo mo	If I don't consider
utsutsu to sara ni	reality
omoeneba	to be real,
yume wo mo yume to	why should I think
nankia omowan	of a dream as a dream?

The Art of Haiku

In 1180, Saigyō moved to Ise, the most sacred area for the indigenous Japanese religion of Shinto. This may seem unusual for a Buddhist monk, but it was believed that the multiple gods of Shinto (*kami*) corresponded to Buddhist deities; he stated in one of his tanka: *kami mo hotoke nari* (gods also become buddhas). Saigyō may also have been discouraged by the continuing competition, sometimes violent, between Buddhist sects and temples. The poet, now sixty-three years old, certainly must have appreciated the Shinto reverence for nature.

Fukaku irite	Entering deeply,
kamiji no oku wo	if I ask about
tazunureba	the path of the gods,
mata ue mo naki	there is the tallest peak
mine no matsukaze	and the wind in the pines

Despite the strength of his religious poems, perhaps Saigyō's greatest influence in later ages came from his lifestyle of journeying through Japan, and his deep empathy with nature. Both of these became models for Bashō, who wrote that Saigyō had "a mind both obeying and at one with nature through the four seasons."[11] Several tanka by Saigyō express his sense of wonder in natural forces as he travels through Japan, ranging from observations of common people (who since the *Man'yōshū* had been almost entirely absent from tanka), to his most beloved Yoshino Mountain with its spectacular cherry-blossoms.

Yamagatsu no	As I look around
suminu to miyuru	to see where
watari kana	mountain people dwell—
fuyu ni aseyuku	a quiet village
shizuhara no sato	fading into winter?

Ko no moto ni	As I rest on my journey
tabine wo sureba	under a tree
Yoshino yama	on Yoshino Mountain
hana no fusuma wo	the spring breeze spreads out
kisuru harukaze	a quilt of blossoms

In 1186 at the age of sixty-nine, Saigyō took one more lengthy trip to the northeast. Part of the reason may have been to raise funds for the temple Tōdai-ji, which had been partly destroyed in 1180 at the height of the civil war. On this journey he had a fine view of Mount Fuji in a semi-dormant state, inspiring a tanka that has echoes of the previous "heart-mind that becomes empty."

Kaze ni nabiku	Fluttering on the wind
Fuji no keburi no	the smoke from Mount Fuji
sora ni kiete	fades into the sky—
yukue mo shiranu	I also don't know where
waga omoi kana	my passions have gone

Another poem on the question of human passions has become Saigyō's best-known tanka. It centers upon one of the most difficult words to translate from the Japanese, *aware,* which can mean "feeling," "sorrow," "melancholy," "pathos," "pity," "compassion," and awareness of the fleeting nature of human life.

Kokoro naki	Beyond passion,
mi ni mo aware wa	I did not know that
shirarekeri	I could feel such pathos—
shigi tatsu sawa no	a snipe rises from the marsh
aki no yūgure	this autumn evening

The Art of Haiku

As he neared the end of his life, Saigyō wrote several tanka that are lighter in spirit than many that had come before. Perhaps he had reached a certain ironic contentment, as when he reflected once more on his childhood with a poem about the *takeuma* (bamboo horse) beloved by children.

Takeuma wo	The bamboo staff
tsue ni mo kyō wa	that today serves
tanomu kana	as my trusty cane,
warawa asobi wo	I remember once using
omoikidetsutsu	to play horsey-horsey

It was this kind of poem, so much more informal and everyday in spirit and diction than most courtly tanka, that was to influence later haiku masters.

Broadly speaking, Saigyō was able in his tanka to expand the range of subjects and vocabulary, add more spiritual elements, and stress the importance of nature as such, not only using it as a metaphor for human passions. He thereby added new life to a form that had become somewhat static in its expression. The result was that Saigyō became revered: twelve years after his death in 1190, he was the most frequently represented poet in the imperial anthology *Shinkokinshū* (Modern Old and New Collection, 1201), with no less than 94 of the total 1,981 verses. Partly as a result of the inclusion of so many of Saigyō's poems, this anthology is considered less subjective than the *Kokinshū*, with broader themes, more fragmentation of syntax, and a more bleak and melancholy tone that suggests a nostalgia for the more glorious past.

During the eight centuries since Saigyō's day, tanka have gradually included larger sections of the Japanese public as both poets and audience, and now it is growing as a verse form in the West. However, a new form of poetry dominated Japanese culture during the samurai era of 1185–1568: this is the *renga* (linked verse) tradition, which will be discussed in the following chapter.

2

Renga, Hokku, Haikai, and Haiga

THE PRACTICE OF ONE POET writing half a tanka and another poet completing it started very early in Japanese literature; there are a few examples in the *Man'yōshū*. The division of tanka into 5–7–5 and 7–7 syllables seems to fall naturally; many tanka are divided subtly or not so subtly into these parts, through meaning or imagery. For several centuries the two-poet tanka, called *tan-renga,* was popular, primarily as a kind of poetic game in which a clever second half had to be composed to suit a challenging first half.

Occasionally a half-tanka became known as a successful poem in itself, as in this 5–7–5 verse by Fujiwara no Sadaie (also known as Fujiwara no Teika, 1162–1241).

chiru hana wo	falling blossoms
oikakete yuku	are pursued
arashi kana	by the storm

At first, such individual units were less important than elegant combinations. There is a renga section in the anthology *Kin'yōshū* (Collection of Golden Leaves, 1124–27), and by the mid-twelfth century, renga had often expanded into multiple segments. Renga's popularity doubtless increased due to its socializing opportunities, and poets became accustomed to alternating 5–7–5 and 7–7 links into at least one hundred links, and sometimes many more verses; by 1333 a renga sequence of one thousand links had been created.

During the fifteenth and sixteenth centuries, renga expanded exponentially to become the most prominent genre in Japanese literature. Although there are instances of long solo renga, more often a group of poets gathered together, and either took turns or offered a segment when inspired to do so. Some renga were composed on set topics (*fushimono*), in which every verse had to make some (often slight) reference to the theme, while other renga were more free in their total structure.

Two forms of renga gained the greatest popularity during Japan's samurai era (the Kamakura period [1185–1333] and the Muromachi period [1333–1568]). One was the clever and comic *mushin* (mindless) form, which was full of puns and other wordplay, often bawdy and frequently vulgar. In the sixteenth and seventeenth centuries, this form developed into *haikai no renga* (humorous renga), which had a great influence upon the growth of haiku.

The more serious style of renga, called *ushin* (mindful), was closer to an elaboration of the classical tanka tradition. At first, such renga may seem to answer one of the occasional objections to Japanese poetry, namely that it concentrates upon short forms and does not have a longer narrative or epic tradition. Since renga could (and sometimes seemed to) go on indefinitely, wasn't that a longer poetic form?

The answer is both yes and no. Yes, in that the poems themselves were often extremely extended, but no, in that they were not used for narrative or epic purposes; in fact, one of the main rules of most renga is continuous change, rather than following a single theme or even the same weather, time of day, or season. The secret was to make a subtle connection between one link and the next that could be abandoned in the following link or several links further into the poem.

A courtier named Nijō Yoshimoto (1320–88) may have been the most influential of all renga poets. He was not only an expert at the form, but he compiled one of the earliest anthologies of renga, and he also wrote a number of important essays about it. His main aesthetic points were: first, renga should be entertaining and "delight the people present"; second, that

"without an elegant spirit there could not be an elegant word or style";
third, renga must have "unity in variety"; and fourth, "the ideal is to express
an old familiar truth in a new, refreshing way."[1]

Many rules were developed for this serious form of renga, such as that
segments should be able both to stand alone and to combine with their
other halves in order to form complete poems. Just as in classical tanka,
Chinese-derived words were frowned upon, but seasonal references should
be included in roughly half the segments, while the other half should be
nonseasonal. More specifically, segments about autumn and spring should
occur at least three links in a row, but no more than five; summer, winter,
travel, Buddhism, Shintoism, lamentation, mountains, dwellings, and wa-
ters no more than three links in a row; wild geese two; and so forth. Certain
words like "pine" and "dream" should be separated by at least seven links,
and "love" by five links; the moon was restricted to eight total appearances,
and cherry-blossoms to four.

Furthermore, each month had special attributes that might be men-
tioned, such as lingering winter, unmelted snow, plum blossoms, and
warblers for the first month (corresponding generally to our February), or
summer showers, fans, summer grasses, cicadas, glowworms, and the eve-
ning cool for the sixth month.[2] However, according to Yoshimoto, words
that should be used only once in a hundred-link sequence include azaleas,
peonies, wisteria, roses, irises, monkeys, deer, horses, cuckoos, fireflies, cica-
das, and unknown insects.[3] And as Howard S. Hibbett put it, "A few words
were so alarming that they were traditionally supposed to appear only 'once
in a thousand verses,' *oni* ('demon'), *tora* ('tiger'), *tatsu* ('dragon'), and *onna*
('woman')."[4]

Following Japanese ideas about the organization of music, the first eight
links were sometimes considered the slow introduction, segments nine
to ninety-two were the development, and the final eight were the rapid
conclusion. Another system was to give the first twenty-two links a quiet
mood, make the next twenty-eight more lighthearted, and construct the
final fifty so they were especially exciting. As time went by, many more

rules of all kinds were proposed, but those noted here were among the most often accepted.[5]

More generally, *ushin* renga did not demand individual expression, but were considered at their height when the participating poets worked seamlessly together to create a gradually shifting mosaic of verse. As Yoshitomo wrote, "A stanza by an expert poet is integrated with its preceding stanza through an interesting turn of spirit, though at first sight it may not seem to be linked at all."[6] As a result, many fine but occasionally obscure renga were later given elaborate commentaries, although experts have not always agreed on all the subtleties of their meanings and connections.

Yoshitomo's book *Tsukuba-shū* (Tsukuba Collection) of 1356 appeared in twenty volumes (similar to imperial collections), and included almost two thousand pairs of verses, with only the second half of the verses including the author's name. In addition, one volume contains Japanese verses connected to Chinese poems, and another is devoted to the opening 5–7–5 syllable verses called *hokku*. At this point we may identify hokku as proto-haiku since they can stand alone, although they may also become the first stanza of a much longer poem. Hokku were by now supposed to contain a *kireji* (a "cutting word" such as *ya*, which offers a pause or a mild exclamation in the middle of a verse, or the word *kana* at the end, which gives a sense of completeness) and a seasonal reference (*kigo*), both of which became important in traditional haiku. The main point of *Tsukuba-shū* and other writings by Yoshitomo, however, was to demonstrate for people wishing to join in renga how they could compose appropriate linkages, of which he listed fifteen basic varieties in one of his books.

Shinkei

The poet Shinkei (1406–75) was head priest at the temple Jūjūshin-in in Kyoto and a tanka and renga expert. He helped to set the tone for *ushin* renga for some decades to come, and also wrote individual verses and links that are admired as poems in themselves. During the destructive Ōnin

Wars of 1467–77 he traveled a great deal; the opening to his renga *Dokugin hyakuin* (Solo 100 Links) represents his first view of Mount Fuji and suggests his solitary state during a time of flux.

hototogisu	cuckoo
kikishi wa mono ka	does anyone hear it?
Fuji no yuki	snow on Fuji

He followed this with:

kumo mo tomaranu	clouds never pause
sora no suzushisa	in the chilly sky

More significant for the gradual development of haiku, a number of Shinkei's 5–7–5 stanzas are fully developed as poems in themselves. Several of these are perceptions of nature far removed from towns and cities.

yama fukashi	deep in the mountains—
kokoro ni otsuru	falling into my heart
aki no mizu	autumn streams

yo wa haru to	when the world
kasumeba omou	is hazy with spring—
hana mo nashi	no thought of flowers

natsu fukami	summer deepens—
kaze kiku hodo no	the faint sound of wind
wakaba kana	in the young leaves

kiku ni kesa	chrysanthemums at daybreak—
kumoi no kari no	and the voice of wild geese
koe mogana	beyond the clouds

hi wo itamu	bruised by the sun
hitoha wa otosu	a single leaf falls—
kaze mo nashi	no wind

usuzumi no	is it an eyebrow
mayu ka shigururu	drawn in thin ink?
mika no tsuki	third-day moon in the rain

In addition to his own verses, Shinkei wrote about renga as substantive poetry in a way that remained significant for several generations. In many regards he could be called the poet who established linked verse as a serious art form.

The best way to illustrate the social and interactive poetic form of renga may be to present the opening portion of one of the most celebrated of all *ushin* renga, which has often been used as a model for aspiring poets.[7] The notes given here after each segment are merely a beginning at establishing some of the linkage pattern.

Sōgi, Shōhaku, and Sōchō
Three Poets at Minase

In the second month of 1488, the poet Sōgi (1421–1502) and his major disciples Botanka Shōhaku (1443–1527) and Saiokuken Sōchō (1448–1532) composed one of the most famous of all renga to honor the memory of Emperor Go-toba (1180–1239), whose spring tanka written at Minase (the site of his detached palace) served as their initial inspiration:

Miwataseba	As I look out and view
yamamoto kasumu	haze at the foot of the mountains
Minasegawa	beyond Minase River—
yūbe wa aki to	I used to imagine that autumn
nani omoikemu	was the best season for evening

—EMPEROR GO-TOBA

The Art of Haiku

Following this lead, the three poets started a hundred-segment renga, at first quite literally following the emperor's poem but then enlarging the scene, changing the season, and adding multiple meanings. Here are the first twelve segments, and the last:

1

yuki nagara	despite the snow,
yamamoto kasumu	haze at the foot of the mountains—
yūbe kana	evening

—SŌGI (EARLY SPRING)

Note: The opening hokku is considered the most important segment, and must be able to stand by itself; here it follows the lead of Go-toba within its own more terse rhythm. In addition, each of the three elements of this first stanza begin with the soft "y" sound, as does the opening of the second segment (*yuki nagara, yamamoto, yūbe*, and *yuku,* which includes two words that had been used by Go-toba).

2

| *yuku mizu tōku* | distant waters flow past |
| *ume niou sato* | a plum-scented village |

—SHŌHAKU (EARLY SPRING)

Note: the second link both expands and completes the first, while remaining in the same season.

3

kawakaze ni	the river breeze
hitomura yanagi	in a single clump of willows
haru miete	shows us springtime

—SŌCHŌ (EARLY SPRING)

Renga, Hokku, Haikai, and Haiga

Note: the third link retains the season, and adds to the river imagery.

4

fune sasu oto mo	the sounds of poling a boat
shiruki akegata	are clear at dawn

—SŌGI (NO SEASON)

Note: the fourth link has no obvious season, but continues the theme of the river while moving distinctly to daybreak.

5

tsuki ya nao	is the remaining moon
kiri wataru yo ni	still crossing over
nokoruran	this misty night?

—SHŌHAKU (AUTUMN)

Note: the fifth link takes us back to the evening, or is it just the break of dawn? The image of the moon plus mist suggests autumn.

6

shimo oku nohara	with frost covering the fields
aki wa kurekeri	autumn draws to a close

—SŌCHŌ (LATE AUTUMN)

Note: the sixth link reinforces autumn, and the frost hints that there may be moonlight.

7

naku mushi no	for the cries of insects
kokoro to mo naku	having no compassion
kusa karete	grasses wither

—SŌGI (AUTUMN)

The Art of Haiku

Note: The seventh link again reinforces autumn, now more desolate. To emphasize the crying (*naku*) insects ignored by the grasses, the poet repeated "o" sounds and a play on the word *naku* (*kokoro to mo naku*). The next lines pick up the "k" sound for two successive words (*kusa karete*), and the following segment opens with another "k" (*kakine*).

8

kakine wo toeba	coming to the hedge,
awara naru michi	the path has opened up

—SHŌHAKU (AUTUMN)

Note: the eighth link suggests that the withering of the grasses has made a path visible.

9

yama fukaki	in the deep mountains
sato ya arashi ni	the village is beset
okururan	by storm winds

—SŌCHŌ (NO SEASON)

Note: after four links about autumn, the ninth link moves to a seasonless segment, with just a suggestion that the grasses withering and the path clearing could have been due in part to storm winds.

10

narenu sumai zo	when not used to such a dwelling
sabishisa mo uki	the solitude can be miserable

—SŌGI (NO SEASON)

Note: the tenth link is the first to specifically address human life, as well as presenting a moment in nature.

Renga, Hokku, Haikai, and Haiga

11

imasara ni	after all this time
hitori aru mi wo	don't feel that you
omou na yo	are all alone

—SHŌHAKU (NO SEASON)

Note: the eleventh link goes even further in directly speaking to the reader.

12

utsurowan to wa	haven't you already learned
kanete shirazu ya	that all things change?

—SŌCHŌ (NO SEASON)

Note: the twelfth link states what may be the main theme of the entire renga sequence, the inevitability of change and transience.

Here is the hundredth and final segment:

hito ni oshinabe	for all people
michi zo tadashiki	the Way is straightforward

—SŌCHŌ (NO SEASON)

Note: The path (*michi*) that opened up in segment eight has become the Way (*michi*) for all people in the final link.

Finally, as befits a fine renga, not only can each segment stand alone, but each pair of 5–7–5 and 7–7 links also forms a complete poem. For example, here is the combination of segments seven and eight:

for the cries of insects
having no compassion
 grasses wither—
coming to the hedge,
the path has opened up

One of the interesting aspects of many renga poets is that they did not all come from the highest reaches of society. Courtiers did their best to reserve the classical form of tanka for themselves, but with warriors now ruling Japan, they could not completely control all literary and artistic matters. Renga in particular became the province of educated people from several different classes.

Sōgi, for example, may have been the son of a *gigaku* (ancient masked dance) performer, although by becoming a Zen monk at Shōkoku-ji in Kyoto he gained access to cultural matters. Shōhaku was the son of a court noble, but Sōchō's father was a blacksmith. This would have disqualified him from high-level poetry during an earlier age, but during the flux of the early sixteenth century, this humble origin seems to have done him no harm.

Of the three men, Sōgi became the most renowned renga poet and scholar of the later fifteenth century. At a time when a poet could evoke a famous scene in Japan simply by the use of a common phrase, he traveled extensively (like Saigyō before him), wishing to see the celebrated places in Japan for himself. Sōgi also learned the "secret teachings" (mostly obscure pronunciations) of the *Kōkinshū,* and became widely known for his lectures and writings, particularly on the art of renga. His individual hokku and 5–7–5 links also become known as fine poems on their own.

kusa mo ki mo	grasses and trees
tsuki matsu tsuyu no	all waiting for the moon—
yūbe kana	dewy evening

suzushisa wa	cooler
mizu yori fukashi	than water
aki no sora	the deep autumn sky

michi-shiba no	sweeping the dew
asatsuyu harau	from the grasses on the path
yanagi kana	the willow

Another of Sōgi's poems is interesting for its conclusion.

samidare wa	is it the end
harete mo iku ka	of midsummer rains?
mizu no koe	the voice of water

The final words of this verse are almost the same as the ending of Bashō's most famous haiku: "the sound of water." This may not be coincidence; Bashō was a great admirer of Sōgi, in part for the travels that helped to give his poems their strength and authenticity. In 1682, Bashō took the following Sōgi renga section, with its pun on *furu* meaning both "to rain" and "to spend time":

yo ni furu wa	raining over the earth
sara ni shigure	and showering even more
yadori kana	on my home
—Sōgi	

Bashō then transformed it to:

yo ni furu no	raining over the earth—
sara ni Sōgi no	and even more on
yadori kana	Sōgi's home
—Bashō	

Shōhaku was the highest born of the three collaborators, but he too became a monk and traveled during the Ōnin Wars. His individual verses include several that feature his special combination of natural observation and refinement.

hototogisu	the cuckoo—
kyō ni kagarite	but just for today
dare mo nashi	no one's here
shizukasa wa	silence—
kuri no ha shizumu	the leaf of a chestnut sinks
shimizu kana	in the clear water
hoshizukiyo	night of stars and moon—
sora no hirosa yo	what a spacious sky,
ōkisa ya	what grandness!
nabatake ya	rape-flower field—
futaba no naka no	inside a leaf
mushi no koe	an insect chirps

At the time of the Minase renga series, Saiokuken Sōchō may have been the least celebrated of the three poets at *ushin* renga. Nevertheless, after facing a Japan full of disorder due to the Ōnin Wars through his twenties and thereupon leading an unconventional life, he admitted to having two children by a washerwoman despite being a monk. He became the primary renga master upon his teacher Sōgi's death in 1502. Instead of composing tanka, Sōchō concentrated upon linked verse, and wrote *mushin* comic links that were occasionally quite salacious. His friendship with the eccentric Zen master Ikkyū Sōjun (1394–1481) in the latter's final years no doubt stimulated both his literary and lifestyle experimentation. Although most of his *ushin* renga links are relatively conservative, he also collaborated with Yamazaki Sōkan (1458–1586), who is usually considered a founder of the humorous *haikai no renga*.

Sōchō's poetry covers a range of styles and purposes. On one hand, he wrote anniversary poems in honor of Sōgi, such as the following:

asagao ya	morning glories—
hana to iu hana	every flower called a flower
hana no yume	has this flower's dream

On the other hand, Sōchō also wrote ironic and comic verse; one example is given on page 296.

Yamazaki Sōkan

We have concentrated in this chapter upon *ushin* renga, particularly the opening stanzas called hokku, in part because these are what have generally been preserved. However *mushin* renga was at least equally popular, if much more ephemeral. Chinese-derived words were now freely admitted, and jokes, puns, parodies, slang, crass, lascivious, and even tawdry elements were welcomed. Bolstered by goodly quantities of saké, composing humorous linked verse became a very popular pastime.

Sōkan's background does not suggest that of a comic poet; he served as a calligrapher for the shogun Ashikaga Yoshihisa (1465–89); upon the latter's death, Sōkan became a Buddhist monk. After some time spent in travel, he settled in a quiet hermitage in Yamazaki. Five years later, he moved permanently to another hermitage, this one on the grounds of the temple Kōhō-ji in Sanuki. His poems were compiled into a book, and he is also credited with editing an important anthology of *haikai no renga* called *Inu-tsukuba-shū* (A Dog's Tsukuba Collection, also known as the Mongrel Collection). All the poems in this anthology, which are mostly composed in two parts as *tan-renga*, are anonymous, and the following may give their general flavor:

saru no shiri	the monkey's ass
kogarashi shiranu	not concerned with winter winds—
momiji kana	autumn maple leaves

An example of how poems could be linked in *haikai no renga* is the following *maeku* (first half):

kiritaku mo ari	I both want to cut
kiritaku mo nashi	and don't want to cut

One poetic *tsukeku* (second half) is satisfactory but rather conventional.

sayaka naru	becoming bright
tsuki wo kakuseru	the moon is hidden from view
hana no eda	by a branch of blossoms

Much more in the spirit of comic haikai is this imaginative *tsukeku*.

nusubito wo	when I catch the thief
toraete mireba	I discover that he's
waga ko nari	my own son

Although he was known for an unrefined style of poetry that was to inspire the Danrin school of Sōin (see pages 67–69), many of Sōkan's individual poems are charming, such as his observation that a frog bowing is much like a courtier about to emote.

te wo tsuite	bending down his hands
uta mōshiagaru	and offering up a song—
kawazu kana	the frog

Sōkan also noticed that the Chinese-style round fan, unlike the Japanese folding fan, needed a separate handle. This verse might be termed a "riddle poem," since the last line explains the mystery of the first two.

tsuki ni e wo	if you add
sashitaraba yoki	a handle to the moon—
uchiwa kana	a Chinese fan!

Sōkan also painted one of the first haiga (*hai* for "haikai/haiku," and *ga* for "painting"). The ease in which a poet could move from writing to painting, using the same materials of brush, ink, and paper, make it difficult to determine when this form of art began, but this work is surely one of the earliest to combine a haiku and an image, something that every major poet would later practice.

Sōkan's haiga (Plate 2-1) may need a little explanation. According to Shinto lore, during the eleventh month in Japan all the deities (*kami*) return to Izumo, leaving the rest of the country without gods. The word *kami* also means the paper from which doors and windows were made, leading to the pun in the inscription.

kaze samushi	cold wind
yabure shōji no	torn paper doors—
kami-nazuki	the month without *kami*

The poem is given spatial precedence in this work, covering more than 80 percent of the surface, with the first and third lines given one column each, while the longer middle line is arranged in three diagonally placed sections. Looking out at the bold calligraphy, a solitary figure sits within his thatched hut, seeming to endure the cold with patience and fortitude. One unusual feature of this haiga is the several narrow horizontal bands of silver-and-gold paint, perhaps an allusion to the art tradition of golden clouds across screens, or perhaps merely a decorative element on the paper chosen by Sōkan. In any case, they are reminiscent of designs on smaller decorated papers used for poetry, and provide a horizontal counterpoint to the primarily vertical elements in the haiga.

Before leaving Sōkan, we should include his response to the first *maeku*

that opens the *Mongrel Collection*. This opening image is a personification of a spring morning.

kasumi no koromo	the robe of mist
suso wa nurekeri	is damp at its hems

Sōkan's *tsukeku* shows the lewd tone that many *haikai no renga* display.

Saohime no	now that spring has come
haru tachinagara	the goddess Sao
shito wo shite	pisses standing up

A more discreet *tsukeku* was composed by the renga master Sōchō.

nawashiro wo	evicted from
oitaterarete	the rice plantings—
kaeru kari	departing geese

Three more *tsukeku* were written by Teitoku (see p. 63), who was conservative to his core. Here is one of them, which loses any touch of humor:

tennin ya	a deity seems
amakudarurashi	to have descended from heaven—
haru no umi	spring ocean

Arakida Moritake

Contemporary with Sōkan and sometimes considered a cofounder of *haikai no renga*, Arakida Moritake (1473–1549) was a pupil of Sōgi who served as a Shinto priest at the inner shrine at Ise. He is considered the originator of Ise haikai, although he was also a well-known *ushin* renga poet in his earlier years.

The first poem given here shows Moritake's Shinto beliefs, while the second is one of the most famous verses of all early haikai poets. It also can be seen as another riddle poem, since the final line explains the first two:

ganchō ya	New Year's morning
kami yo no koto mo	also brings to my mind
omowaruru	the age of the gods

rakka eda ni	watching the falling blossom
kaeru to mireba	return to its branch—
kochō kana	a butterfly

This second poem gains even more resonance if one is aware of the Zen saying: "The fallen blossom cannot return to its branch."

Moritake also excelled at adding links to the opening hokku of a sequence, or completing a *tan-renga* of five lines after being given the first two or three. Here are two examples of *tsukeku* by Moritake that show his sympathy, his subtlety, and his humor.

zatō e to	to the blind minstrel
goze no moto yori	from the blind female singer—
fumi no kite	a letter

—ANONYMOUS

Moritake's response:

horori to me yori	falling tears
namida ochikeri	drop from the eyes

—MORITAKE

| *abunaku mo ari* | it's dangerous |
| *medetaku mo ari* | but also auspicious— |

—ANONYMOUS

Moritake's response:

muko iri no	the groom joining
yūbe ni wataru	his wife's family at night
hitotsubashi	crosses the log bridge

—MORITAKE

Two more poems by Moritake show his range as a haikai master.

aoyagi no	green willows paint
mayu kaku kishi no	on the forehead of the riverbank—
hitai kana	eyebrows

natsu no yo wa	the summer night
akuredo akanu	never tires of the new dawn
mabuta kana	but my eyelids

Matsunaga Teitoku

The sixteenth century was a difficult one for Japan, with almost constant warfare either threatened or actually taking place between rival daimyo armies, and the resultant dispersion of people and culture. Despite this (or perhaps partly because of it), *haikai no renga* linked verse gained great popularity, with poets traveling to the provinces to lead gatherings that were usually reputed to be higher in exuberance than wit.

The work of most influential haikai master, Matsunaga Teitoku (1571–1653), appeared at the end of the century and was notable in the history of the form. He might have been surprised at this, because he saw himself primarily

as a tanka poet (composing almost three thousand verses) and secondarly as a renga master, but his hokku, *haikai, maeku,* and *tsukeku* were more influential. Although he did not see these as discrete units like modern haiku, they helped to lay the groundwork for the poets who came after him. Despite the fact that he had served as a scribe for the warlord Toyotomi Hideyoshi (1536–98), studied with members of the imperial court, and was a close friend with the Confucian scholar Hayashi Razan (1583–1657), it was in comic verse that Teitoku's popularity became immense, and members of his school, which was called Teimon (meaning the "Tei[toku] school"), eventually published more than 260 collections of haikai.[8]

For some reason, most haikai by Teitoku do not seem to resonate with readers today, and he tends to be ignored in recent anthologies despite his historical importance. One cause may be his use of puns, which today don't seem to please Japanese readers as much as they once did, and which are almost impossible to translate. For example, the word *anzu* is a *kakekotoba* (pivot word) that can mean both "apricot" and "grief," giving two meanings to this Teitoku haikai:

shioruru wa	are they drooping
nanika anzu no	some apricot branches?
hana no iro	the color of blossoms

shioruru wa	are they drooping
nanika anzu no	because of some grief?
hana no iro	the color of blossoms

Remembering that *iro* (color) can also mean passion, there is some emotion in the poem, but the clever pun does not help sustain it. More satisfying are two Teitoku poems that mention either sleeping or not sleeping.

minahito no	the reason for everyone's
hirune no tane ya	noontime nap—
aki no tsuki	the autumn moon

kukurime wo	all night long
mitsutsu yo nagaki	staring at the tied strings
makura kana	on my pillow

Another nature poem by Teitoku takes the "riddle poem" form, dealing with *utsugi,* a shrub (*Deutzia scabra*) with small white flowers, juxtaposed with the three main exemplars of natural beauty in Japan.

setsugekka	in a single look
ichidō ni miyuru	we can see snow, moon, and flowers—
utsugi kana	*utsugi* blossoms

One of Teitoku's more empathic haikai is one he wrote on a *tanzaku* (tall, thin poem-card) in a single column on decorated paper (Plate 2-2). Both blue and gold are utilized to add impact to what might otherwise seem a simple calligraphy. However, the varying thickness of the lines, along with the tilts and mixes of complex Chinese characters and simpler kana (Japanese syllabary), gives the poem a sense of motion. Staying in the center of the *tanzaku,* the calligraphy seems to move with a personal sense of rhythm that helps it come alive from the strong "a" syllable (あ) at the beginning of the haikai to the heavily inked cypher-signature at the bottom.

ari tatsu ni	still standing here
hisuru tachitaru	while another year
kotoshi kana	silently passes

Ultimately Teitoku may have been more important historically than as a poet, but his influence was to remain strong for several generations.

Nonoguchi Ryūho

The editor of the first two Teitoku collections was his disciple Nonoguchi Ryūho (1595–1669), who might well be called the "father of haiga" since he was the first poet to produce a large number of haikai paintings.[9] Born in Kyoto, he made his living as the owner of a doll shop called Hinaya, so he is also known as Hinaya Ryūho.

After helping to compile further volumes by Teitoku, Ryūho eventually founded his own school of haikai. He then published a number of his own books, including one in 1636 that set out a code of rules for haikai. This prompted Teitoku in 1651 to publish his own set of rules in an extensive compendium of word usage in haikai with their various overtones. Compared with the freewheeling style of Moritake a century earlier, these rules were all very conservative, but they did give haikai some standing in the poetry world of Japan during a significant moment in its history, the beginning of the early modern period under Tokugawa rule in the seventeenth century.

Ryūho's own poetry is often either verses that are basically good-luck wishes, often with uncomplicated drawings, or more serious haikai that occasionally have surprising imagery. An example of the former includes a painting of Hotei, the god of good fortune, asleep.

neburumaya	while sleeping
kokoro no tsuki no	the moon in his heart
sokuikari	is his inner mind

A somewhat similar moon poem by Ryūho is accompanied by a simple picture of a boat.

nishi e yuku	as my heart travels west—
kokoro ya sora ni	the moon in the sky
tsuki no fune	is my boat

The Art of Haiku

One of Ryūho's more successful haiga shows a pine tree (Plate 2-3) with the following verse:

suzukaze ya	cool breeze
matsu ni tsutaite	bequeathed to the pine's
sagari eda	leaning branch

In this hanging scroll, the first two lines of the poem form a single column, with the final line in a shorter column lower to the left. The inscription is spatially removed from the painting of the tree, with the tree's leaning branch balanced by a band of mist cutting off the center of the upper branch. The freedom of the brushwork depicting the pine perhaps suggests the cool breeze bequeathed to the tree, and now also to us.

Ryūho's imagination is not seen in all his poems, but one of his haikai has a marvelous combination of the unusual with the everyday, exactly the aesthetic of this modest form of poetry at its best.

tsukikage wo	pouring
kumi koboshikeri	moonbeams
chōzubachi	into the washbasin

Ryūho has a place in the history of haikai as a poet, but it is his haiga, ranging from humorous sketches of earlier poets and figures symbolizing good fortune to small landscapes and other scenes, that became his greatest contribution to the field.[10]

Nishiyama Sōin

The founder of the Danrin school of haikai was a *rōnin* (masterless samurai) from Kyushu named Nishiyama Sōin (1605–82), who eventually became an Obaku sect Zen monk. Like most of the other poets at this time, he began with renga and moved toward haikai as his life went on. His school was

born in 1675 when eight haikai poets, acknowledging Sōin as their leader, called themselves in jest "Danrin," meaning "forest of sermons." Rejecting the rather conservative Teimon school, they claimed to revive the bold spirit of Moritake and Sōkan, and Sōin himself began a *haikai no renga* at that time with the poem:

sareba koko ni	and yet here
danrin no ki ari	there are *danrin* trees—
ume no hana	blossoms of the plum

Known for its freedom and spontaneity compared with the more formal standards of the Teitoku's followers, the Danrin school encouraged breaks with tradition such as allowing extra syllables (*ji-amari*), especially in the final line of the poem. It also featured the language of everyday life and a certain amount of playfulness that sometimes became frivolity. However, this school also produced many teachers who developed technical features such as unusual figures of speech and literary precedents that made much of their work obscure. Yet between 1765 and 1775, the Danrin style held sway over the Teitoku tradition—in his very early days, even Bashō was a Danrin poet, although he moved away from this school early in his career.

Four haikai by Sōin can give a sense of the range in this school, the first being an observation of nature, the second introducing a new subject based upon the importation of books from Holland, and the third and fourth more humorous.

no no hana ya	rape-seed flowers
hito moto sakishi	just one plant has blossomed
matsu no moto	under the pine
Oranda no	Dutch letters?
moji ka yokotau	a line of wild geese
amatsukari	across the sky

matsu no fuji	wisteria on the pine—
tako ki ni noboru	like an octopus
keshiki kana	climbing a tree

nagamu tote	viewing cherry-blossoms
hana ni mo itashi	is also
kube no hone	a pain in the neck

Sōin also wrote a hundred-verse solo renga dealing with love, including these links from a regretful husband.

komusume ka tote	wasn't she just a young girl
yobishi kuyashisa	when I foolishly wooed her?

mikaeshi no	I just had a glance
kasa no uchi wo mo	at her under her umbrella
chira to mite	only a glimpse

Namu Amida Butsu	Hail to Amida Buddha
koi wa kusemono	love is but a scoundrel!

Ihara Saikaku

In his fifty years of life, Ihara Saikaku (1642–93) accomplished an amazing amount of writing, including huge numbers of haikai, although he is best known today for his stories of the floating world. Born to an Osaka merchant family, at age thirty-four he suffered the tragedies of his wife's death and one of his daughters going blind and dying, after which he turned over the family business to his chief clerk and lived a life of a bon vivant, especially in literary circles.

Saikaku seems to have started writing haikai in his early teens, first following the Teimon school and then becoming a pupil of Sōin's Danrin

school. Although Sōin's tradition is sometimes considered emotionally rather shallow, he did write two memorial hokku honoring his departed wife. Saikaku greatly enlarged this idea by composing one of the most moving renga of this period, the "One Haikai Alone on a Single Day" (*Haikai dokugin ichinichi*) written three days after his wife died in 1675.[11] It begins with an introduction:

We mourned for others while you were alive, but I couldn't stop you from departing yourself. Waking from a dream, I know the world is only a mirage, which helps me forget that you are gone. We enjoyed viewing the moon, snow, and blossoms together, but one day you felt illness coming, and as spring ended you grew more and more weak. Like a crane leaving her children weeping, you died on the third evening of the fourth month. Just then I heard the call of a cuckoo, and a hokku arose in my mind. Between dawn and sunset today, I have composed a thousand haikai for you, and a calligrapher has written them down for me—please accept them as my farewell offering.

myaku no agaru	fold your hands
te wo awashite yo	that have no pulse
mujōdori	bird of transience
shidai no iki wa	when her breaths became short
mijikayo jūnen	ten callings of the Buddha's name
mokuyoku wo	her body bathed
shigatsu no mikka	the third day of the fourth month
bōzu nite	by monks
naka ni wa nani mo	nothing at all to see
mienu kusa no ya	inside the thatched hut

The Art of Haiku

Later in the renga are more links that specifically pertain to his wife's death.

kakkokaka ga	cuckoo, mother, wife—
satori no katachi	what is the form
wa ikani	of your satori?

—LINK 201

hiru hana ya	fallen blossoms—
ima ni shinda to	even now I can't fully
omowarezu	realize she's dead

—LINK 899

In the 201st link above, we may note the repetition of the "ah" and "k" sounds, which add a sense of insistent rhythm. Eventually the renga goes on to cover a broad range of topics that go beyond his wife's death, with some links even descending to vulgarity, but the spirit of loss remains throughout.

Stemming from this experience, in 1677 Saikaku invented the "poetry marathon," in which a poet tried to see how many haikai links he could compose within twenty-four hours. Saikaku himself took the honor with 1,600 verses, and in 1680 he raised the record to 4,000 verses, finally reaching his apex in 1684 with 23,500 verses in one day and night, spouting them out faster than a scribe could record them. After his teacher Sōin died in 1682, however, Saikaku generally turned his attention to prose, and it was in this field that he gained his greatest success.

Despite his flamboyant nature, some of Saikaku's haikai show his powers of observation and modesty of emotional expression, such as this verse about the Yodo River.

samidare ya	midsummer rain—
Yodo no kobashi no	under the small Yodo bridge
mizu-andon	a lantern to show the way

Saikaku also wrote about *rōnin,* an increasing problem in a peaceful society; some of these former samurai became bureaucrats for the new government, but others were left to wander. In this case, the words *kamiko* and *jūmonji* refer to a sturdy paper clothing treated with persimmon tannin and then dried in the sun; first worn by upper-class Japanese, they later became popular with everyday people.

rōnin ya—	*rōnin—*
kamiko mukashi wa	wearing a paper kimono
jūmonji	like the old days

Two Saikaku poems with the same final line about the moon show both how people take it for granted, and how it becomes special.

sasake atama	shining on our heads
yo no fūzoku nari	it just becomes a habit—
kyō no tsuki	tonight's moon

tai wa hana wa	sea-bream and blossoms
minu sato mo ari	and a village out of sight—
kyō no tsuki	tonight's moon

The first line of the second poem contains five "ah" sounds, but another haikai by Saikaku is even more a tour de force in its use of language.

kokoro koko ni	was I paying no attention,
naki ka nakanu ka	or did it not yet sing?
hototogisu	the cuckoo

There are eight "o" and eight "k" sounds in this poem, including four "ko" syllables in the first line, as well as another "o." The second line offers a contrast with five "ah" sounds, including two "na" and three "ka" syllables.

The Art of Haiku

The final line then adds three more "o" sounds, two of which are "to." Despite this brilliance of effect, the poem has a nice "riddle style" meaning, and perhaps the repetitions of sounds are meant to suggest the (missing?) song of the cuckoo.

In some ways Saikaku marks the final brilliance of the Danrin school, which gradually become clever to the point of triviality; his contemporary Bashō was to take haikai in a completely different direction. First, however, we should consider the poet Onitsura, who in some ways anticipated the style that most poets would follow in the future.

Ueshima Onitsura

A slightly later contemporary rather than predecessor of Bashō, Ueshima Onitsura (1660/1–1738) came from samurai-status birth; he started writing haiku at the age of eight, and by his teens was already an expert. First a follower of Teitoku, he then became a pupil of Sōin and his Danrin school, but soon began to break away in his work. A friend of Saikaku, he also came to know several of Bashō's pupils, but never really joined the Bashō movement despite some similarities in their verses. To make a living, he became a saké distiller, then an acupuncturist, but finally lived for poetry, eventually taking the tonsure as a monk. Most notably in his aesthetic, from the age of twenty-five he stressed that "apart from *makoto* (sincerity, truth, reality), there is no haikai."[12]

Generally speaking, Onitsura avoided the puns and clever references to earlier literature, although there are exceptions to the former. For example:

ume wo shiru	truly to know plum blossoms
kokoro mo onore	needs your heart
hana mo onore	as well as your nose

Since *hana* can mean "flower" as well as "nose," the final line could also be understood as "and for you to be the flower." The repetition of the word

onore (you) points to a frequent aspect of Onitsura's poems, often seen in his use of double-word onomatopoeias.

<table>
<tr><td>

koi koi to
iedo hotaru ga
tonde yuku

</td><td>

come here, come here
we say, but the firefly
flies off

</td></tr>
</table>

<table>
<tr><td>

sawasawa to
hachisu ugokasu
ike no kame

</td><td>

rustling and rippling
the lotus stirs—
a tortoise in the pond

</td></tr>
</table>

<table>
<tr><td>

haru no mizu
tokorodokoro ni
miyuru kana

</td><td>

spring waters
hither and thither
can be seen

</td></tr>
</table>

<table>
<tr><td>

hyū-hyū to
kaze wa sora yuku
kan-botan

</td><td>

hissing and whistling
the wind flies into the sky—
winter peonies

</td></tr>
</table>

Onitsura was clearly concerned with the sound of his poems, sometimes using identical or very similar words.

<table>
<tr><td>

shirauo ya
me made shirauo
me wa kurouo

</td><td>

the whitefish—
up to his eyes, whitefish—
his eyes, blackfish

</td></tr>
</table>

Sound is also a factor when Onitsura begins the three words comprising lines two and three of a haikai with the syllable *na,* and includes the vowel "a" seven times.

The Art of Haiku

uguisu no	when the warbler sings
nakeba naniyara	I feel nostalgic
natsukashiu	for something . . .

In Onitsura's own words, however, his primary aim was to represent even the most simple and unassuming aspects of nature as they really were. Sometimes this led to poems that are very direct in feeling, as when watching cormorant fishing at night.[13]

u no tomo ni	along with the cormorants
kokoro wa mizu wo	my heart also dives
kuguriyuku	into the river

Other poems by Onitsura could be quite personal.

kono aki wa	this autumn
hiza ni ko no nai	with no child in my lap
tsukimi kana	moon-viewing

koi mo nai	without a lover
mi ni mo ureshi ya	I'm still happy to change
koromogae	into summer clothes

shitagau ya	if we submit
oto naki hana mo	the silent blossoms are also
mimi no oku	deep in our ears

Several of these verses deal with sound rather than sight, and this trend is continued in other poems by Onitsura.

tōkitaru	coming from afar
kane no ayumi ya	the sound of the temple bell roams
haru kasumi	through spring haze
suzukaze ya	cool breeze
kokū ni michite	the empty sky filled
matsu no koe	with pine voices
tanimizu ya	valley stream—
ishi mo uta yomu	stones also chant songs
yamazakura	of mountain cherries

Onitsura's greatest gift was to see elements of nature and humanity with fresh eyes, and to express them in a direct and simple way. In this regard he was similar to Bashō, if perhaps without Bashō's depth of spirit. Nevertheless, the best of Onitsura's verses can give a sense of delight that makes him one of the finest, if undervalued, of all haikai poets. Here are some of his best verses:

haru no hi ya	spring day—
niwa ni suzume no	sparrows in the garden
suna abite	bathe in the sand
gaikotsu no	skeletons
ue wo yosōte	all dressed up
hanami kana	flower-viewing
yaretsubo ni	in the cracked jar
omodaka hosoku	a water-plantain blooms
saki ni keri	slenderly

nusubito no	also on the thief's grave
tsuka mo musaruru	shabby and untidy
natsu no kusa	summer grasses
tobu ayu no	under the leaping trout
soko ni kumo yuku	clouds float
nagare kana	on the stream
nani yue ni	why are some long
naga mijika aru	and some short?
tsurara zo ya	icicles

While Onitsura did not have a great personal influence on many later poets, his straightforward verses and sincerity of style marked a new direction for haikai, which would be greatly deepened and amplified by Bashō.

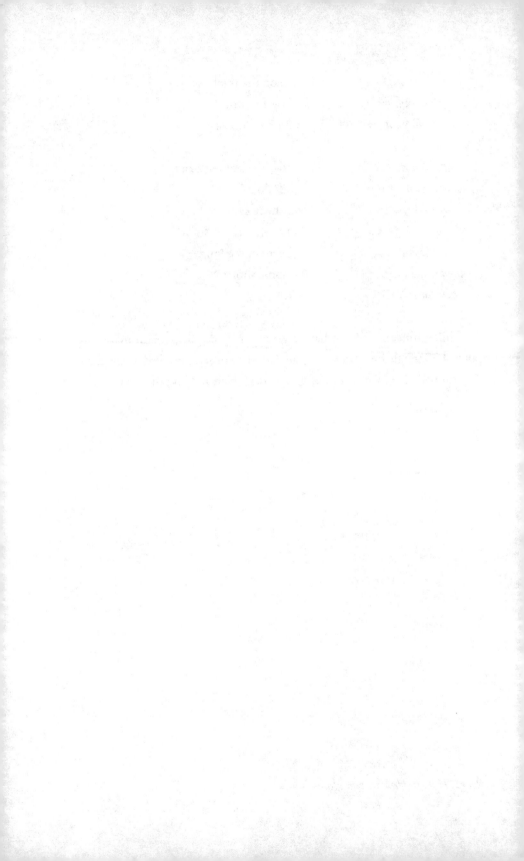

3

Bashō

I T IS RARE THAT A SINGLE PERSON can dominate a form of art over its entire span. In the Western world, we have perhaps Shakespeare in theater and Michelangelo in sculpture, but in music there is Bach, Mozart, and Beethoven, in painting everyone from Giotto to Leonardo da Vinci to Picasso, and a plethora of masters in novels, Western poetry, and even in more recent arts such as photography, fashion, and film. But in haiku, Matsuo Bashō (1644–94) stands alone. Buson and Issa are considered second and third, but it is a very rare critic who would not place Bashō first, and usually by a large margin.[1] What was his appeal, and how did he become so important both aesthetically and historically?

It is true that Bashō came along at the right moment, when culture was flourishing and literacy expanding in the newly peaceful Japan that had just shut itself off from the outside world. The Teimon (Teitoku) and Danrin (Sōin) schools of haikai were weakening, and Japanese society was ready for a verse form that could not only be enjoyed but also composed by almost anyone among the general public. Yet this does not explain Bashō's appeal and influence any more than it would if we merely said that he was a genius.

Scholars have taken various approaches to understanding Bashō, one of which is chronological, with comments about his changes of style. This approach can be very helpful, since Bashō indeed went through several phases in his work, but it still does not explain the myriad exceptions to any generalities that one might make about his haiku. The American Zen master Robert Aitken has written a fascinating book called *A Zen Wave,*

which relates Bashō's poems to his spiritual attainments.[2] Others have emphasized the poet's influence from Taoism, or disputed Bashō's ties to Zen and found other ways to explain his work, including the importance of influences from classical Chinese and Japanese literature. Again, there is much to be learned from all of these approaches, but none of them seems to come close to conveying fully the range as well as the quality of Bashō's poetry.

While generally following chronology, the most useful approach might be to discuss Bashō's importance in terms of the variety of subjects and styles he used, and how he brought them forth through his attitude toward life. This was consistently refreshed and replenished by the choices he made to keep his work ever fresh and resonant through his lifetime, especially through travel; as Robert Aitken wrote, "It is at the edge of transition that we find experience."[3]

Although the world's most famous haiku are by Bashō, such as the classic haiku about the frog and the old pond, his verses often seem simple and undramatic compared to those by poets such as Buson. Yet Bashō's flavor is the kind that lingers, rather than being entirely apparent at first and then quickly fading. It might be difficult to convince someone that Bashō was even a major poet, for example, if that person did not have an "ear" or the "eye" for his work. Nevertheless Bashō has been almost universally regarded as the greatest master of haiku, and in this chapter we will try to discover how and why.

In the process of understanding Bashō, we can switch from the words hokku (first poem in a sequence) and *haikai* (comic verse or sequence) to the better-known term *haiku*. Although technically this word did not appear until the end of the nineteenth century, it has gained such currency in the past century that haiku is probably the most known and practiced form of verse in the world. And although Bashō certainly participated in verse sequences, often opening them with a hokku, it is his single poems, along with his *haibun* (haiku prose) and haiga paintings, that are his greatest achievements.

The Art of Haiku

Becoming a Poet

Bashō was born in 1644, probably in Ueno in the province of Iga, thirty miles south of Kyoto. This was at a time when the Tokugawa government had firmly established itself in Edo (Tokyo), and after long periods of civil war, Japan was at peace. It was also a time when the government almost completely cut off connections with the outside world, turning the Japanese populace inward toward its own interests and achievements. In addition, it was an era when, despite the government's efforts to keep the merchant class in check, this sector of society began gradually to gain in influence.

Bashō's father was a landed farmer with the privilege of holding a family name, but he died in 1646. Bashō entered the service of Tōdō Yoshikiyo (n.d.), a relative of the ruling daimyo, becoming especial friends with Yoshikiyo's son Yoshitada, an amateur haiku poet in the Teimon tradition. This style of witty allusions to classical verse influenced the young Bashō, although he discovered the more rough-and-ready Danrin style as well.

Bashō was no Mozart. He did not create lively and prodigious works in his childhood, and his first extant poem, written at age nineteen, is no indication that he would come to excel in his field. Playing on the fact that the Japanese calendar occasionally had an extra day or two at the end of the year from following the moon cycle, he created a slightly wry question of when the New Year (representing spring) actually arrives.

haru ka koshi	has spring come
toshi ya yukiken	and the old year gone?
kotsugomori	the second-to-last day of the year

—1663

While certainly not a great haiku, the poem does show the use of plain language and direct phrasing that were to be features of Bashō's mature work.

Few other early haiku by Bashō remain, although he must have written many that have since disappeared. Most were probably somewhat trite or unexceptional, although there is a hint of compassion in the following:

ubazakura	the old-lady cherry
saku ya rōgo no	blossoms—a remembrance
omoiide	of declining years

—1664

Here the double meaning is contained in the word *ubazakura,* which can also mean "faded beauty."

The next major event in Bashō's life was Yoshitada's sudden death in 1666; Bashō seems to have been strongly affected; he gave up his position and possibly moved to a temple in Kyoto, although this is uncertain. In any case he maintained connections with Ueno, and began to have some of his haiku published in anthologies. He continued to write about the most popular of haiku subjects, such as cherry-blossoms and the moon, sometimes with a touch of humor.

Kyō wa kuman kusen	Kyoto—
kunju no	ninety-nine thousand people
hanami kana	flower-viewing

—1666

hana no kao ni	shy before
hareute shite ya	cherry-blossom faces—
oborozuki	the hazy moon

—1667

Interestingly, the first of these poems has a 10–4–5 (or 4–10–5) syllable pattern, and the second 6–7–5, showing that the young Bashō was not a slave to convention. The first poem also has five "k" sounds to begin words, stressing the number 99,000.

A more standard poem from about the same time makes a play on the word *kuchi,* meaning both "mouth" and "opening."

akikaze no	the autumn wind
yarido no kuchi ya	through an opening in the sliding door—
togarigoe	a piercing voice

—1666

After dedicating a poetry-contest book in Ueno, a competition for which he had served as referee, Bashō moved to the new capital of Edo in 1672, where at first he served as a scribe for another poet while trying to build up his own career. From being a big fish in a small pond Bashō was now the reverse, but one important step that he took personally was to study Zen under the monk Butchō (1642–1716). Butchō was only two years older than Bashō, but he had an abiding influence upon him. Not many poems survive from this period of Bashō's life, but we can assume he was slowly building both his technique and his reputation while considering deeply the direction that he wanted his life and his haiku to follow.

In 1675, Bashō was introduced to the visiting poet Sōin (see the previous chapter), considered the founder of the Danrin school of haiku, and we can see some of the more mundane aspects of this tradition in the young poet's work of this time, including references to both the delicious but potentially lethal fugu soup (in 8–7–5 syllables) and to visiting Dutch merchants.

ara nani tomo no ya	well, nothing's happened—
kinō wa sugite	even though yesterday I ate
fukutojiru	fugu soup

—1677

Kabitan mo	the Dutch captain
tsukubawasekeri	also bows down before
kimi ga haru	the shogun in spring

—1678

Oranda mo	the Dutchmen are also
hana ni ki ni keri	coming to see cherry-blossoms—
uma ni kura	saddle the horses!

—1679

Two more poems from 1679 illustrate the young Bashō's life of both ob-servation and enjoyment, still with an atmosphere of wit rather than depth.

kesa no yuki	morning snow—
nebuka wo sono no	onions send up
shiori kana	bookmarks

—1679

sōkai no nami	waves on the blue sea
saké kusashi	smell of saké—
kyō no tsuki	tonight's moon

—1679

In 1680, Bashō moved from downtown Edo to Fukugawa, a more rustic part of Edo near the Sumida River. Although he and his followers put out two more books with his commentaries, Bashō seems to have turned against the secure life of a haiku teacher who corrected poems and judged contests for a fee, and instead reached for more depth in his own work. This coin-cided with a greater interest in Chinese poetry, and he compared his "Bashō hut" dwelling to that of Po Chu-i (772–846) who described living in Chang-an as "a place rough enough for a traveler empty-handed and penniless."[4]

The Art of Haiku

Contrasting with the poem about the scent of saké of 1679 is this haiku from 1680 with a 10–7–5 syllable pattern:

ro no koe nami wo utte	the sound of oars beating the waves
harawata kōru	freezes my bowels—
yo ya namida	night tears

—1680

Other haiku from the same year show an increasing seriousness on the part of Bashō, with a general focus on the season of autumn.

kumo nani to	spider—
ne wo nan to naku	what voice and what song?
aki no kaze	autumn wind

—1680

yoru hisoka ni	in the moonlight
mushi wa gekka no	a worm secretly burrows
kuri wo ugatsu	into a chestnut

—1680

guanzuru ni	it seems to me that
meido mo kaku ya	beyond the grave is like this—
aki no kure	autumn evening

—1680

Maturity as a Poet

Using the same final phrase, this same year Bashō composed one of his most famous haiku, often considered the first poem that fully expressed his individual genius.

kare-eda ni	crow perched
karasu no tomarikeri	on a withered branch—
aki no kure	autumn evening

—1680

There are a number of interesting features about this poem. First, since Japanese nouns can be either singular or plural, it might be "crows perched / on withered branches." Bashō either painted or inscribed this verse at least three times, once with multiple crows and branches, and twice with one crow on one branch (see plate 4-3). Did he change his mind about his own poem—or did he appreciate the ambiguity where readers might paint the picture in their own minds?

Next, once again Bashō has defied the "rule" of haiku that it be organized in 5–7–5 syllables, in this case preferring 5–9–5. Surely Bashō was expert enough as a poet to have found a way to write this verse in 5–7–5 had he wished to, but he clearly wanted something different, perhaps in part as a way of engaging the reader with a rhythmic surprise.

As for the imagery, later critics generally found it to express loneliness in direct and unadorned words, although Shiki criticized it as being too close to the Chinese phrase "a chilly looking crow on a bare tree."[5] A story arose that Bashō composed this haiku after being asked by other poets to help launch a new poetic style, away from Danrin influence, but this is historically questionable. In any event, this verse helped move haiku away from clever allusions and recondite imagery to something more simple and at the same time more evocative, and it can be regarded as the poem that put the Bashō tradition in the foreground from this time onward.

The year 1681 was important for Bashō: he was given a plantain (banana, *bashō*) tree by a pupil for his new home, and he so identified with the tree that it became his most celebrated haiku name. While banana-trees would not bear fruit in the Edo climate with its cold winters, the poet much enjoyed the large leaves that provided shade in the summer and gave forth a natural music in the wind and rain, even though the leaves were not very sturdy and liable to

split in a storm. Was all this part of his sense of identification with the *bashō*? He even wrote a poem that compares two different sounds of a rain shower.

bashō nowaki shite	*bashō* leaves in the storm—
tarai ni ame wo	at night I can hear the rain
kiku yo kana	dripping in the tub
—1681	

The sense of *wabi* (a word impossible to translate, but generally meaning "rustic simplicity," "poverty," and "solitude") that this poem conveys is part of what Bashō gave to the haiku movement, although later commentators have disagreed whether the tub had been left outside or was indoors gathering leaks from the ceiling. In this regard, Makoto Ueda has written a valuable book about Bashō poems with various comments from Japanese poets and scholars through the years, called *Bashō and His Interpreters*.[6] Regarding the meanings of the various haiku, it is surprising to see so much disagreement—which only suggests that the ambiguities that the poet included were meant for his readers to interpret according to their own experiences.

Two more poems from 1681 have an even darker and colder tone. Here Bashō is certainly opening up new ground for haiku; it was his depth and seriousness rather than his wit that transformed haiku into a much richer poetic form than before.

hinzan no	the poor temple's kettle
kama shimo ni naku	calls out in the frost
koe samushi	with a chilly voice
—1681	

ishi karete	stones exhausted,
mizu shibomeru ya	waters withered—
fuyu mo nashi	winter also empty
—1681	

It would be too simple, however, to credit Bashō with only expressing darker scenes and emotions; he still maintained a kind of humane humor, the smile of experience rather than allusion, which was another way of saying "Just so!" or "Just like that!"

samidare ni	summer rain—
tsuru no ashi	the legs of the crane
mijikaku nareri	have become shorter

—1681

gu ni kuraku	foolishly in the dark
ibara wo tsukamu	grabbing a thorn—
hotaru kana	fireflies

—1681

Hunting for fireflies was an age-old Japanese pastime with many literary precedents, but only Bashō writes of the minor dangers involved. The syllable count of the first of these poems is 5–5–7, a further indication of the freedom that Bashō felt when writing his haiku. Confirmation that this was deliberate comes from a letter he wrote to an aspiring poet in 1682, in which he commented: "Even if you have three or four extra syllables—or as many as five or seven—you need not worry as long as the verse sounds right. If even one syllable stagnates in your mouth, give it a careful scrutiny."[7]

Two haiku he wrote in 1682 confirm multiple views of Bashō—the poet—as someone especially attuned to nature, and as everyman.[8]

hige kaze wo	who is lamenting
fuite boshū tanzuru wa	as the wind blows his beard,
tare ga ko zo	for late autumn?

—1682

asagao ni	along with morning glories
ware wa meshi kū	I eat my breakfast—
otoko kana	just another fellow

—1682

In the first month of 1683, there was a major fire in Edo, and the Bashō hut burned to the ground. According to his pupil Enomoto Kikaku (1661–1707), Bashō survived by submerging himself in water, and this experience certainly strengthened his view of life as transitory.

Bashō spent the spring in Kai Province, but returned to Edo in the summer to edit the first full-scale book of his school's haiku, *Minashiguri* (Shriveled Chestnuts). Bashō wrote a postscript pointing out four flavors in the haiku: the lyricism of the Chinese Tang-dynasty masters Li Po (701–62) and Tu Fu (712–70); the *wabi* of Saigyō; the Zen spirit of the eccentric mountain-wanderer Han-shan (ninth century); and the romanticism of Po Chu-i.[9] Perhaps the words that most characterize Bashō's own haiku, however, are sincerity and integrity.

Another difficult moment came in the seventh month; when Bashō's mother died in Ueno, he was unable to attend her funeral, probably from lack of funds. However, that autumn his pupils gathered money and materials to build a new Bashō hut, actually part of a larger building near his former hermitage. A few poems from 1683 give us an idea of his various observations and emotions at this stage of his life. On one hand he was resonating with nature, but he was also well aware of the sadness and solitude of his life.

ganjitsu ya	New Year's Day—
omoeba sabishi	thinking lonely thoughts
aki no kure	of an autumn evening

—1683

hana ni ukiyo	among the blossoms
waga sake shiroku	in this floating world—
meshi kuroshi	my saké clouded and rice unmilled

—1683

kiyoku kikan	hearing purely,
mimi ni kō taite	my ears cleansed by incense—
hototogisu	cuckoo

—1683

Sitting in the new Bashō hut, he wrote:

arare kiku ya	listening to hail—
kono mi wa motono	I stay the same
furugashiwa	old oak

—1683

One more poem from that year is also interesting because it gives a sense of Bashō's attitude toward painting. He commented to an artist at work that the man on a horse looked like a monk—where might he be going? The painter replied that the man was Bashō himself, who then wrote this haiku:

uma bokuboku	the horse clip-clopping along
ware wo e ni miru	I see myself in a painting—
natsuno kana	summer fields

—1683

The Years of Poetic Journeys

In his never-ending search for authenticity and integrity of expression, Bashō began to make extended journeys into the countryside, keeping po-

etic journals that he was to revise and turn into *haibun* (haiku prose), of which he is still considered the greatest master. *Haibun* generally consist of prose passages interspersed with haiku, the prose often serving as introductory material to the poem, or sometimes the poem summing up the experiences described in the prose.

The first of these major trips that led to a poetic journal that Bashō began when he started traveling with his friend Naemura Chiri (1648–1716) in the fall of 1684. Starting in Edo, they made their way to Kyoto, with several detours including passing Mount Fuji and stopping at Nagoya, Nara, Osaka, Mount Yoshino, Mount Kōya, and Akashi. Including a pause in Ueno for two months, this trip ended in the summer of 1685. The resultant *Nozarashi kikō* (Journal of a Weather-Beaten Skeleton) was both Bashō's travel diary and the record of forty-five haiku that he composed during that time (along with two by Chiri); the extended prose passages that Bashō would write later in his *haibun* were yet to appear.[10]

There is no particular narrative thread to this journal; things happen when they happen, happy or sorrowful, and that is part of the appeal. The first haiku, however, shows Bashō's somewhat fatalistic attitude toward taking a long and difficult journey in his usual less-than-robust state of health.

nozarashi wo	just a weather-beaten skeleton
kokoro ni kaze no	with my heart exposed—
shimu mi kana	the wind pierces my body

—1684

One element of much Japanese poetry is the use of certain words or phrases to describe famous beauty spots, thus eliminating the need for the poet to actually visit them (Saigyō was a notable exception in this regard). In his quest for authenticity, however, Bashō was determined to experience the actual locations, whatever the results.

kirishigure	misty rain
Fuji wo minu hi zo	the day Fuji can't be seen
omoshiroki	is also beguiling

—1684

One of the most heartrending scenes that Bashō encountered was an abandoned toddler left out in the autumn weather by parents too poor to maintain him.

saru wo kiku hito	for those who have heard a monkey's cry,
sutego ni aki no kaze	this abandoned baby in the autumn wind—
ika ni?	why? how?

—1684

The sound of a monkey's cry was said to be the epitome of sadness, but Bashō had to deal with reality, not poetic convention, and the experience gave him more evidence of the pathos of the floating world, here rendered in an unusual rhythm. He concluded that the child was not despised or neglected by his parents, but rather that this was the will of heaven, and he mourned. Bashō gave the child food, but could not carry him on his journeys.

Taking a detour to the sacred shrine at Ise, Bashō was struck again by the power of nature compared to the relative limitations of humans.

misoka tsuki nashi	moonless last day of the month—
chitose no sugi wo	a thousand-year-old cedar
daku arashi	embraced by a storm

—1684

Early in the ninth month of 1684, Bashō arrived at his home village in Ueno, noticing how much older the members of his family had grown: everyone now had gray in their hair, and there was even gray in Bashō's eye-

brows. Some of his mother's white hair had been preserved in an amulet, and Bashō was moved to write:

te ni toraba	if I held it in my hands
kien namida zo atsuki	my hot tears would melt it—
aki no shimo	autumn frost

—1684

The surprising word "frost" here has several meanings—to compare white with white while contrasting cold with hot, to suggest how the heat of tears would melt the frost, and to imply that holding his mother's hair was very emotional for the poet.

Wayfaring was by no means an easy life. Visiting an old friend in Ōgaki, Bashō was in a somber mood.

shini mo senu	not dead yet
tabine no hate yo	after so much travel—
aki no kure	autumn darkens

—1684

Perhaps the visit with his friend was salutary, or perhaps Bashō was ready to return to more observation in his haiku, but many of the verses he composed as he continued his journey are somewhat lighter in spirit and more wondrous of the everyday. Three of the poems deal with white: the first directly, the second indirectly, and the third in synesthesia through connections to sound.

akebono ya	whitefish
shirauo shiroki	a single inch
koto issun	of white

—1684

Bashō

uma wo sae	we even gaze
nagamuru yuki no	at the horse
ashita kana	this snowy morning

—1684

umi kurete	darkening ocean—
kame no koe	the voices of ducks
honoka ni shiroshi	faintly white

—1684

With the following poems we have now reached 1685, with Bashō continuing his travels.

toshi kurenu	year's end—
kasa kite waraji	still wearing my bamboo hat
hakinagara	and straw sandals

—1685

haru nare ya	it's spring!
na mo naki yama no	a nameless mountain
usugasumi	in thin haze

—1685

na batake ni	in the rape-blossom fields
hanami-gao naru	making flower-viewing faces—
suzume kana	sparrows

—1685

To conclude the *Nozarashi kikō,* Bashō wrote, "Near the end of the fourth month, I came back to my hermitage and recuperated from the wear and tear of the journey."

The Art of Haiku

natsugoromo	from my summer robe
imada shirami wo	I've still not finished
tori tsukusazu	picking all the lice

—1685

For the rest of that year, Bashō seems to have rested while working on making his travel journal into a finished *haibun*. He did not complete the final draft until 1687, demonstrating that although his writing has the feeling of spontaneity, he also worked it over to some extent, perhaps (paradoxically) to make it more authentic to his experiences.

Some commentators have seen a strong Chinese influence in this travelogue, and indeed Bashō was reading and admiring Chinese poets from the past at this time. Others have noted a Zen influence, and again this was surely part of Bashō's background that he made use of without direct imitation. Most important, Bashō was now able to put his observations and encounters into prose and poetry with a direct acceptance of whatever life brought him.

The Old Pond

Despite the vicissitudes of such a journey, the search for this freshness of experience led Bashō to future travels, and it was not long before he was on the road again. In the meantime, however, he was to compose the most famous haiku ever written.

furu ike ya	old pond—
kawazu tobikomu	a frog jumps in
mizu no oto	the sound of water

—1686

As noted before, nouns in Japanese can be singular or plural, so there may have been more than one pond or more than one frog—but one of

each seems sufficient. Bashō wrote this haiku out as a calligraphy several times, no doubt upon request, usually in *tanzaku* (thin poem-card) form. He seems to have enjoyed using the more complex Chinese kanji (characters) for most of the nouns and the verb, and simpler Japanese syllabary for the rest (Plate 3-1). He allows a generous amount of space at the top for the blue wave pattern and includes further empty paper below it, perhaps giving the viewer a short moment to pause before beginning to read. He then does not separate the three parts of the poem in space, but maintains a slightly hooking sense of flow down the *tanzaku,* with thicker and thinner lines adding rhythm to the work.

As might be expected, there has been a great deal of commentary about this poem, of which we can present just a fraction here. For example, there is a story by his pupil Kagami Shikō (1665–1731) that Bashō originally composed the final two phrases, and then considered what words to open with. Supposedly Kikaku suggested "mountain roses," but Bashō decided on "the old pond." A century later, a scholar named Shinten-ō Nobutane compared Bashō's verse with Zen Master Hakuin's "Sound of One Hand" koan (meditation subject; see page 187), writing of the sound in both cases that "it is there and it is not there."[11] The monk Moran perhaps summed up Japanese attitudes by calling this haiku "indescribably mysterious, emancipated, profound, and delicate. One can understand it only with years of experience."[12]

For an American point of view, we can turn to Robert Aitken, who compares this moment with Zen Master Hsiang-yen Chih-hsien (d. 898) becoming enlightened to his Buddha-nature when he heard a small stone strike a bamboo. Aitken wrote that "Bashō changed with that *plop.* The some 650 haiku that he wrote during his remaining eight years point surely and boldly to that essential nature."[13]

With Bashō's great admiration for Saigyō, it is possible that he was influenced by one of the monk-poet's tanka, although Saigyō's poem reads as though it could follow rather than lead Bashō's haiku.

The Art of Haiku

Mizu no oto wa	The sound of water
sabishiki io no	becomes my companion
tomo nare ya	in this lonely hut
mine no arashi no	while the mountain storm
taema taema ni	pauses, pauses

—SAIGYŌ

One other Bashō haiku from the same year mentions a pond again, but this time the poet joins the pond with the circle of the moon.

meigetsu ya	harvest moon—
ike wo megurite	walking around the pond
yomosugara	all night long

—1686

Bashō was very busy in 1687. He made three trips, beginning in the early autumn with a journey to view the harvest moon with his pupil Kawai Sora (1649–1710) and a Zen monk named Sōha (d. 1512–16), then traveling northeast to Fukugawa and Kashima, where they met Bashō's former Zen teacher Butchō.

One early evening on the way to Kashima, Bashō noticed a youth looking upward.

shizuno ko ya	a farmer's child
ine surikakete	stops husking rice
tsuki wo miru	to gaze at the moon

—1687

Unfortunately (or perhaps fortunately), the night of harvest moon itself was rainy, so in Butchō's temple, Bashō composed:

tsuki hayashi	a quick glimpse of the moon—
kozue wa ame wo	while leaves in the treetops
mochi nagara	hold the rain

—1687

Bashō followed this with another poem that is more personal, and again connected to Zen, where there is a koan that asks: "What was your original face?"[14]

tera ni nete	staying at a temple
makoto gao naru	with my own true face
tsukimi kana	I gazed at the moon

—1687

At home in 1687, Bashō composed several of his most delightful haiku, the first having a Buddhist implication.

haranaka ya	in the fields
mono ni mo tsukazu	beyond any attachments
naku hibari	the skylark sings

—1687

nagaki hi mo	the day is not
saezuri taranu	long enough for its song—
hibari kana	the skylark

—1687

sazare kani	a little crab
ashi hainoboru	crawling up my leg—
shimizu kana	clear waters

—1687

kimi hi wo take	If you start a fire
yoki mono misen	I'll show you something good—
yuki-maruge	a snowball!

—1687

Although they are not very often chosen for translation, many haiku by Bashō (and others) had immediate and specific meanings, for instance to celebrate a host or to hail a gathering. In one case, Bashō is inviting a pupil-friend named Sodō (n.d.) to come visit.

minomushi no	come and listen
ne wo kiki ni koyo	to the sound of bagworms—
kusa no io	grass hut

—1687

This, however, is not as simple as it seems, since the bagworm, whose sound is supposedly a sign of autumn, actually makes no noise. Did Bashō want Sodō to be able to hear the sound of silence?

Bashō also painted this scene as a haiga, with the poem placed above a depiction of the *bashō* tree and the gate to his hut (Plate 3-2). But gates demarcate boundaries, and can allow one in or shut one out. Here, is the gate open or closed? Does it depend upon Sodō's (or the viewer's) perceptivity? The long leaves of the tree point both up to the invitation and downward, and the artist's signature and seals are poised just outside the gate like a welcoming host.

The painting is enhanced by very light colors and a subtle range of ink tones that range from soft gray to rich black when visual accents are needed. Interestingly, Bashō divided the haiku into four columns of calligraphy, the shortest merely being the syllables *koyo* (come), which becomes the heart of the invitation. Together, the poem, the calligraphy, and the painting combine three arts into a single, seemingly modest expression that is nevertheless fully realized.

Despite the charm of these haiku and the haiga, Bashō may have felt that his inspiration would grow deeper on the road. In any case, in late 1687 he began a much more extended journey, basically following his earlier route westward, and such was his fame at this time that he received many farewell parties and verses from haiku friends.

Bashō was later to describe this 1687–88 journey in *haibun* form as *Oi no kabumi* (Notes for My Knapsack). Bashō begins with an introduction, telling how he regards the spirit in his body as windblown. It had led him to poetry many years before, initially for pleasure but then as a way of life; he knew that he could not satisfy his spirit either in court or as a scholar.[15] All he could do was to respond to nature, just like the tanka poet Saigyō, the linked-verse master Sōgi, the painter Tōyō Sesshū (1420–1506), and the tea expert Sen no Rikyū (1522–91), who were all moved by the same spirit. Among other meanings, this statement establishes Bashō's belief in haiku being among the highest of Japanese arts. He went on to state that whatever such a heart and mind sees is a flower and whatever it dreams about is the moon, so the initial task of any artist is to become one with nature. For Bashō, replenishing his spirit meant travel, as the first poem in this *haibun* makes clear.

tabibito to	wanderer
waga na yobaren	can be my name—
hatsushigure	first winter shower

—1687

Following a path through rice fields during a storm, Bashō composed four versions of an interesting observation—or at least, four versions have survived.

samuki ta ya	chilly fields—
bajō ni sukumu	crouching on my horse
kagebōshi	a shadow

—1687

The Art of Haiku

fuyu no hi ya	winter sun—
bajō ni kōru	icy on my horse
kagebōshi	a shadow

—1687

sukumi iku yaō	moving at a crouch
bajō ni kōru	icy on my horse—
kagebōshi	a shadow

—1687

fuyu no ta no	winter fields—
bajō ni sukumu	crouching on my horse
kagebōshi	a shadow

—1687

Assuming that these versions are indeed all by Bashō, we can find some small but significant comparisons. The cold is suggested by "winter" "chilly," or "icy"—which word works best? Only the second version omits *sukumu/sukumi* (which means "crouching, "cowering," "be cramped")— how important is this image to the poem? This is up to each of us to decide.

Another significant haiku in this *haibun* uses the word *ukiyo* (floating world), which originally had the Buddhist meaning of "transience," but was now also gaining the flavor of "worldly pleasures." Bashō seems to be using the word in both senses, with an added touch of humor.

tabine shite	stopping at an inn
mishi ya ukiyo no	I see the floating world
susu-harai	house-cleaning

—1687

Bashō included the same word in another haiku the next year.

Kiso no tochi	acorns from Kiso—
ukiyo no hito no	souvenirs for people
miyage kana	of this floating world

—1688

Returning to Bashō's journey, when noting that the mining of coal near Iga Castle emitted an unpleasant odor, Bashō took a positive approach.

ka ni nioe	covering with scent
uni horu oka no	the coal-mining hill—
ume no hana	plum blossoms

—1688

Bashō noticed not only the plum blossoms (the first to appear, even in the snow), but also another sign of early spring.

kareshiba ya	Over the dead grasses—
yaya kagerō no	faint heat waves,
ichi ni sun	one or two inches

—1688

Although Bashō did not very often make extended use of repeated sounds, here we have the syllable *ya* (pronounced "yah") three times in a row. First it serves as the cutting word, like an exclamation point or long dash, and then *yaya* means "a little." Furthermore, the vowel "a" repeats five times in a row (*ba ya ya ya ka*), giving an extra sense of warmth to the poem.

Four "a" vowels followed by five "o" vowels open another poem a little later in the *haibun,* with the "a" vowel returning for five of the final seven syllables.

The Art of Haiku

samazama no	how many memories
koto omoidasu	flood my mind—
sakura kana	cherry-blossoms

—1688

After several more poems praising cherry-blossoms, Bashō also describes the *horohoro* (melodiously or rhythmically dropping petals) of another flower near the sound of falling waters. Accenting the rhythm, the poem begins with five consecutive "o" vowels and ends with three more.

horohoro to	yellow mountain roses,
yamabuki chiru ka	are you falling in rhythm?
taki no oto	the sound of the waterfall

—1688

The final haiku in *Oi no kobumi* is one of Bashō's most celebrated, partly for its unusual subject, but even more for its resonance.

takotsubo ya	octopus pot—
hakanaki yume wo	fleeting dreams
natsu no tsuki	in summer moonlight

—1688

Are the dreams those of the octopus? Or of Bashō? Or are they our own?

Bashō probably did not complete the editing of *Notes for My Knapsack* until 1691. This is more evidence that he considered each word and each scene carefully, and he may have changed the order of some of the prose and haiku if he felt this would be more true to the significance of the experiences. Yet momentary inspiration was still very important to Bashō; one of his most famous comments to his pupil Hattori Dohō (1657–1730) was: "If you get a flash of insight into an object, record it before it fades away in your mind."[16]

Several further statements by Bashō to Dohō reveal his attitude toward fresh and direct experience, as well as the ability of haiku to see many sides of life. One of his most trenchant comments was to learn about a pine tree from a pine tree, and about bamboo from bamboo.[17] Bashō also described a significant difference between renga and haiku in terms of their subject matter: "A willow tree in the spring rain is wholly of the linked-verse world. A crow digging up a mud-snail belongs entirely to haiku."[18] This meant that on his travels, Bashō could explore almost every aspect of life.

Before starting another major expedition, however, in 1688 Bashō made a side journey, of a "Visit to Sarashina" (*Sarashina kikō*) to see the moon over Mount Obasute, where according to legend, villagers once took their old grandmothers to die. Stopping at the temple Zenkō-ji, which was unusual in that it maintained subtemples of various Buddhist sects, Bashō composed a haiku that suggests clearly his ecumenicism.

tsuki kage ya	in the moonlight
shimon shishū mo	four gates and four sects
tada hitotsu	become one

—1688

Journey to the North

In 1689 Bashō took his greatest and most arduous journey on the five-hundredth anniversary of Saigyō's death, the *Oku no hosomichi* (translated variously as "The Narrow Road to the North," "Narrow Road to the Interior," "Back Roads to Far Towns," and, most simply, "A Haiku Journey"). One of the most famous travelogues ever written, it also serves as the ultimate *haibun,* with a good deal more prose mixed with poetry than in Bashō's previous work.

Starting in early summer, this time Bashō went north to much less developed parts of Japan. He often stayed with local poets, took side trips, explored, rested, continued on, and finally turned west and south until reaching his

The Art of Haiku

hometown of Ueno, where he spent the end of the year. The early part of this adventure was shared with his pupil Sora, who had to leave halfway due to poor health, but other poets joined Bashō for some later parts of the journey.

Oku no hosomichi begins with one of the most famous paragraphs in Japanese literature.

> Months and days are eternal travelers, as are the years that come and go.[19] For those who drift through their lives on a boat, or reach old age leading a horse over the earth, every day is a journey, and the journey itself is their home. Many people in the past have died on the road, but for many years, like a fragment of a cloud, I have been lured by the wind into the desire for a life of wandering.

This opening not only sets the tone for all that follows, but also conflates space with time in a way that might have pleased Albert Einstein. In any event, carrying as little as possible—a paper garment, a cloth robe, rain gear, and writing utensils—Bashō set out with Sora. A number of his pupils saw him off in a boat and then lined the road, not sure if they would ever see him again, truly a sad moment of parting that inspired Bashō's haiku:

yuku haru ya	spring passing—
tori naki uo no	birds cry out, there are tears
me wa namida	in the eyes of the fish

—1689

Although it goes beyond the trajectory of this book, the entire *Oku no hosomichi* is such a significant work that it deserves to be enjoyed in full; fortunately there are several fine translations extant. Since we are focusing on haiku here, we will present some of the outstanding verses in this *haibun* with their basic contexts. As usual, Bashō participated in a number of linked verses during this trip, but he also kept the haiku separate in his *haibun*, so they could stand on their own.[20]

Bashō traveled in monk's robes and shaved head, but he never became a monk as such. In effect, he was traveling through Japan beyond any of the official categories of society (in descending official order: samurai, farmers, artisans, and merchants, plus monastics and Confucian scholars). As they began their journey, Sora also shaved his head and put on Buddhist-style robes, writing this haiku himself:

sori-sutete...	cutting off my hair
Kurokami-yama ni	at Black Hair Mountain
koromo-gae	and changing clothes

—SORA, 1689

Bashō commented that this changing of clothes was "pregnant with meaning."

Another Buddhist implication comes in the next haiku. Bashō and Sora climbed into a grotto behind Urami-no-taki (Back-View Falls) where they could see the waterfall from the rear, as though inside it—an appropriate place for a form of meditation.

shibaraku wa	for a time
take ni komoru ya	secluded behind the waterfall—
ge no hajime	summer retreat begins

—1689

The word *ge* (ninety-day summer retreat) is specifically Buddhist, and gives another indication that at least one of the purposes of this journey was spiritual; waterfalls were used for purification rites in both Buddhism and Shintoism. However, it was earlier in the summer than the normal time for "summer retreats," so it seems that Bashō was taking events and opportunities as he found them, rather than having planned them all in advance.

One of Bashō's most significant haiku was composed after passing the Shirakawa barrier, one of the government checkpoints for travelers.

fūryū no	the origin
hajime ya oku no	of poetry—
taue-uta	rice-planting songs

—1689

The word *fūryū* has several meanings in Japanese, so this haiku's opening words could also be translated as "the origin of the arts" or "the origin of elegance." In a society where most poets now lived in cities or towns, Bashō's appreciation for the farmers' natural culture is unusual; we can also note once again that *oku* can mean the far north or the interior, including the human interior.

Bashō and Sora came to a huge chestnut tree where a monk had built a modest hermitage. Bashō recalled that Saigyō had written a poem about gathering chestnuts deep in the mountains in this part of Japan, and so he responded with:

yo no hito no	people in this world
mitsukenu hana ya	don't see these flowers—
noki no kuri	chestnuts under the eaves

—1689

The two travelers continued north, stopping to see the pine islands at Matsushima, which Bashō termed the most beautiful place in Japan, and where he noted that the Zen master Ungo Kiyō (1582–1659) had once sat in meditation and also rebuilt the major temple Zuigan-ji.

Journeying further to where a famous battle had taken place hundreds of years earlier, Bashō recalled the Chinese poet Tu Fu's lines:

As spring returns to the ruined castle,
The grass is always green.[21]

—TU FU

This led Bashō to write another of his best-known haiku.

natsugusa ya	summer grasses—
tsuwamono-domo ga	all that remains from the dreams
yume no ato	of brave warriors

—1689

Somewhat later in the journey Bashō wrote on a similar theme.

muzan ya na	how merciless—
kabuto no shita no	under the helmet
kirigirisu	a katydid

—1689

Moving back and forth from Japanese history to the sometimes igno-
minious world of travel was not always easy, as Bashō and Sora discovered
when they stayed for three heavily raining days in a guard's shack.

nomi shirami	fleas, lice,
uma no shitosura	a horse pissing
makuramoto	by my pillow

—1689

Perhaps most haiku are inspired by what is seen, but what is heard was often
an important element in Bashō's haiku (as in the line "the sound of water"). One
of his poems, written when he found the temple Ryūshaku-ji closed and bolted,
is especially interesting in that it expresses both sound and the loss of sound.[22]

shizukasa ya	silence—
iwa ni shimiiru	penetrating the rocks,
semi no koe	cicada voices

—1689

The Art of Haiku

Another haiku that has become celebrated concerns an incident where Bashō and Sora were staying at an inn and were mistaken for monks by two prostitutes. The women asked if they could travel along with Bashō and Sora. The poets replied they had many detours and side trips, but if the women would follow the road, the gods would see them through. Bashō felt sorrowful about this for some time, and wrote:

hitotsuya ni	under one roof
yūjo mo netari	courtesans are also sleeping—
hagi to tsuki	bush-clover and the moon

—1689

Bashō continued to write haiku at a very high level throughout the journey; as it was coming to a close, he once again turned to *hagi* (bush-clover):

nami no ma ya	between the waves—
kogai ni majiru	mingled with tiny shells
hagi no chiri	are fragments of bush-clover

—1689

The Final Years

Spending the last two months of 1689 in his hometown seems to have given Bashō a chance to recover from the arduous journey. In the first month of 1690 he went to Nara, and then the next month he stopped in Kyoto and the nearby town of Zeze, visiting pupils during his stay.

Kyō nite mo	although in Kyoto
Kyō natsukashi ya	nostalgic for Kyoto—
hototogisu	cuckoo

—1690

At that point Bashō returned to Ueno for three months, and then spent the summer in a cottage near Zeze (at "my unreal hut"). Afterward he spent two more months in a nearby hermitage in the precincts of the temple Gichū-ji, finally returning to Ueno for the rest of the year.

Now a famous poet, Bashō faced a steady influx of pupils or would-be pupils, perhaps one of the reasons he moved frequently to outlying areas.

waga yado wa at my hut
ka no chiisaki wo all I can offer is that
chisō kana the mosquitoes are small

—1690

He also warned a potential student named Shidō (n.d.):

ware ni niru na don't be like me
futatsu ni wareshi even if we resemble
makuwauri two halves of a melon

—1690

Bothered by ill health for some of this time, Bashō returned to his reading of the Taoist sage Chuang-tzu, especially the story of the sage going to sleep and dreaming he was a butterfly. When he awoke, was he Chuang-tzu who dreamt he was a butterfly, or was he a butterfly now dreaming he was Chuang-tzu? Two haiku that Bashō composed, one perhaps a decade earlier and one about this time, refer to this theme.

oki yo! oki yo! wake up! wake up!
waga tomo ni sen and let's be friends—
neru kochō sleeping butterfly

—1681–83

kimi ya chō	you the butterfly
ware wa Sōshi ga	and I Chuang-tzu—
yume-gokoro	a dreaming heart

—1690

The progression of these haiku spells out something about Bashō's state of mind from before to after his major travels. At first he wants to be friends with the butterfly, who may be Chuang-tzu, but later he becomes one with the Taoist sage who could fully identify with another form of life, while at the same time questioning what it means to be human.

It is dangerous, however, to try to read too much into individual haiku, since Bashō was certainly aware of the very different observations, moods, feelings, and expressions that we all can feel, sometimes in close succession. For example, in 1690 Bashō wrote two haiku that seem to contradict each other, at least by implication.

tsukimi suru	among those
za ni utsukushiki	viewing the moon,
kao mo nashi	not one beautiful face

—1690

meigetsu ya	harvest moon—
chigotachi narabu	children lined up
dō no en	on the temple veranda

—1690

Despite the first poem, one may strongly suspect that Bashō found these children's faces to be beautiful. Equally, he honored the music of the cicadas as autumn deepened.

Bashō

yagate shinu	showing no signs
keshiki wa miezu	that they will soon die—
semi no koe	cicada voices

—1690

As winter came, Bashō's observations became darker. The first of these haiku describes a scene on Ishiyama (Stone Mountain); the first two lines both begin with the word *ishi*, followed by eight "ah" sounds:

Ishiyama no	flying among
ishi ni tabashiru	the stones of Stone Mountain—
arare kana	hail

—1690

shigururu ya	early winter shower—
ta no arakabu no	enough to plaster the field
kuromu hodo	black

—1690

inoshishi mo	even wild boars
tomo ni fukaruru	are blown along
nowaki kana	by wintry blasts

—1690

byōgan no	the sick wild duck
yosamu ni ochite	in the cold of night
tabine kana	flies down to rest

—1690

The latter poem comes with an interesting anecdote from Bashō's pupil Mukai Kyorai (1651–1704). Throughout his life the master was very interested in linked haiku, now called *renku*, and while compiling the *renku* and

The Art of Haiku

haiku anthology *Sarumino* (Monkey's Raincoat, 1691), Bashō asked his pupils Nozawa Bonchō (1640–1714) and Kyorai to select either the wild duck poem above or the following poem:

ama no ya wa	fisherman's hut—
koebi ni majiru .	mixed among the small shrimp
itodo kana	crickets

—1690

Although Bonchō preferred the second poem as fresh in subject and superb in choice of words, Bashō replied that while it had new material, the ailing duck had more profound implications. The students asked if they could include them both, but Bashō laughed and asked whether they would discuss each poem on the same level?[23]

Bashō spent most of 1691 in and around Ueno and Kyoto, finally returning to Edo near the end of the year—he had been gone more than two and a half years. A selection of Bashō haiku from 1691 shows his continued combination of variety and empathy, with perhaps an extra touch of melancholy as the seasons flow by.

shibaraku wa	lingering a moment
hana no ue naru	above cherry-blossoms
tsukiyo kana	this evening's moon

—1691

matsudake ya	mushroom
shiranu ki no ha no	stuck to the leaf
hebaritsuku	of an unknown tree

—1691

samidare ya	midsummer rains
shikishi hegitaru	traces on the wall where
kabe no ato	poem-cards have peeled

—1691

ushibeya ni	in the cowshed
ka no koe kuraki	mosquito voices darken—
zansho kana	summer heat

—1691

te wo uteba	when I clap my hands
kodama ni akuru	they echo with
natsu no tsuki	the summer dawn's moon

—1691

In contrast with this last poem are two haiku from the same year.

uki ware wo	already sorrowful
sabishi garese yo	he makes me more lonely—
kankodori	the mountain cuckoo

—1691

otoroi ya	becoming feeble—
ha ni kuiateshi	my teeth grate on
nori no suna	sand in the seaweed

—1691

Bashō also may have been referring to himself as he evokes the chill of winter.

2-1 Yamazaki Sōkan (1465–1553), *Cool Wind.* Ink and colors on paper, 26.2 x 43.4 cm. Kakimori Bunko.

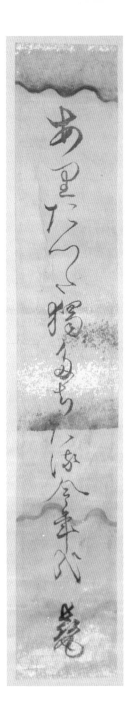

2-2 Matsunaga Teitoku (1571–1653), *Still Standing Here*. Ink on decorated paper *tanzaku,*
35 x 5.6 cm. Private Collection, Japan.

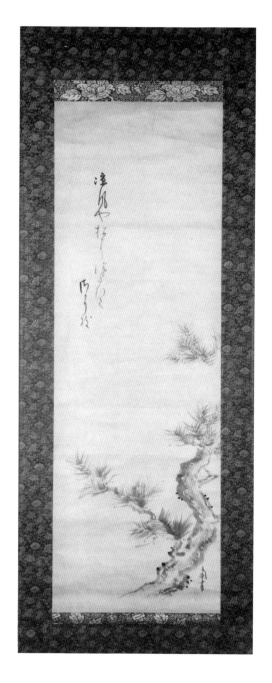

2-3 Nonoguchi Ryūho (1595–1669), *Cool Breeze,* Ink on paper, 80 x 27 cm. Arimura Collection.

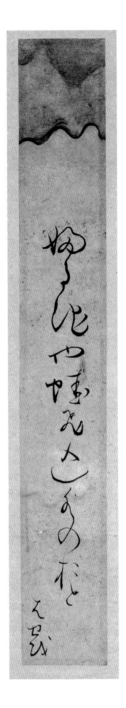

3-1 Matsuo Bashō (1644–94), *Old Pond*. Ink on decorated paper *tanzaku*, 35.2 x 5.7 cm.
Kakimori Bunko.

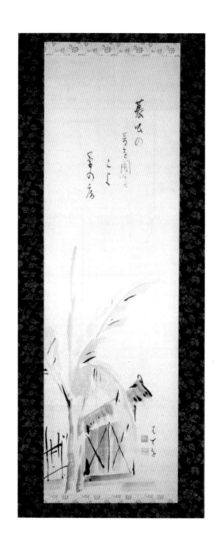

3-2 Matsuo Bashō (1644–94), *Gate and Banana Plant.* Ink and colors on paper, 97.3 x 29.7 cm. Idemitsu Museum.

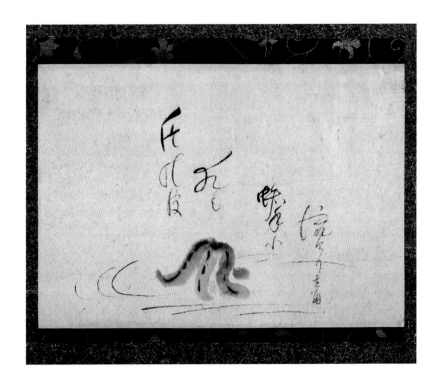

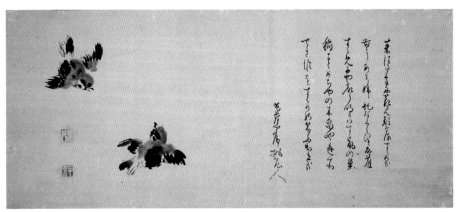

4-1 Enomoto Kikaku (1661–1707), *Melon Skin.* Ink on paper, 31 x 44.4 cm.

4-2 Morikawa Kyoroku (1656–1715), *Sparrows, with Five Haiku by Bashō.* Ink and color on paper, 28.6 x 76.5 cm. Private Collection.

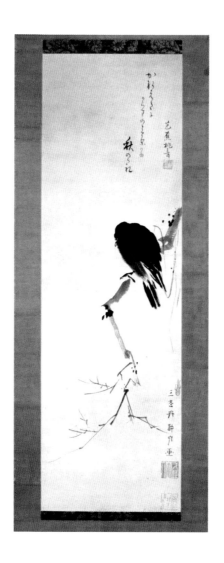

4-3 Morikawa Kyoroku (1656–1715), *Crow on a Withered Branch*. Haiku by Bashō. Ink on paper, 100 x 30.1 cm. Idemitsu Museum.

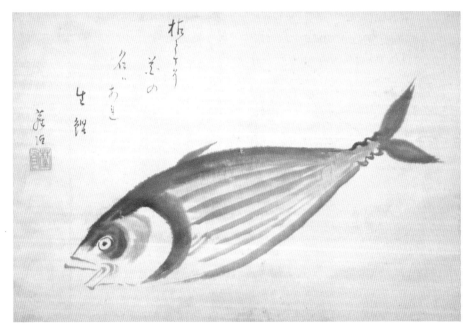

4-4 Kaga no Chiyo (1703–75), *Introduction and Six Haiku.* Ink on paper, 15.8 x 44.1 cm.

4-5 Yokoi Yayu (1702–83), *Katsuo.* Ink on paper, 36 x 50.5 cm. Marui Collection.

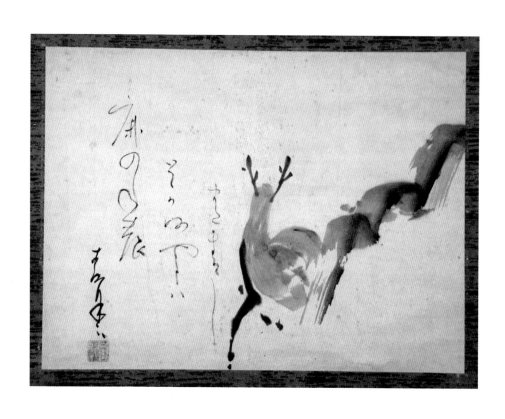

4-6 Nakagawa Otsuyū (1675–1739), *Deer*. Ink on paper, 27.7 x 37.6 cm.

5-1 Hakuin Ekaku (1685–1768), *Hotei as a Kite*. Ink on paper, 38.3 x 54.5 cm. Hōsei-an
Collection.

5-2 Hakuin Ekaku (1685–1768), *Monkey and Cuckoo*. Ink on paper, 55.4 x 43 cm. Shin'wa-an.

5-3 Reigen Etō (1721–85), *Gun.* Ink on paper, 70.1 x 25.2 cm.

5-4 Suiō Genro (1717–89), *Ax*. Ink on paper, 119 x 28.8 cm.

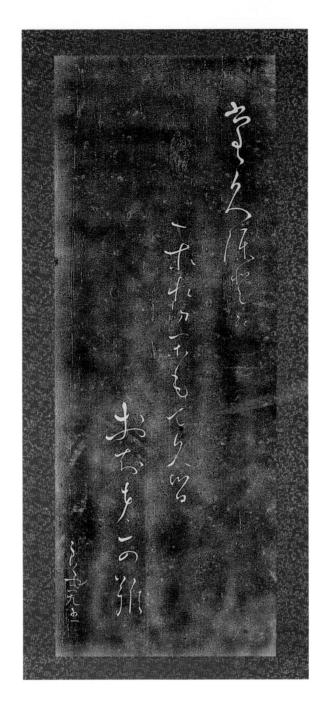

5-5 Daigu Ryōkan (1758–1831), *Enough for a Fire*. Rubbing, ink on paper, 117 x 44.8 cm.

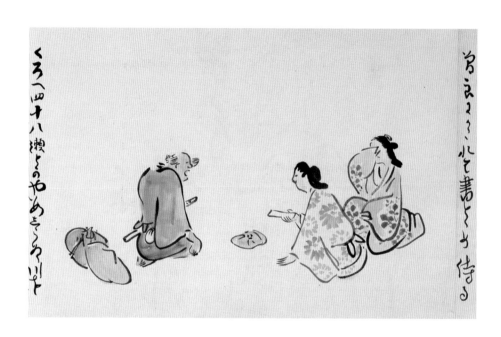

6-1 Yosa Buson (1716–84), *Oku no hosomichi* (Detail of hand-scroll). Ink and color on
 paper, 48.2 x 28.8 cm. Itsuo Art Museum.

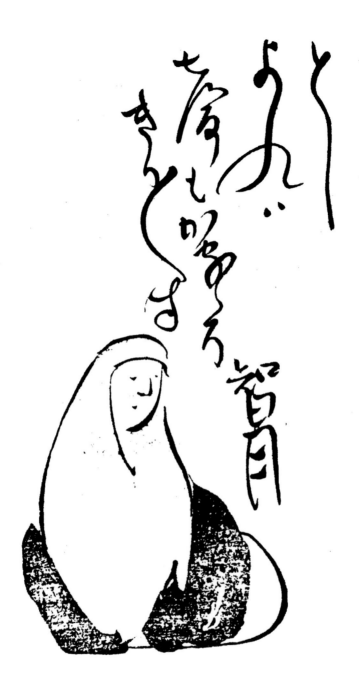

6-2　Yosa Buson (1716–84), *The Poet Chigetsu*. Wood-block print from *Haikai sanjūrokkasen*
(Thirty-Six Haiku Poets, 1799). Ink on paper, 26.8 x 19.3 cm.

tomokakumo	somehow surviving—
narade ya yuki no	dry pampas-grass
kareobana	in the snow

—1691

He was also able to suggest the season with both indoor and outdoor images.

negi shiroku	leeks washed
arai tatetaru	completely white—
samusa kana	the cold

—1691

kogarashi ni	winter wind
iwa fuki togaru	through the cedars
sugima kana	sharpens the rocks

—1691

Bashō spent most of 1692 in Edo, where he renewed friendships and eventually moved into a third Bashō hut, with the plantain tree transplanted next to it. However, he was sorry to see the general craze for winning haiku prizes. Some of his former pupils were now earning fees as haiku-contest judges, and at one point Bashō even considered giving up haiku himself, but inevitably a poetic sentiment would appear that he could not resist.

Bashō's own output of haiku was relatively modest that year. This may have reflected to some extent his disappointment with the haiku world of Edo, but at a reduced pace he continued expressing his observations of nature and humanity, sometimes with humor.

neko no koi	when the cats' affair
yamu toki neya no	is ended, hazy moonlight
oborozuki	in the bedroom

—1692

uguisu ya	a warbler
mochi ni funsuru	poops on the rice cake
en no saki	on the edge of the veranda

—1692

aokute mo	better
aru beki mono wo	to have stayed green—
tōgarashi	the pepper

—1692

And, in reverse:

yuku aki no	still hoping
nao tanomoshi ya	as autumn ends—
aomikan	green tangerines

—1692

This may refer to Bashō's own feeling that he had not accomplished every-thing he had hoped for. In any event, he was also cognizant of his age.

kyō bakari	just today
hito mo toshiyore	everyone feels old—
hatsu-shigure	first winter rain

—1692

The following year brought forth more haiku on similar emotions.

The Art of Haiku

kinbyōbu	on the golden screen
matsu no furubi ya	the pine trees get older—
fuyugoromi	winter seclusion

—1693

toshidoshi ya	year after year
saru ni kisetaru	the monkey wears
saru no men	a monkey mask

—1693

In many ways 1693 was a sad year for Bashō. The nephew he had been supporting died of tuberculosis after being taken into Bashō's home. The great poet became depressed to the point of stopping haiku for a time, but fortunately this did not last very long. He even shut and bolted his gate in early autumn, trying to reduce the number of visitors, as he "grew weary of people."

asagao ya	morning glories—
hiru wa jō orosu	my gate shut
mon no kaki	all day long

—1693

Around this time he wrote a more ambiguous poem on this subject.

asagao ya	morning glories—
kore mo mata waga	you too are no longer
tomo narazu	my friends

—1693

Japanese commentators have long questioned why this "friendship" had ended, and some of the possible reasons that they have advanced include:

- Bashō's depression compared to the cheerful flowers
- The flowers' transience
- Bashō no longer being able to get up early enough in the morning to enjoy the flowers
- The competitive colors of the flowers
- The fact that the flowers could no longer lift his spirits[24]

One of the most interesting comments about this haiku is a Zen interpretation by Robert Aitken. He wrote that "the friendlessness of the morning glory and of Bashō are the fundamental aloneness in which each of us is born. . . . Each individual entity is its own reason for being. . . . There is only Bashō in the universe. There is only the morning glory in the whole universe."[25]

In any event, Bashō had not lost his sense of humor, as a poem on the "evening glory" (*yūgao*), also know as "moonflower," makes clear.

yūgao ya moonflowers—
yōte kao dasu I stick my drunken face
mado no ana out the window

—1693

Among the many elements that make Bashō unique is his ability to use the same image, in this case the large radish called daikon, for totally different purposes.

kuratsubo ni on the saddle
kobōzu nosete a little boy is settled—
daikon-hiki going to pull radishes

—1693

mononofu no	the radish-flavored
daikon nigaki	acid conversations
hanashi kana	of samurai

—1693

This was a time when Bashō was advocating *karumi* (lightness) in haiku, as opposed to the heaviness of logic and reason that can easily lead poetry toward over-elaboration. His own variety of direct observation and expression can be seen in several further poems from 1693.

tsuki hana no	acupuncture
gu ni hari taten	for flower-moon foolishness—
kan no iri	the cold weather's sting

—1693

hototogisu	the cuckoo's call
koe yokotau ya	stretches
mizu no ue	across the water

—1693

kodomo-ra yo	hey children!
hirugao sakinu	the noontime flowers are blooming
uri mukan	I'll peel a melon

—1693

shira tsuyu mo	without scattering
kobosanu hagi no	the white dew, bush-clover
uneri kana	undulates

—1693

But Bashō's imagery was not always so attractive, as in the following poem:

Bashō

namagusashi	on the waterweeds
konagi ga ue no	the smell
hae no wata	dace-fish guts

—1693

At this time, the poet could bring out different flavors through using different contexts for a single image, in this case the chrysanthemum.

kiku no hana	chrysanthemums—
saku ya ishiya no	blooming between the stones
ishi no ai	of a stonemason

—1693

kiku no ka	chrysanthemum fragrance—
niwa ni kiretaru	in the garden, the sole
kutsu no soko	of a broken sandal

—1693

kangiku ya	winter chrysanthemum—
konuka no kakaru	rice bran fallen
usu no hata	at the mortar's edge

—1693

Although Japanese (and Chinese) poetry had praised the chrysanthemum for blooming late into the year and surviving the cold, Bashō took a different approach. He contrasts the flower with the humanistic elements of a stonemason, a broken sandal, and rice bran, which brings out the flower's beauty without a word of praise being needed.

Bashō's final year was 1694. Suspecting as much, he sent a letter to a friend saying, "I fear the end is drawing close."[26] He still wanted to try one more journey, so in the summer he left Edo, carried on a litter, for stops in Nagoya, Ueno, Lake Biwa, and Kyoto, and finally back to Ueno. In the fall

The Art of Haiku

he traveled to Nara and then Osaka, but fell severely ill there, and he died on November 28th.

Despite his health problems, Bashō was actively writing haiku in his final year, perhaps to help spread the idea of *karumi* that was, in his words, like "looking at a shallow river with a sandy bed."[27] In any case, a number of Bashō's haiku from his final year have a certain lightness of spirit that belies the poet's age and precarious health.

hiyahiya to	the coolness
kabe wo fumaete	of my feet against the wall—
hirune kana	midday nap

—1694

sara hachi mo	plates and bowls
honokani yami no	faintly gleaming
yoisuzumi	in the cool darkness

—1694

asa tsuyu ni	in the morning dew
yogarete suzushi	a little muddy but cool—
uri no tsuchi	melons on the ground

—1694

It may be more difficult to see *karumi* in the following poems that inevitably describe his feelings of old age and ill health, but Bashō was determined not to let his haiku become weighty or oppressive.

iki nagara	still alive
hitotsu ni kōru	but frozen into one—
namako kana	sea-slugs

—1694

Bashō

uguisu ya	the warbler
take no ko yabu ni	in the bamboo-shoot grove
oi wo naku	sings of old age

—1694

Nehan-e ya	Buddha's death day—
shiwade awasuru	the sound of wrinkled hands
juzu no oto	rubbing prayer beads

—1694

u-no-hana ya	leaning over
kuraki yanagino	white hedge-flowers—
oyobi goshi	a dark willow

—1694

kono aki wa	this autumn
nan de toshiyoru	why am I feeling old?
kumo ni tori	a bird in the clouds

—1694

tōgan ya	winter melon—
tagai ni kawaru	how our faces
kao no nari	have changed!

—1694

samidare ya	midsummer rain—
kaiko wazurau	a silkworm ill
kuwa no hata	in a mulberry field

—1694

The Art of Haiku

mugi no ho wo	clutching some ears of wheat
chikara ni tsukamu	for strength
wakare kana	and parting

—1694

kono michi ya	on this road
yuku hito nashi ni	not one traveler—
aki no kure	autumn deepens

—1694

And Bashō's final poem "during my illness":

tabi ni yande	ill from journeying
yume wa kareno wo	but my dreams circle
kake-meguru	over withered fields

—1694

Conclusion

What makes Bashō so special in the history of haiku, and what makes his poems so distinct? The first question is easier than the second: he came along at just the right time to turn haiku from a clever and often frivolous form of verse to poetry that could express depth and richness of both observation and spirit. This was recognized in his own day, and later in his life he was besieged by prospective and actual pupils from many different parts of Japan. Indeed, Bashō's followers were to dominate the next generation of poets, and his influence has remained vital in haiku to this day.

Accepting that Bashō accomplished all this, the question remains: How? For anything approaching an answer, we need to examine in what ways his own character and life choices advanced his poetry. In this regard, there are a number of factors that can be cited.

First, Bashō maintained his freedom. By giving up his official position,

by frequently moving, and especially by his journeys, he never grew stale or redundant, but could view fresh places, meet new people, and experience multiple aspects of nature. He changed his aesthetic approach to haiku several times, starting with the Teimon and Danrin traditions, but quickly moving on to deeper observation and expression of the world around him, and ending with *karumi* just when one might expect the opposite. He studied Zen, shaved his head, and wore a monk's robe, but never become a monk. In short, Bashō didn't fit into a category or niche in a society that was very niche conscious.

Second, he appreciated the past without being overwhelmed by it. Through his deep admiration of both classical Chinese poets and Japanese masters such as Saigyō and Sōgi, Bashō could use them as exemplars of travel, nonattachment, and profound observation of the world around them. Earlier haikai poets used the past primarily for parody or to demonstrate their erudition and wit, whereas Bashō had a more personal, and often more poignant, response to his predecessors that still retained his own poetic spirit.

Third, Bashō never became self-satisfied. In a world where humility could often be a pose, he felt it deeply; despite his success, he never stopped searching for greater significance and range of expression. It helped that he seems to have been boundlessly curious and nonjudgmental; he did not find dace-fish guts, or a horse pissing near his pillow, to be unworthy of poetry. Bashō's journeying became a way to always seek the new, rather than resting content with what had gone before.

yo wa tabi ni	traveling the world
shiro kaku oda no	instead of tilling a small field
yuki modori	round and round

—1694

Fourth, Bashō added a kind of humor to his haiku that did not depend upon puns or esoteric references to earlier literature, although both might

occasionally appear in his verses. Instead, he celebrated the humor of daily life, where a small smile of recognition became more valuable than an "I get it" grin or an "Isn't that clever" smirk.

susuhaki wa	year-end cleaning—
ono ga tana tsuru	the carpenter builds a shelf
daiku kana	for his own home

—1694

Fifth, Bashō was an expert in combining into a single haiku two images or two elements that might not seem to match, but which together become very evocative. Sometimes these involved synesthesia, where two different senses are combined, such as sight and sound.

inazuma ya	lightning—
yami no kata yuku	into the darkness
goi no koe	a heron's cry

—1694

Sixth, although Bashō did not paint many haiga himself, he gave this form of visual art a kind of sanction and significance through his interactions with other poet-artists, especially Kyorai, as well as his own modest paintings. One haiku from his final year shows his belief that visual art could express just what his poems put forth.

suzushisa wo	coolness
e ni utsushikeri	painted on a scroll—
Saga no take	the bamboo at Saga

—1694

Seventh, Bashō continued to develop his art with ever-greater depth. As noted, to keep from becoming heavy-handed or overly serious, in his

final years he advocated lightness in haiku. As Robert Aitken wrote, "The path of clarity is the path of weightlessness. . . . Assumptions, explanations (including this), extrapolations, personal associations—all add weight, and the experience will not rise."[28]

Finally, Bashō was a poet of great humanity. Although people do not appear in the majority of his haiku, they are always present, if only in the forms of Bashō himself and his readers. For Bashō, nature included human nature, and there need be no separation of the two into different worlds of feeling or expression. This is made clear in two more haiku from his final year.

yuku aki ya
te wo hirogetaru
kuri no iga

—1694

autumn passes—
with their hands spread open
chestnut burs

aki chikaki
kokoro no yoru ya
yojōhan

—1694

autumn is near—
hearts come together
in the tearoom

4

Followers of Bashō

B ASHŌ HAD MANY PUPILS and even more followers. This was in part
due to his poetry and personality, and in part because during his
travels he frequently met with local poets and would-be poets in many
parts of Japan. Therefore, one aspect of Bashō's pupils is their geographical
range, which helped provide the variety that can be seen in their work.

In addition, as Bashō himself developed and changed his views on haiku,
he tended to work with different pupils. The result was that separate aspects
of his aesthetic became significant to various poets at various times. For
example, the pupils he worked with at the end of his life were more likely
to have been influenced by Bashō's views on *karumi* (lightness), than those
whom he had taught earlier.

What all Bashō's students had in common was taking haiku as a worthy
kind of poetry and not a clever game. Although the Teimon and Danrin
schools continued in a very weakened way, the influence of Bashō was so
vast that in one sense, all haiku poets after his day might be considered his
followers.[1]

Another factor among Bashō's direct and indirect pupils was their varied
backgrounds—samurai, ex-samurai, monks, nuns, farmers, artisans, doc-
tors, officials, merchants, saké brewers, even a beggar—so they saw and
experienced many aspects of Japanese life, and frequently recorded them
with both skill and empathy. As Bashō taught, "In composing haiku, my
students begin by looking within the topic, but when they start by looking
outside the topic, they find a plethora of material."[2]

It would be impossible to consider all of Bashō's followers here, but some of the most significant will be examined, however briefly, and the growing interest in haiga during this period will also be discussed and illustrated.

Enomoto Kikaku

Enomoto Kikaku (1661–1707) may have been Bashō's favorite pupil, despite (or perhaps because of) their differences in lifestyle, poetry, and vision of nature. He began learning from the master at age thirteen, and also studied both Chinese and Japanese classical prose and poems, as well as medicine, calligraphy, and painting.

While Bashō was subtle and sympathetic in his haiku, Kikaku definitely had a more radical sense of the world around him, including a robust sense of humor. Unlike the humor in pre-Bashō haiku, however, Kikaku's wit rarely depended upon elaborate puns or references to earlier literature, but rather arose from observation. Here are a group of haiku by Kikaku, moving through the seasons.

uguisu no
mi wo sakasama ni
hatsune kana

the warbler
sings its first song
upside-down

kane hitotsu
urenu hito nashi
Edo no haru

not one temple bell
that someone won't sell—
springtime in Edo

yogi wo kite
aruite mitari
doyō-boshi

wrapping myself in a quilt
and walking around just to see—
summer airing

The Art of Haiku

hito nagaya	locking the door
jo wo oroshite	everyone in the boarding house
odori kana	goes out to dance
kabashira ni	the floating bridge
yume no ukibashi	of my dreams is suspended
kakaru nari	on a column of gnats
hatsu yuki ni	first snow—
kono shōben wa	what creature
nini yatsu zo	has pissed on it?

Kikaku even utilized humor when writing a poem commemorating the death of a Bashō pupil named Kōsai (n.d.).

sono hito no	even his snores
ibiki sae nashi	have disappeared—
semi no koe	cicada voices

Another poem shows Kikaku's effective use of words in a riddle haiku.

kiraretaru	stabbed—
yume wa makoto ka	was my dream a reality?
nomi no ato	a flea-bite!

In a conversation with Bashō, his pupil Kyorai commented that "Kikaku is really a clever writer. Who else would ever have thought of writing a poem merely about being bitten by a flea?" The master said, "You're quite right. He deals with trifling matters in a most eloquent way."[3]

To become the major haiku master that he was, of course Kikaku wrote many more serious haiku, showing a sharp eye for the world around him. Some of these seem extremely simple, as though the outgoing personality

of Kikaku were now retreating inward with only nature as his guide—
or might the first of these have a reference to his relationship with his
teacher?

ama-gaeru	the tree-frog
bashō ni norite	riding a banana leaf
soyogikeri	rustles and sways
aoyagi ni	the bat skims
kōmori tsutau	among green willows—
yūbae ya	sunset glow
tombō ya	dragonflies
kurui shizumaru	quiet their mad darting—
mikka no tsuki	crescent moon
kojiki kana	the beggar
tenchi wo kitaru	wears heaven and earth
natsu-goromo	as his summer clothes
sumu tsuki ya	clear moon—
hige wo tatetaru	lifting up its whiskers
kirigirisu	a katydid

To use moonlight to observe an insect (a katydid is a form of grasshopper)
is typical of Kikaku's approach to haiku.

We can compare two of his haiku that begin with almost the same first
line to discover the difference between his humor and his empathy.

yūdachi ya	sudden evening shower—
ie wo megurite	running in circles around the house
naku ahiru	quacking ducks

The Art of Haiku

yūdachi ni	sudden evening shower—
hitori soto miru	alone and looking outside
onna kana	a woman

Kikaku was also a talented painter; his works tend to be minimalistic in a manner appropriate to haiku, although the subject matter is sometimes unusual. One of his haiga, for example, shows the skin of a melon that someone has thrown into a stream (Plate 4-1). The poem can be read two ways, depending on whether one translates *kumode* as "spider-legs" or "crisscross."

uri no kawa	melon skin—
mizu mo kumode ni	spider-legs floating
nagarekeri	on the water

melon skin—
the water also flowing
in crisscross directions

Not many poets would take such a plebian image, really just a piece of garbage, and see it resembling a spider as it floats down the stream.

Kikaku has gone even a step further by enclosing the painting with his spidery calligraphy, now moving in its columns (unusually) from left to right, in ways that echo parts of the painting. For example, the darker lines of the calligraphy bring forth the heavier accents of the calligraphy, while the character that begins the second column (from the left) is a cursive-script version of "water" (水), rendered in one bending line that resembles the curving lines of the stream in the painting. In effect, the water flows, the melon skin flows, the poem flows, and the calligraphy flows, showing how haiga can add to the total imagery while unifying its underlying expression.

Hattori Ransetsu

A second pupil who was very close to Bashō was Hattori Ransetsu (1654–1707). He led a much more modest life than Kikaku, but seems to have been equally admired by the master, who included them both in two 1680 anthologies. From a farming family, Ransetsu first served a daimyo in a samurai capacity, and also studied painting from Hanabusa Itchō (1652–1724) and Zen from Saiun Hōjō (1637–1713). At Bashō's death, Ransetsu became a Zen monk.

Ransetsu's haiku have sometimes been noted for what Bashō called their austerity, although there are many lighter poems as well. Above all Ransetsu shows sympathy for all living creatures.



mino hoshite drying my straw raincoat
asa-asa furuu morning after morning I shake out
hotaru kana fireflies

kamo arite the ducks walk
mizu made ayumu all the way to the water—
kōri kana on ice

ganjitsu ya New Year's Day
harete suzume no is clear—sparrows are
monogatari telling stories

kao ni tsuku stuck to my face
meshitsubu hae ni I give this grain of rice
ataekeri to a fly



Ransetsu was observant and empathetic to many aspects of life, as a number of his haiku attest, ranging from a small hint of spring to the "Heavenly River" of the Milky Way.

The Art of Haiku

ume ichirin	one blossom of plum—
ichirin hodo no	and one blossom's worth
atatakasa	of warmth

wakatake wa	the young bamboo
kata hada nugi no	bares one shoulder
kioi kana	dashingly

mayonaka ya	in the depths of night
furi kawaritaru	it has lost and gained a place—
ama no kawa	the Milky Way

meigetsu ya	harvest moon—
kemuri haiyuku	the smoke slithers
mizu no ue	over the water

Three final Ransetsu poems are given below: the first refers to a small home altar, seen in most Japanese dwellings of the time; the second is his most famous haiku; and the third is his death poem, which includes the Zen shout "Totsu!"

tamadana wa	altar shelf
tsuyu to namida mo	dew and tears both
abura kana	oil for the lamps

umazume no	the childless woman
hina kashizuku zo	touches the dolls
aware naru	so tenderly

hitoha chiri	a leaf falls
Totsu! hitoha chiru	Totsu! a leaf falls—
kaze no ue	riding the wind

Followers of Bashō

Mukai Kyorai

A third pupil of Bashō who became a major haiku poet was Mukai Kyorai (1651–1704), the son of a high-ranking Confucian scholar and physician in Nagasaki. A member of the samurai class and an expert in archery, at the age of twenty-three he gave up his position in order to become a poet. This was due in large part to a meeting with Kikaku, after which Kyorai also became a disciple and friend of Bashō. Building a hermitage on the outskirts of Kyoto, he dedicated himself to haiku.

hito aze wa	from one ridge
shibashi naki yamu	they call for a time and stop—
kawazu kana	frogs

go roppon	five or six trees
yorite shidaruru	weighing each other down—
yanagi kana	willows

Other poems by Kyorai give his sense of the relation of humans to nature, and to each other.

ugoku tomo	although hoeing
miede hata utsu	the man in the field
otoko kana	seems motionless

"ō-ō" to	although I call "yes yes"
iedo tataku ya	someone still knocks
yuki no mon	at the snowy gate

The companion (and possibly the wife) of Kyorai known as Kana-jo (n.d.) also wrote several haiku that effectively suggest the season.

The Art of Haiku

yukuharu no	the back view
ushiro sugata ya	of passing spring—
fuji no hana	wisteria

mugi no ho ni	ears of barley
owareru chō ni	chase the agitated
midare kana	butterflies

Kyorai's sister Chine (1660–88) was also an accomplished haiku poet, and wrote of journeying with her brother.

Ise made no	as far as Ise
yoki michi-zure yo	you are welcome companions—
kesa no kari	this morning's geese

Chine's death poem, and the response by her brother Kyorai, are among the most affecting examples of these forms of haiku.

moe yasuku	easily blazing
mata kie yasuki	and easily extinguished—
hotaru kana	the firefly

—CHINE

te no ue ni	in the palm of my hand
kanashiku kiyuru	so sadly extinguished—
hotaru kana	the firefly

—KYORAI

We can compare this with Bashō's poem on Chine's death.

naki hito no	the clothing of the dead
kosode mo ima ya	also now has its
doyōboshi	summer airing
—BASHŌ	

Chigetsu, Sute-jo, and Sono-jo

Although the list that someone made of the "ten outstanding pupils of Bashō" included only men, Kana-jo and Chine were only two of many fine women poets who either studied directly with Bashō or followed his lead.[4] One of the former was Kawai Chigetsu (1632–1706), also known as Chigetsu-jo or Chigetsu-ni (*jo* meaning "woman," and *ni* meaning "nun"). In her youth she seems to have served at court before marrying the owner of a carting business in Ōtsu, outside Kyoto. She was not only Bashō's haiku pupil but also his friend, and he visited her home on his travels. After Chigetsu's husband died (probably in 1686), she asked her younger brother Otokuni (1657–1720, also a student of Bashō) to manage the family business, and she became a nun.

For women in early modern Japan, taking Buddhist orders not only represented a sincere vocation, but also allowed them a role in society where they could travel and have a certain amount of freedom. One of Chigetsu's haiku, however, indicates this lifestyle was not entirely blissful; it was written on the seventh anniversary of her husband's death.

kakashi ni mo	just like scarecrows,
awaresa makeji	how sorrowful—
ama-nakama	a group of nuns

Chigetsu also used the image of a scarecrow for a happier scene.

kirigirisu	a katydid
naku ya kakashi no	chirps from the sleeves
sode no uchi	of a scarecrow

The Art of Haiku

Repeating an image but changing the mood, Chigetsu again uses the word that itself chirps, *ki-ri-gi-ri-su*.

toshi yoreba	when it gets old
koe mo kanashiki	its voice becomes plaintive—
kirigirisu	katydid

Other haiku by Chigetsu express her observations of those admiring the moon, a form of indirect praise well suited to haiku.

yubi sashite	stretching out
nobi suru chigo no	and pointing their fingers—
tsukimi kana	children moon-viewing

meigetsu ni	at the full moon
karasu wa koe wo	crows
nomarekeri	swallow their voices

Perhaps what made Chigetsu unique was her ability to represent attractive moments of nature amid the detritus of the everyday world.

uguisu ni	a warbler—
temoto yasumen	I stop doing what's at hand
nagashimoto	in my sink

matsu haru ya	waiting for spring—
kōri ni majiru	ice mixed together
chiri-akuta	with rubbish

Born into a samurai family near Kyoto, Den Sute-jo (1633–98) became fascinated with renga and haiku as a young woman. Rather than a direct follower of Bashō, she was his slightly elder contemporary, writing most

of her haiku in the 1650s and 1660s. Seven years after her husband's death in 1674, she took Buddhist orders in the Pure Land sect. She then converted to Zen in 1686, becoming a follower of the major Zen master Bankei Yōtaku (1622–93), and the leader of a group of nuns in Himeji.

The first known haiku by Sute-jo came at the age of six when she noticed the pattern made by her wooden clogs.

yuki no asa	morning snow
ni no ji ni no ji no	the characters "two, two" (二 二)
geta no ato	made by my *geta*

Sute-jo's mature haiku show that she had some range as a poet, moving from comparisons between nature and a woman's life to more complex verses. The last of these four verses might be considered Zen in spirit.

mizukagami	with water as a mirror
mite ya mayu kaku	you can paint your eyebrows—
kawayanagi	willow by the river

natsu mata de	not waiting for summer
baika no yuki ya	the plum blossoms have
shiragasane	put on a white dress

kumoji ni mo	does the path of clouds
chikamichi aru ya	also have a shortcut?
natsu no tsuki	summer moon

omou koto	my face showing
naki kao shite mo	nothing—
aki no kure	autumn darkens

Sono-jo (1649–1723) also had an interesting life. She studied haiku with Bashō in 1689, and then with Kikaku the following year; she is reputed to have been an eye doctor, and finally became a nun. Two of her haiku refer to her hair.

suzushisaya the coolness
eri ni todokanu does not reach my neck—
kami no tsuto the chignon

outa ko ni the child on my back
kami naburaruru plays with my hair—
atsusa kana the heat!

Bashō seems to have admired Sono-jo greatly, and wrote the following haiku about her only a few months before his death:

shiragiku no white chrysanthemums—
me ni tatete miru not one speck of dust
chiri mo nashi to be seen

—BASHŌ

After Bashō died, Sono-jo wrote a haiku of mourning.

samusō na when seeing the cold
kasa sae mireba bamboo traveling hat—
namida kana tears

Kyoroku and Jōso

Among the other direct pupils of Bashō, of whom there were many, a few deserve to be singled out. One is Morikawa Kyoroku (also pronounced "Kyoriku," 1656–1715), a late pupil of the master who is reputed to have

given him advice (or lessons) in painting after having himself studied with Kanō Yasunobu (1613–85). Bashō and Kyoroku did several joint haiga; for example, a scroll of sparrows was painted by Kyoroku with five haiku added by Bashō. The birds interact joyfully on the left of the scroll, with Bashō's sparrow poems on the right (Plate 4-2).

nabatake ni	in the mustard fields
hanamigao naru	making flower-viewing faces—
suzume kana	sparrows
hana ni asobu	please don't eat the horsefly
abu na kurai so	as you play in the blossoms—
tomosuzume	friend sparrows
suzumego ya	baby sparrows—
koe nakikawasu	exchanging their chirps
nezumi no su	with a nest of mice
ine suzume	rice-field sparrows
cha no ki batake ya	find sanctuary
nige dokoro	in the tea groves
sekizoro wo	year-end mummers—
suzume no warau	a sight to make
detachi kana	even sparrows laugh

Bashō wrote his poems in modest size and style, not intruding on the pleasure of the sparrows. Each haiku is given a single column, with the signature on the lower left of the poems.

Another collaboration shows Kyoroku painting one of Bashō's most famous poetic subjects (Plate 4-3), with Bashō adding in calligraphy his celebrated haiku, which was discussed in the previous chapter (see pages 85–86).

The Art of Haiku

kare-eda ni	crow perched
karasu no tomarikeri	on a withered branch—
aki no kure	autumn evening

—1680

The powerful image of the crow, facing away from us and huddled over, brings forcefulness to this otherwise melancholy scene. Bashō's calligraphy emphasizes the first word in the final (left) column, "autumn" (秋). This haiga demonstrates once again how a painting can add resonance to a poem and vice versa, whether or not they express different pictorial elements.

Kyoroku's own poems demonstrate his strong visual sense. The first of these haiku was composed in 1692 when Kyoroku was visiting the Bashō hut, and drew praise from the master.

kangiku no	even next to
tonari mo ari ya	the winter chrysanthemums—
ikedaikon	a living radish

shirakumo no	above the white clouds
yue ni koe aru	there are voices—
hibari kana	skylarks

u-no-hana ni	among the hedge-flowers
ashige no uma no	a gray horse—
yoake kana	first touch of dawn

Jōso (1662–1704) resigned his samurai position to become a Zen monk at the Obaku sect temple Kōsei-ji. His haiku are often about living creatures, which he views with a fresh eye.

hi wo uteba	as I strike a light
noki ni naki-au	they start their chorus—
amagaeru	tree-frogs in the eaves

ōkami no	wolves
koe sorou nari	howling in harmony—
yuki no kure	snowy evening

kuyami iu	in the pauses between
hito no togire ya	his condolences—
kirigirisu	a katydid

hototogisu	a cuckoo cries
naku ya kosui no	and the lake waters
sasanigori	slightly cloud over

One of Jōso's haiku is particularly Zen in spirit, while another is much darker in tone.

toritsukanu	by not clinging,
chikara de ukabu	he has the power to float—
kawazu kana	the frog

sabishisa no	the bottom falling out
soko nukete furu	of loneliness—
nizori kana	blowing sleet

Completing the "ten [male] pupils" of Bashō, there were some fine poets including Tachibana Hokushi (1665–1718), a sword sharpener who met the master in Kanazawa; Ochi Etsujin (1656?–1739), with whom Bashō traveled; Sugiyama Sampū (1647–1732), a fish merchant who provided Bashō with a hermitage; Kagami Shikō (1665–1731), a Zen monk at Daichi-ji who

The Art of Haiku

also became a doctor; and Shida Yaha (1662–1740), a merchant from Fukui who moved to Edo.

Here, one haiku by Etsujin can represent these poets, offering a scene that allows for various interpretations.

yuku toshi ya	year's end—
oya ni shiraga wo	I hide my gray hair
kakushikeri	from my parents

Does Etsujin merely feel embarrassed by his aging, or is he worried that seeing his gray hair will make his parents feel even older?

Kaga no Chiyo

Some critics have felt that the spirit of Bashō was gradually lost over time, particularly as clever wordplay and excessive literary references started returning to haiku. However, a number of second-generation masters continued to write excellent verses in the Bashō style. One of these, Kaga no Chiyo (1703–75), is sometimes considered the finest of all female haiku poets.

Also called Chiyo-jo, or Chiyo-ni after she became a nun, Kaga no Chiyo was born near Kanazawa along a major road previously traveled by Bashō.[5] Her family ran a scroll-mounting business, so she was familiar with artists and calligrapher-poets from a young age. Exhibiting an early interest in haiku, she had a number of mentors, including Bashō's pupils Hokushi and Shikō. The latter is generally considered her principal teacher, although they apparently met only once in person, with the rest of their lessons conducted by correspondence.[6]

It is not certain whether Chiyo ever married, despite a well-known haiku attributed to her wedding day.

shibukaru ka	I don't know
shiranedo kaki no	if it will be bitter—
hatsu-chigiri	the first persimmon

In any case, if Chiyo did marry, either her husband died young or they separated, because she lived her life almost entirely in her family home in Matto. There she associated with a number of both male and female poets, and gradually became celebrated as an outstanding talent. In her middle years, however, her parents, her brother, and his wife all died, leaving the scroll-mounting business for Chiyo to manage. During this time she wrote few haiku, but around the age of fifty she adopted a young couple, in part to care for the business.

In 1754, Chiyo became the nun Chiyo-ni, and was once more able to devote more of her time to writing poetry. One of her calligraphy scrolls may have been written near the beginning of Chiyo's second period of creativity (Plate 4-4). It begins with a prose introduction and continues with six haiku, one with a title and a Bashō ending. The name "Okame," mentioned in the fourth poem, refers to a prototype of the good-natured, middle-aged woman.

I was troubled for about three years, but the melody of this morning's spring breeze brought forth a new tune and I felt, indeed, it was the sky of early spring—my heart was encouraged and so I happily took up my brush.

chikara nara	in terms of strength
chō makesasemu	the butterfly yields
kesa no haru	to this morning's spring

Spring Pleasure

uguisu ya	the warbler
uguisu ni naru	becoming a warbler—
mizu no oto	the sound of water

wakakusa ya	young grasses—
mada dochira e no	not yet bent
kata yorazu	in any direction
Okame mono	Okame
miru asa asa ya	every morning views
haru no niwa	her spring garden
kiji nakite	a pheasant sings
yama wa asane	and the mountain's morning sleep
wakare kana	comes to an end
ame no hi mo	even on rainy days
nani omoidete	perhaps remembering something—
naku kaeru	the frog sings[7]

Chiyo's calligraphy is somewhat compressed and gnarly, with a sense of the poet's intensity brought forth by the interplay of darker and lighter forms. The heavier forms are created when the brush has been dipped again in ink; however, this redipping does not always occur at the beginning of a column, which creates asymmetrical variations in the total visual expression.

In order to create a sense of structure, each haiku begins a new tall column, and the poems usually conclude with two more partial columns. This pattern is not totally consistent, as the six haiku have 3–2–3–3–3–4 columns respectively. But although these columns generally coincide with the 5–7–5 syllabic poetic structure, even here there is some variation. For example, the second poem, just after the two-word title, is written in a single column until its final word, *oto* (sound). As a result of these patterns being created but not consistently followed, the calligraphy takes on a feeling of life's own repetition and changes. Chiyo, returned to joy and creativity by the melody of the spring breeze, is composing both haiku and calligraphy in her own personal rhythm.

As well as her personal and flavorful calligraphy, Chiyo was known for her haiga. However, she was most celebrated for her verses: a sampling shows her range of subject and emphasis, with a special closeness to nature and a good ear for sounds. For example, the first haiku investigates a warbler's call, while the second has a middle line entirely using the vowel sound "ah," and the third repeats *kirema* (between).

uguisu ya	the warbler
mata ii-naoshi	practices his song
ii naoshi	and practices again

more izuru	gradually appearing,
yama mata yama ya	mountain after mountain—
hatsu-gasumi	the first mist

wakakusa ya	young grasses—
kirema kirema ni	and between each blade
mizu no iro	the color of water

Two Chiyo haiku seem to contrast with each other.

chōchō ya	as she walks
onago no michi no	butterflies in front
ato ya saki	and behind her

shimizu ni wa	clear waters—
ura mo omote mo	front and back
nakarikeri	don't exist

Other Chiyo haiku emphasize her variety of poetic effects, from the momentary to the unhurried.

yuku mizu ni	over the stream
onoga kage ou	pursuing its own shadow—
tonbo kana	a dragonfly

hirou mono	everything we pick up
mina ugoku nari	moves—
shiohigata	low tide

tsuri-zao no	the line from the fishing rod
ito ni sawaru ya	just touches
natsu no tsuki	the summer moon

hyaku nari ya	hundreds of gourds
tsuru hitosuji no	all coming from the heart
kokoro yori	of a single vine

Like many fine poets, Chiyo was prepared to write when she was away from home.

michi no ki no	for her travel diary
fude ni mo musubu	she also scoops up clear water
shimizu kana	for her brush

Of all Chiyo poems, the following is her best known; in fact it has become one of the most famous of all haiku by any poet, male or female.

asagao ni	the morning glory
tsurube torarete	has claimed the well bucket—
morai mizu	I'll go borrow water

Haiga Masters Yayu and Otsuyū

In addition to Kyoroku and Chine, within the first and second generation of Bashō followers were several poet-artists who were gifted in producing evocative images that extended the focused world of haiku. One of these was Yokoi Yayu (1702–83). Born to a samurai family serving the daimyo of Owari, Yayu continued this tradition until the age of fifty-three, when he retired to enjoy artistic pursuits including Noh drama, music, painting, and calligraphy, as well as haiku. He was exceptionally well read and well traveled, having had the experience of journeying with his daimyo to Edo at least eight times, and meeting the Tokugawa shogun himself. Ultimately, Yayu's most famous work was a collection of often humorous essays, entitled *Uzuragoromo* (Patchwork Robe), which was published after his death.

Since his grandfather had studied haikai under the Teimon-school poet Kitamura Kigin (1624–1705), it is not surprising that Yayu took up haiku early in his life, learning primarily on his own. His poems are noted for their range of expression.

ha wa ha wa mo	"leaves, leaves"
fuyu no kozue wo	cry out the crows
naku karasu	from winter treetops
hiya-hiya to	flowing "hiya-hiya"
ta ni hashirikomu	into the paddies—
shimizu kana	clear waters[8]
yuki-akari	lit by snow
akaruki neya wa	the bedroom is bright—
mata samushi	but cold!

degawari ya	a change of servants—
kawaru hōki no	and a different place
kakedokoro	to hang the broom

Yayu wrote many humorous haiku, yet he always seems to capture the natural moment.

ashimoto no	beans are stolen
mame nusumaruru	from right under his legs—
kakashi kana	the scarecrow

shōben wa	when pulling rice shoots
yoso no ta e shite	he pees
sanae-tori	in the next field

kusame shite	one sneeze
miushinōtaru	and he's lost from view—
hibari kana	the skylark

monomou no	hearing "is anybody there?"
koe ni mono kiru	I put on my clothes—
atsusa kana	the heat!

Yayu wrote several other poems using the same last line.

ido-hori no	the well-digger
ukiyo e detaru	comes out into the floating world—
atsusa kana	the heat!

keisei no	the prostitute sells
ase no mi wo uru	her sweaty body—
atsusa kana	the heat!

Followers of Bashō

And with the opposite final line:

kuragari ni	in the dark
zatō wasurete	he forgets his blindness—
suzumi kana	the cool!

One of Yayu's many evocative haiga depends upon the viewer knowing that dried bonito flakes look very much like flower petals and are called *hana-katsuo* (bonito blossoms), while *nama katsuo* means "raw bonito."

karashite zo	all dried-up
hana no na wa are	this flower's name is
nama katsuo	uncooked *katsuo*

To provide a strong image to accompany the poem, Yayu fills most of the space with a large fish moving down in a diagonal, which is echoed by the lightly written calligraphy of the haiku (Plate 4-5). Most of the gray-toned brushwork is moist and fuzzing, and the only true black is the eye of the fish. For added humor and a sense of movement, Yayu added playful wiggles just before the bonito's tail.

A second master of haiga was Nakagawa Otsuyū (also known as Bakurin, 1675–1739). Born in Ise to a family of lumber merchants, he is said to have become a disciple of Bashō at age fifteen, but studied more fully with Shikō in 1694 when the latter opened a poetry school in Ise. The Shikō-Bakurin tradition was to continue as a "countrified" style for several generations, with naturalistic haiku such as this verse by Otsuyū.

aki fukete	autumn deepens—
ko-no-ha goromo no	dressed in a robe of leaves
kakashi kana	a scarecrow

Otsuyū also had a sharp eye for the unexpected, or more accurately, for presenting an unexpected view of everyday matters.

tsubakuro ya	the swallow
nani wo wasurete	must have forgotten something
chūgaeri	and turns a somersault

yūdachi ya	sudden evening shower—
chie samazama no	people cover their heads according
kaburimono	to their inventiveness

In a more serious and traditional vein, Otsuyū created one of the most fascinating haiga of his generation. It relates back to a tanka by the courtier Onakatomi no Yoshinobu (921–91), which depends upon the Japanese belief that autumn's arrival can be known by the lonely cries of the deer.

Momiji senu	The deer who live
tokiwa no yama ni	without maple leaves
sumu shika wo	on old pine mountain
onore nakite ya	can know that autumn has come
aki wo shiruramu	only by their own cries

In this tanka the scene is clearly spelled out: without maple leaves turning red, yellow, and orange, the deer create their own sense of autumn. Otsuyū's haiku, on the other hand, goes further while suggesting more than it defines.

shika no ne no	the mountain
todokanu yama wa	no deer's cry has reached
mada aoshi	is still green

Otsuyū's implication, that the cries of deer are not just a response to the experience of autumn colors but actually its cause, is certainly a poetic fancy. Yet this poem serves as an expression of empathy for feelings of loneliness and loss as the season changes, which are reinforced and extended by his haiga (Plate 4-6).

Otsuyū has painted a deer and a simplified shape that can be read as a mountain, but the manner in which he depicts them is significant. First, the major forms are created with the same kind of broad, wet, and tonally varied brushwork. Second, they seem to merge into each other; the body of the deer could easily be understood as part of the mountain but for the darker brush-strokes that define its antlers and legs. Third, these lines relate both to the somewhat more gossamer calligraphy on their left and to the strongly inked signature in the lower left. Thus the mountains become the deer, the deer becomes the poem, and the deer as well as the poem become Otsuyū. To emphasize the interconnection, the poet-artist has composed the entire work into a diagonally structured totality that can also be seen as leading the eye in a pendulum-shaped movement. By this intense interaction of verbal and visual imagery, Otsuyū brings us a moment in which we may sense a unity of poetry and art, which provides the delight of a fine haiga.

Many more followers of Bashō composed fine verses, and his influence has never been lost in Japanese haiku. As we shall see, however, new directions also developed as the form became ever more popular, particularly in the towns and cities, where literacy was growing exponentially.

5

Senryu and Zen

URING THE DEVELOPMENT of mainstream haiku in Japan's early
modern period, there were two related cultural elements of note.
The first was a form of humorous verse called senryu that kept the
5–7–5 syllable count but tended to eliminate most references to nature, and
the second was the changing world of Zen Buddhism, which influenced
haiku and occasionally intersected with it. This chapter will examine each
in turn.

Senryu

When Bashō redefined the haiku poem by adding depth, richness, and a
profound connection with nature, he also left a vacuum for poems that
were clever and often satiric. Into this vacuum came senryu, which usually
stressed the foibles of human nature. Reaching a peak of inventiveness and
popularity in the middle of the eighteenth century, senryu were evanescent,
often disappearing as soon as they were composed. Fortunately many of
them were collected in anthologies, without crediting the poets themselves,
and it is from these anthologies that we still have a sense of what the verses
expressed about Japanese society in the early modern period.[1]

The first senryu were often selected from longer *haikai no renga,* using
both 5–7–5 and 7–7 segments, although eventually the more interesting
asymmetrical 5–7–5 form predominated. One of the first anthologies was the
Mutomagawa (Mutama River) of 1750, which proved so popular that seven
more volumes were published in the next three years, and eventually a total

of eighteen were printed by 1776. The editor of these volumes until his death was a poet and judge named Kei Kiitsu (1694–1761), and among the 7–7 poems he included are several that show some of the range of senryu.

The best of these poems exhibit the kind of irony that is typical of this poetic form, with occasionally a bit of wisdom as well—no one is exempt from scrutiny, including mothers, sons, daughters, poets, courtesans and their customers, courtiers, monks, and nuns.

mekura musuko no	the blind boy long drinks
chichi wo nagaku nomi	his mother's milk
haha mo aware to	even her mother pities her—
omou hodo hore	so deep in love
shini sokonōte	not dying yet
jisei shi-naosu	he revises his death poem
futta tokoro ga	turning him down
keisei no zen	is a courtesan's Zen
ōmiyabito mo	even the courtier makes a face
nomi wo taru kao	when catching a flea
daisōjō no	the great monk's fart
he ni oboe nashi	totally forgotten
yudono ni sukoshi	in the bath the nun
ama no onnake	becomes a little bit female

Of the 5–7–5 verses, the following are from the initial volume, which was published in 1750. They represent the general style and subject matter of the anthology, including the first poem that is purportedly simply about

nature but carries a human message, and the second that refers to the large radish called daikon.

suzume-go no	young sparrows
kawaigararete	being fussed over
nigete yuki	fly away
shiba no to wo	knocking on the brushwood gate
daikon de tataku	with a daikon—
shimo no hana	flowers of frost

Three poems from the second volume (published a year later) are about beauty and love, and as might be expected they each have an ironic viewpoint. Rather than being especially Japanese in spirit, these seem universal.

sararetomo	divorced
sararetomo mada	and again divorced—
utsukushiki	but beautiful
utsukushii	to the beautiful face
kao de hanashi ga	his talking
nagaku nari	goes on and on
deru koi ni	love leaving
uchi e kuru koi	passes
surechigai	love coming in

The second major editor of senryu anthologies was Karai Senryu (1718–90), from whom the form gained its name. His major editions include *Yanagidaru* (Willow Cask), which eventually totaled 167 volumes from 1765 to 1837, and several other series that took poems from the *Yanagidaru*

and included additions, such as the *Yanagidaru shui* (Premier Willow Cask, ten volumes beginning in 1796).

Although Senryu is said to have received twenty-five thousand submissions in 1779,[2] his anthologies often included verses from previous compilations such as the *Mutomagawa,* so it is difficult to know when any particular senryu was first written. Furthermore, at this time senryu were almost always anonymous, so perhaps the most useful way to organize them is by subject matter.

Parody and Professions

In senryu, no one was too lofty for parody, no matter how admired and revered. Bashō himself was occasionally the subject, as in this rather heartless takeoff on his most famous haiku.

hashi no ban	the bridge-keeper calls
tashika ni nageta	"must be another jumper"—
mizu no oto	the sound of water

Even the master's death poem was made the subject of parody. In other countries, this might be considered too unkind, but in Japan it was accepted as par for the course. Here is Bashō's poem:

tabi ni yande	ill from journeying
yume wa kareno wo	but my dreams circle
kake-meguru	over withered fields

—Bashō

And here is the anonymous senryu:

zashiki-rō	stuck at home
yume ni kuruwa wo	my dreams circle
kake-meguri	to the gay quarters

—Anonymous

The Art of Haiku

Although not parody in the same sense, senryu about the various professions had much of the same kind of humor. For example, doctors were fair game for satire, as were their patients.

itai koto	"this won't hurt"
nai to geka-dono	says the surgeon
hari wo dashi	taking out his needle

iigoke ga	"she'll become
dekiru to hanasu	a fine widow"—
isha nakama	doctors' gossip

mō shite mo	I'm feeling fine now—
ii no sa isha ga	what do
nani shitte	doctors know?

Other professions treated in senryu include farmers, timber merchants, and carpenters, with the former treated the most poetically.

hatake kara	home from the fields
senzoku hodo no	enough sunshine remains
hi wo amashi	to wash his feet

zaimokuya	the timber-seller
tsuite aruite	follows him
sora wo mise	pointing upward

te ni ataru	whatever's at hand
mono wo daiku no	becomes the carpenter's
makura shite	pillow

Money

A favorite topic in senryu is money, of which there is never enough, or occasionally too much. Two such poems begin with the same words, but one is more poetic with a typical haiku final line, while the other is more specific.

shindai no	a hole in finances
ana kara shireru	can be known by
aki no koe	autumn voices

shindai no	a hole in finances
ana wa yane kara	starts appearing
miete kuru	in the roof

Three more senryu are even more ironic.

kari ni kita	coming to borrow money
toki wa shōjiki-sō	he looks
na kao	very honest

kasanu kuse	rather than money
iken gamashii	he just offers
koto wo ii	advice

tsukaubeki	owned by the money
kane ni tsukaware	he should have owned
oiru nari	he got old

Love and Romance

One might expect that affairs of the heart are well represented in senryu, and indeed they are, with several different points of view represented. Many aspects of love are described, often with humor's propensity to see things as

they are, rather than as we might wish. In the following senryu, first there is courting and then success—one could make an entire story from this series of separate poems.

kudokarete	being wooed
eki mo nai mono	she picks up something
motte miru	she doesn't need

ura no yo wa	the second night
shi-go sun chikaku	she sits four or five inches
kite suwari	closer

ashioto de	hearing footsteps
futatsu ni wareru	it divides into two
kagebōshi	the shadow

ii-nikui	hard-to-say things
koto no ii-yoi	become easy to say
kaya no uchi	under the mosquito net

Of course, there were many senryu that stressed other aspects of male-female interactions that were anything but romantic. In the first poem below, we hear a complaint but may wonder if it is honest, while the second and third verses represent the aftermath of a love that has faded.

tsukamaemo	running away when
senu noni nigeru	I wasn't going to touch her—
iyarashisa	how annoying!

horegusuri	the love potion
mukashi kiita wo	that once succeeded
kuyashigari	he now regrets

Senryu and Zen

saiken wa	only when far from home
yoppodo saki e	does he buy
yatte kai	the list of courtesans

Beauty and Hips

In senryu, as often in life, beauty is not always positive. There can be a sharpness that is not always attractive, while the tears of a (young?) prostitute are just grist for the mill of her panderer. There is both irony and sadness in the following two poems.

shō futari	two concubines
hamono no yō ni	as beautiful
utsukushiki	as knives

nakigao ga	even when crying
ano kurai da to	she looks noble
zegen ii	says the pimp

With the somewhat cynical attitude that underlies many senryu, it seems that a woman's hips were often more effective in the world of romance than a beautiful face, sometimes too much so.

shimete yaru	tying her sash
oido wo hitotsu	she pats her hips once
ton to home	in praise

koshi obi wo	when the sash
shimeru to koshi ga	is tied
ikite kuru	her hips come to life

kuchi kikanu	onto his silent lap
hiza e kuchi kiku	she lowers her
hiza wo nose	eloquent hips

machigai de	the hips
tataita shiri ga	he patted by mistake
fūjite ki	send him a letter

Before leaving the world of romance, one senryu can be added that has a more romantic, and possibly plaintive, tone.

sagi de sae	even herons
kure mutsu sugi wa	after six in the evening
futatsu tobi	fly two by two

Marriage

In early modern Japan, women had few rights; they were expected to stay in the family home until marriage, and tend to their husbands and children after that. Even *kanai,* one of the words for "wife," literally means "within the house." Yet what society tried to establish was not always what actually happened, and depending on personality and character, roles could be reversed. Behind the scenes, it was women who often held the interpersonal power, sometimes for the good of the husband, even if he couldn't (or shouldn't) admit it.

hitokoto mo	without a single word
iwade naigi no	my wife
kachi ni nari	triumphs

nyōbō wo	after he married
motte ninsō-zura	he began to look
ni nari	human

nyōbō wo	praising his wife
taisetsu ni suru	too much—
migurushisa	unseemly

Naturally, there was another side to the story. One of the most frustrating things for many a wife was her husband's ability to spend as much time away from home as he pleased, especially when he was enjoying nature (or a drinking party with the excuse of viewing nature) without her.

nyōbō no	painful for a wife
ku wa hana ga saki	blooming cherry-blossoms
tsuki ga sashi	and the shining moon

tsuki ochi	moon setting
karasu naite nyōbō	crows calling
hara wo tate	wife seething

Entertainment and Umbrellas

Senryu depict various aspects of the entertainment world, including different forms of theater as they became more and more important in early modern Japanese society. There were the stately Noh drama from the past, the exquisite puppet plays of Bunraku, and most notably the newly popular Kabuki theater. Senryu went about deflating the pretentious and gently mocking the earnest, usually without the sense of celebration that contemporary wood-block prints of similar subjects tended to provide. In addition, as literacy grew quickly among the populace, wood-block books became part of everyday life, including novels and poetry compilations of all kinds.

gakuya de wa	backstage
Yoritomo-kō no	Lord Yoritomo
heya wa nashi	has no dressing room

The Art of Haiku

yaku-busoku	everyone unhappy
darake shiroto no	with their roles—
shibai jami	amateur theater

kōshaku no	in the story
teki wa ashita e	the enemy escapes
nige-nobite	into tomorrow

While entertainment was a frequent subject of senryu, another subject that turns up more than one might expect is the umbrella. Colorful, waxed-paper Japanese umbrellas were later to be highly admired in the West, but to senryu poets they provided the opportunity to make interesting juxtapositions. The first two of these verses show how umbrellas could strengthen or reveal an emotion, the third implies a romance, while the fourth has a striking visual sense of an artisan gradually enclosing himself in his work.

karakasa de	when I go out
deru hi wa kowai	with my umbrella
mono ga nashi	nothing scares me

hara tatte	going out angry—
deru karakasa wa	the umbrella opens
hirakisugi	too far

ototoi no	the shower from
shigure wo modosu	the day before yesterday—
kasa nihon	returned by two umbrellas

shimai ni wa	his face
kao hari nakusu	finally disappears—
karakasa-ya	the umbrella maker

Nature, Animals, and Religion

Although one of the characteristics of senryu is the focus upon humanity, there are also examples that center on nature. Some of these senryu are indistinguishable from haiku; they remind us that the difference between these poetic forms is not absolute, but rather a sliding scale where a poem may be either haiku or senryu, or both, to any degree.

akatsuki no	listening to
koe wo kiki-suru	the voices of dawn—
mine no matsu	mountain pines
kumo wo haki	breathing out clouds,
kumo wo suikomu	breathing in clouds—
mine no matsu	pine trees on the peak
yuki ni neta	sleeping in the snow
take wo asahi ga	the bamboo is shaken awake
yuriokoshi	by the morning sun
shini-yō wo	chrysanthemums—
sakura ni narae	learn from cherry-blossoms
kiku no hana	how to die

Similarly, with animals, senryu are at times very close to haiku, but at other times the sense of irony is quite strong. Moving from mainly haiku to fully senryu are the following three verses:

yoru mireba	when seen at night
me bakari aruku	only his eyes are walking—
karasu-neko	black cat

mekura uma	the blind horse
mino no sawareba	touched by the straw coat
kuchi wo ake	opens his mouth

ureshisa ya	so happy
ki ni tsukiataru	the freed bird
hanashidori	collides with a tree

The next three verses similarly move in the same direction toward pure irony. Nature in Japan is very close to religion, so senryu on this topic sometimes combine the two, while at other times they simply note hypocrisy.

ki no tsukanu	singing so well
tera ni yoku naku	in the neglected temple—
kirigirisu	the katydid

furudera ya	old temple—
ayumeba ugoku	when I walk by
hotoke tachi	the buddhas move

Hokekyō no	chanting the *Lotus Sutra*
kuchibiru bakari	only his lips
isogashiki	are busy

Human Foolishness and Human Nature

A very high percentage of senryu are about human foolishness. Some are simple observations, and may lead us to realize that we are no different from the people being mocked. We can also note that the next poem has 3–9–5 syllables; the "rules" are certainly not "laws."

ki ni wa	saying not to worry
kakerarena to kakeru	he says something
koto wo ii	worrisome

Three more senryu also focus upon the difference between what we think of ourselves and what we really are like.

fuyu no tsuki	the winter moon—
hometarikeri de	he praises it
batari tate	and shuts the window

mono omou	as I think things over
mukō wo tōru	across the way
katatsumuri	passes a snail

ato no kusame	looking foolish
wo matte iru	while awaiting
baka na tsura	another sneeze

On the other hand, senryu can also explore those moments when we are more in tune with ourselves, sometimes in ways that reveal the manner in which we live our lives.

gyōzui no	bathing
to wo seki de	he shuts the door
osaeru	with a cough

fukikeseba	blowing out the lamp—
waga mi ni modoru	my shadow
kagebōshi	returns to my body

In two verses about women, one may find unexpected triumph and loss, the tables may be turned, and at the end one may find a wry smile.

yome no koto	she talks about
shūtome miburi	her daughter-in-law
shite hanashi	with gestures

nido karita	she inherits
kosode wo morau	a robe she had
katamiwake	twice borrowed

As we can see, senryu tend to find humor in turning things around and taking a different point of view—husbands may be weaker than their wives, animals may not act as we expect, and religiosity may be a sham—but this form of verse is not just negative. For example, children are generally treated in a sympathetic manner. If there are problems, they may not be the child's fault, a parent may gain a wider acquaintanceship, and, poignantly, a toy may become unexpectedly useful.

narōta wo	what he had learned
ato no shishō ni	was only a nuisance
jamagarare	for his next teacher

ko wo motte	having a child
kinjo no inu no	and learning the names
na wo oboe	of neighborhood dogs

mayoigo no	searching for
onoga taiko de	the lost child
tazunerare	with his own drum

In conclusion, senryu formed an important part of Japanese culture. Haiku alone could not express every kind of human experience, every shade of human feeling, or every aspect of human thought. These verses, whether sympathetic or (more often) satiric, include many aspects of human nature, sometimes the simple surprise of noticing something for the first time. Above all, senryu make us more aware of the life that we lead, and finally, how even in violent actions there may be humor.

miken kizu	when the wound
heiyu suru to	on his face was healed
kubi ga ochi	he was beheaded

Zen and Haiku

It may seem a far leap from senryu to Zen, from the shallower waters of irony and satire to the depths of a profound spiritual tradition. Yet senryu and Zen haiku have several features in common, such as seldom including a seasonal word and often omitting references to nature. One major difference, however, is that senryu rarely inspired paintings to accompany the poems, while Zen haiku were often used as inscriptions on images. Another even more important difference is that senryu look at life from the outside, whereas Zen haiku focus on the inside.

The relation of Zen to haiku is often debated, especially since R. H. Blyth gave it such prominence in his many books on haiku and senryu.[3] On one hand, Bashō himself studied Zen seriously, as did several of his followers, and one may interpret Bashō's poems in a Zen context, as did Robert Aitken.[4] On the other hand, most haiku poets did not study Zen; many of them followed other Buddhist sects, Taoism, Shintoism, or Confucianism, and some professed no religion at all.

Furthermore, when Zen masters themselves created haiga, it was often to reach a wider audience with their teachings; until the modern period

they generally did not write haiku as an avocation. So is the Zen influence in this form of poetry exaggerated? Or is the issue more complex?

It may help to consider that the word "Zen" has come to have two meanings. First it is usually a noun, referring to the specific sect of Buddhism that stresses meditation and finding one's inner Buddha-nature. Its second usage is more amorphous; it is usually an adjective, and tends to mean "natural," "simple," "peaceful," "focused," and "unworldly." Both meanings relate to haiku, the first in some specific cases and the second more broadly.

In pursuing this question, first we can examine some haiku by Bashō in order to investigate the Zen influence or Zen spirit in his poems. Next we can present some haiga by Zen masters, and finally we can discuss more broadly the influence of Zen in Japanese culture, and therefore also in haiku.

Bashō and Zen

Using his haiku as guideposts, there are some factors that ally Bashō and Zen. On his travels, he shaved his head and wore a monk's robe, but he considered himself somewhere between a monastic and a layperson; he jestingly called himself a bat—between a bird and a mouse.[5] A number of his poems mention Buddhism, but not always specifically Zen. For example, in one haiku he mentions the *nembutsu,* which is the chant to Amida Buddha of the Pure Land sect.

yo ni sakaru	to blossoming cherries
hana ni mo nembutsu	we also recite
mōshi keri	the *nembutsu*

It is significant that the poet here combines his love of nature with the religious mantra.

Other haiku of Bashō mention Buddhism without being specific as to the sect.[6] In general, he seems to have a broad conception of Buddhism that could be understood by any of his readers.

kanbutsu no	Buddha's birthday—
hi ni umare-au	a dappled fawn
kanoko kana	is born

There are some Bashō haiku, however, that suggest Zen more strongly, for example this reference to the "unblown flute."

Sumadera ya	Suma Temple—
fukanu fue kiku	hearing the unblown flute
ko shita yami	in the shade of the trees[7]

Perhaps the most interesting Zen influence in Bashō's poetry comes when there is no overt religious reference, but the haiku resonates with Zen spirit. Bashō himself commented that haiku "is simply what is happening here and now,"[8] and according to his pupil Dohō, he advised, "Attain a high stage of enlightenment and return to the world of common men."[9] In Bashō's haiku, the everyday, the "just this" of Zen, is convincingly presented through his ability to take the ordinary world and perceive unexpected images and interactions.

ika-uri no	the squid-seller's voice
koe magirawashi	mixed with that of
hototogisu	the cuckoo

takotsubo ya	octopus pot—
hakanaki yume wo	transient dreams
natsu no tsuki	in summer moonlight

fuyugare ya	withered in winter—
yo wa hito iro ni	in a single-color world
kaze no oto	the sound of wind

The Art of Haiku

niwa hakite	sweeping the garden
yuki wo wasururu	forgetting the snow—
habaki kana	the broom

Finally, we can consider a haiku by Bashō that adds a touch of humor, often a feature of Zen, to keep the poet and his readers from feeling too self-important.

inazuma ni	how honorable the person
satoranu hito no	who doesn't feel enlightened
tōtosa yo	when seeing lightning

Haiga by Hakuin and Other Zen Masters

As mentioned above, Zen masters did not tend to write haiku very frequently until the modern era, but some monks added haiku inscriptions to their paintings. The pioneer in this field, as in many others, was Hakuin Ekaku (1685–1768), who has been recognized as the most important Zen master of the past five hundred years. It was Hakuin who invented the koan "What is the sound of one hand?" (the Japanese does not include a word for "clapping"). He also taught many monk and lay followers, wrote a number of books, gave frequent public lectures, and created several thousand Zen paintings (*zenga*) and works of calligraphy. In the process Hakuin not only painted traditional Zen subjects, such as the First Patriarch Daruma, but invented so many new themes (including everyday activities, images from folklore, birds, animals, and insects) that he created a new visual language for Zen.[10]

Although Hakuin wrote Chinese poems as well as Japanese tanka, he also composed haiku that he inscribed on some of his paintings, often with more Buddhist meanings than they first suggest. One humorous haiga by Hakuin shows Hotei, the happy-go-lucky wandering monk and god of good fortune, flying through the air as a kite, with its string held by five

small figures (Plate 5-1). Hakuin often painted Hotei in various guises, and this scroll shows one of the unique contexts that he invented for the black-robed laughing Buddha. In spidery calligraphy, Hakuin added a haiku that suggests the English phrase, "It's a dog's life."

unu ga mama ni	you can't just do
yaranu ga ika no	anything you want—
inochi kana	it's a squid's life

The strong diagonals of the painting and poem give the haiga a sense of movement, but is Hotei truly free, as he seems to break forth from the kite, or is he still tied by the string to this world? As an enlightened monk, Hotei should be liberated, but still, "it's a squid's life."

Some of Hakuin's painting designs were published during his own lifetime in a small wood-block book, another way in which he could reach out to a broader public.[11] One of these designs is a portrait of Bashō with his "old pond" poem and Hakuin's laudatory inscription in Chinese: "A linked-verse master and haikai expert, he heard a frog jump into the water and dropped off mind and body."

Another haiga by Hakuin, *Monkey and Cuckoo,* represents his most famous teaching. The work is painted in gray ink except for black accents depicting the monkey's face and feet, plus darker gray for the cuckoo. The image might seem to symbolize the "hear no evil" theme, but Hakuin turns this idea upside down (Plate 5-2). Here the monkey refuses to listen to the song of a cuckoo flying above him, but the inscription says:

kikazu to mo	even when not listening,
katate wageyo	lift up one hand—
hototogisu	the cuckoo!

The Art of Haiku

The sound of the cuckoo has long been celebrated in Japan, in part because it is one of the rare birds that sings as it flies. But what of the monkey? Instead of simply not hearing evil, this little creature is cutting himself off from the world, avoiding any chance for an enlightening moment. As Hakuin suggests, it's much better to hear the sound of one hand.

Hakuin's Followers

Hakuin's direct pupils carried his teachings to many of the most important temples in Japan, and over time it was the Hakuin tradition that reestablished Rinzai Zen as a powerful force in Japanese Buddhism. His pupils and followers also continued his ink-painting tradition, including haiga, although they did not often make major new steps beyond what Hakuin had created. His pupil Reigen Etō (1721–85), for example, often utilized haiga themes by Hakuin, including the unusual subject of a gun (Plate 5-3). Here the poem depends on the understanding that guns were imported through the island of Tanegashima.

pon to iu	the sound of a gun
oto wa jigoku no	is the Tanegashima entrance
Tanegashima	to hell

Reigen painted the gun horizontally in gray ink tones that include a drybrush stroke on the left. Within the divided composition, the gun looks as though it had been consigned to the lowest reaches of the format, far from the vertically arranged haiku calligraphy above it. Since in most *zenga* the interrelationship of the painting and the poem is significant, this use of empty space between words and image is a deliberate element in the visual experience created by Reigen.

Another direct pupil of Hakuin, Suiō Genro (1717–89), portrayed an ax in a haiga where the relationship of text and image is quite different (Plate 5-4). Although there is a good deal of space between the poem and the ax blade, the handle of the ax completes the diagonal downward flow of the

calligraphy, moving the viewer's eye to the serrated blade. Suiō adds a sense of life to the entire work through the varied ink tones for the handle, the blade, and the calligraphy—nothing more is needed.

There are several possible interpretations for the haiku, showing just how multivarious Zen haiga can become—*yoki* can mean both goodness and hand ax, and *wariki* can be both evil (*warui*) and split firewood.[12]

waga yoki ni	this ax of mine
hito no wariki wa	chops away people's
nakimono zo	wickedness

The early nineteenth century Zen master Sengai Gibon (1750–1837) was second only to Hakuin in inventing new painting subjects, and his charm and humor are unique. At one point he created delightful responses to Bashō's celebrated poem, inscribing his scrolls of a frog and a banana plant (*bashō*) with senryu-like haiku:

furu ike ya	old pond—
nani yarapon to	something has PLOP!
tobikonda	jumped in

furu ike ya	old pond—
Bashō tobikomu	Bashō jumps in
mizu no oto	the sound of water

ike naraba	if there were a pond
tobite Bashō ni	I'd jump in
kikasetai	for Bashō to hear!

The well-known Zen scholar D. T. Suzuki commented that these verses "are not to be understood as mere parodies; they are in truth comments from [Sengai's] Zen viewpoint."[13] Suzuki also wrote about the original

haiku that "Bashō's mind penetrated into the secrets of creation and captured the whole universe from the beginningless beginning to the endless end."[14] Is Sengai being disrespectful? Without trying to explain away his humor (never a worthy task), we can note that he himself takes an increasingly active role in the poems.

A contemporary of Sengai was the hermit monk-poet Daigu (or Taigu) Ryōkan (1758–1831). While Sengai lived in the warm southern island of Kyushu, Ryōkan spent most of his life in the chilly northwest of Japan. Instead of a temple, he preferred living in a small hut in the mountains, from which he could go out to wander, beg, or play with children. Most of his poems are either tanka or written in Chinese, but he also wrote haiku, including the following:

taku hodo wa	enough for a fire—
kaze ga mote kuru	the wind has blown me
ochiba kana	maple leaves

Ryōkan became so beloved in his Echigo District that poems such as this were carved into stone stelae, reproduced exactly from his highly admired calligraphy. This meant that ordinary people could not only enjoy the poems, but also make rubbings. Here the haiku was composed in three descending columns using a form of script (*man'yōgana*) in which a Chinese character is used for each Japanese sound, with Ryōkan's signature in the lower left (Plate 5-5). The tonal variations in the dark background of the rubbing add an extra sense of life to the gentle but confident cursive-script calligraphy.

Other haiku by Ryōkan include one written when his little hut on the mountain was robbed.

nusubito ni	left behind
torinokosareshi	by the thief—
mado no tsuki	the moon at my window

Ryōkan could also express in haiku both his understanding of the connections between nature and humanity, and his acceptance of life as always the same, and always different.



nabe migaku
oto ni magiruru
amagaeru

blending with the sounds
of scouring the cooking pot—
tree-frogs





taorureba
taoruru mama no
niwa no kusa

when they fall
and just as they fall—
garden grasses



Conclusion

There is yet one more issue on the relationship of Zen and haiku, and that is the broader question of Zen and Japanese culture. During Japan's medieval period, which ended around 1600, Zen became the dominant cultural force. Zen monks served as advisers to the government, were in charge of much of the education, created ink paintings that were considered appropriate for palaces and fine homes as well as temples, and even led trading missions to China. During this period, Zen strongly influenced many Japanese arts including everything from garden design to the tea ceremony, and ideals such as *wabi* (rustic simplicity), *sabi* (withered elegance), and *yūgen* (mysterious beauty) had an impact on many aspects of Japanese life.

The Tokugawa government moved away from strong sponsorship of Zen during the seventeenth century, but it was still from this medieval context that haiku grew to be a major form of literature. This meant that even poets who had no direct connection to Zen were nevertheless influenced by it. To see how far this influence extended, we can compare Zen aesthetics to those of haiku. Both emphasize seeing the world as it is, right here and right now, rather than the past, the future, or the wished-for. Both find beauty and meaning in the ordinary, rather than the special, the ornate, or the elaborate. Both are experiential rather than theoretical or intellectual.

Both go beyond the ego to a state of selflessness. Both feature their own kind of humor, albeit more paradoxical in Zen and more subtle and gentle in haiku. Both shy away from telling in favor of discovering. Finally, both favor simplicity and terse expression, as exemplified in the Zen phrase: "Nothing missing, nothing in excess."

The fact that these parallels exist does not, of course, prove a direct transmission or even influence. But considering the cultural fabric in which Bashō, the avatar of haiku, grew up, and his own studies of Zen—as well as the significant points they have in common—at least a certain amount of influence from Zen can be inferred in haiku. When we add the haiku and haiga created by Zen masters, the connection can be established even more fully. This is not to say that all haiku are Zen, but rather that haiku came of age in a Zen-influenced context, and the two cannot be completely separated.

6

Buson

IN BOTH EAST ASIA and the Western world, a number of painters have written poetry, and a smaller number of poets have painted, but it is exceedingly rare to have one person become a truly major figure in both arts. Yet such is the case with Yosa Buson (1716–84), who is regarded as one of the greatest literati and haiga painters in Japanese history, and is considered second only to Bashō as a haiku master.

Early Life and Poetry

Born in a village outside Osaka in the last month of 1716 (which becomes 1717 in the Western calendar), Buson seems to have lost both parents at a young age.[1] He moved to Edo in 1736 or 1737, where he is said to have squandered his inheritance and perhaps trained briefly as an actor.[2] Broadening his education, he attended lectures by the Confucian scholar and Chinese-style poet Hattori Nankaku (1683–1759), as well as studying haiku as a live-in pupil of Hayano Hajin (also known as Sōa, 1677–1742), who had been a pupil of Bashō's followers Kikaku and Ransetsu. Significantly, Hajin, also known as the Master of Yahantei (midnight pavilion), told Buson not to follow any teacher too closely but to change his style by time and occasion, setting it apart from the past and the future.[3]

Buson also seems to have been influenced by Sakaki Hyakusen (1698–1753), a haiku poet who had studied with Otsuyū, and who also painted in the Chinese-derived literati style. This combination of Chinese and Japanese studies was very important to Buson, who saw no barrier between the

two despite their differences; he later recommended the study of Chinese poetry to his own followers.[4] Again, the most important point was to develop one's own style; Buson commented that Hyakusen had studied with Otsuyū but did not try to imitate him, while he himself followed the Kikaku tradition without trying to copy Kikaku.[5]

Like other haiku masters, Buson wrote other forms of poetry such as linked verse and in his case a few longer poems, but his great success came through haiku. Only a few of Buson's earliest efforts in this form remain, including this poem for a New Year's album.[6]

shirami toru	the beggar's wife
kojiki no tsuma ya	plucking off his lice—
ume ga moto	under the plum tree

—1739

What is the connection between the two parts of this poem? Solely the contrast between the beauty of the plum blossoms and the unattractive lice? Or is there some sense of familial affection and the new possibilities of springtime?

The following year, Buson went to Shimōsa and wrote a haiku with the headnote: "Waiting for the springtime in the foothills of Mount Tsukuba." This time the cutting word *ya* (indicating a pause) appears after the first line rather than after the second, giving a different rhythm to the poem.

yuku toshi ya	the year is ending—
akuta nagaruru	rubbish floats down
Sakuragawa	Cherry-Blossom River[7]

—1740

After Hayano Hajin died in 1742, Buson spent the next decade sojourning and wandering north of Edo in the spirit of Bashō, and in fact he re-

The Art of Haiku

traced Bashō's famous northern journey of 1689 during this time. Not too surprisingly, one of Buson's extant haiku of this period borrows the last line of a haiku from the *Oku no hosomichi*.

aki suzushi	autumn cool—
tegoto ni muke ya	hands busy peeling
uri nasubi	melons and eggplants[8]
—BASHŌ, 1689[9]	

mizuoke ni	in the bucket
unazuki-au ya	bowing to each other—
uri nasubi	melons and eggplants
—BUSON, BEFORE 1748	

Another Buson haiku from this period has an even more complex pedigree. Saigyō had written a tanka about a willow tree at Ashino on his northeastern journey:

Michinobe ni	Along the roadside
shimizu nagaruru	a clear stream flows
yanagi kage	in the shade of a willow—
shibashi to te koso	I paused for a short rest
tachidomaritsure	and I am still here[10]
—SAIGYŌ	

Visiting the same scene in 1689, Bashō wrote an ensuing haiku:

ta ichimai	an entire field planted
uete tachisaru	before I would leave
yanagi kana	the willow
—BASHŌ	

Buson was also aware that the great Chinese poet Su Shih (1036–1101) had famously visited the Red Cliff twice, the second time seeing the water level low and rocks sticking out. Buson then responded with his own haiku:

yanagi chiri willow bare,
shimizu kare ishi stream dried up
tokorodokoro rocks here and there

—BEFORE 1752

Why so pessimistic? Perhaps he simply recorded what he saw, but there is certainly the implication that for Buson, the great poetic ages of Saigyō and Bashō were gone.

While working seriously on haiku at this point in his life, Buson seems to have supported himself at least partly through painting, although he was by no means the master artist he would later become. In any event, he moved to Kyoto in 1751, where he first lived in Zen monasteries, shaving his head and wearing black robes.

In 1754, Buson moved again, this time to the temple Kenshō-ji in Tango Province (Yosa District), near where his mother had been born. He seems to have devoted much of his efforts during this period to painting, especially literati-style landscapes but also figures and bird-and-flower subjects. As late as 1757, he regarded himself as following the official Kanō school of painting, but was already moving toward the literati style. He compared himself with Hyakusen, writing in a haibun that "we have ventured into virgin territory in art, not being afraid of falling into a stream that might be hidden there."[11]

Buson returned to Kyoto in late 1757, and other than a few subsequent journeys, Kyoto was his home for the rest of his life. A year after his return to the city, he officially changed his family name from "Taniguchi" to "Yosa." Buson was earning an income both from teaching poetry and from his paintings, but still found ample time for his own haiku, which began to flow in ever-greater abundance over the next few decades. He formed

his first haiku group in Kyoto in 1766, but was listed in the *Heian jimbut-sushi* (Who's Who in Kyoto) in 1768 as a painter. Finally becoming settled, around the age of 45 or 46 he married a woman named Tomo (d. 1814) and they had one child, a daughter called Kuno.

Buson's haiku during this time had an interesting range of themes, sometimes traditional but often with a new and inventive touch.

sararetaru	although divorced
mi wo fungonde	she goes into his field
taue kana	to help plant rice

—1758

akikaze no	the autumn wind
ugokashite yuku	stirs a scarecrow
kakashi kana	and moves on

—1760

sarudono no	visiting Mr. Monkey
yo samutoi yuku	on a cold night—
usagi kana	a rabbit

—BEFORE 1761

haru no umi	spring ocean—
hinemosu notari	all day rising and falling
notari kana	rising and falling

—1762

kaminari ni	by the small house
koya wa yakurete	struck by lightning—
uri no hana	melon flowers

—1766

waga sono no	picking my own
makuwa mo nusumu	garden's melon
kokoro kana	I feel like a thief

—1766

The *notari notari* of the fourth poem is an early indication of Buson's oc-
casional fondness for repetition, here appropriate to the rising and falling
of ocean waves.

Poems from 1768 and 1769

An even more clear use of repetition and onomatopoeia occurs in one of a
number of poems Buson composed, or at least published, in 1768. It refers
to the sound of women pounding (fulling) cloth, one of the distinctive fea-
tures of autumn in the countryside.

ochikochi	far and near,
ochikochi to utsu	far and near, the beating
kinuta kana	of fulling blocks

—1768

Many writers have speculated that since Buson was a painter, his haiku
should stress the visual—but to what degree is this actually the case?[12] The
previous poem features sound, but most of Buson's poems, like the major-
ity of haiku in general, stem from the act of seeing. This selection from
1768 and 1769 begins with spring poems, some of which are perhaps more
melancholy than usual for this season of rebirth.

yamadori no	treading on
o wo fumu haru no	the tail of a pheasant—
irihi kana	the setting spring sun

—1769

Fuji hitotsu	Fuji alone
uzumi nokoshite	remains unburied—
wakaba kana	young leaves

—1769

nashi no hana	pear-tree blossoms—
tsuki ni fumi yomu	a woman reads a letter
onna ari	in the moonlight

—1769

yama-oroshi	mountain winds
sanae wo nadete	come down to stroke
yuku e kana	the young rice seedlings

—1768

kyō nomi no	the last day of spring
haru wo aruite	ended
shimaikeri	by my stroll

—1769

In several other haiku, Buson adds a touch of humor to cheer up any sense of melancholy.

yuku haru ya	spring passes—
me ni awanu megane	the glasses that don't fit my eyes
ushinainu	are lost

—1769

sumiuri ni	a woman's mirror
kagami misetaru	shows the charcoal-seller
onna kana	his face

—1768

katatsumuri	the snail
nani omou tsuno no	with one horn long and one short—
naga mijika	what is he thinking?

—1768

makumajiki	pillow talk—
sumai wo	the sumo bout
nemonogatari kana	he shouldn't have lost

—1768

In these same years, summer and (especially) autumn led Buson to several of his more celebrated visual haiku, some again with a wistful mood. The summer poems include two in which moments in the ordinary life of a stonemason come alive in haiku with the same first and third lines.

mijika yo ya	the night is short—
kemushi no ue ni	on the caterpillar,
tsuyu no tama	beads of dew

—1769

ishigiri no	the stonemason's
tobihi nagaruru	flying sparks flow away—
shimizu kana	clear waters

—1768

ishigiri no	the stonemason
nomi hiyashitaru	cools his chisel—
shimizu kana	clear waters

—1768

The Art of Haiku

Autumn is a time equally for admiring the harvest moon and regretting the loss of summer; one of Buson's haiku captures a sad moment with a surprising matter-of-factness.

meigetsu ni	under the harvest moon
inukoro suteru	a manservant goes out
shimobe kana	to discard a puppy

—1768

An almost opposite mood comes from another poem of the same year.

shi go nin ni	the moonlight begins to fall
tsuki ochikakaru	on four or five people—
odori kana	dancing

—1768

Buson's usual view of nature from autumn to winter was by no means always this benign. He wrote several haiku about autumn storms (*nowaki*) and fallen petals or leaves, as well as about withered grasses; the second-to-last poem in this series suggests a Shinto source.

kō no su no	the swan's nest
ajiro ni kakaru	caught in a fish trap—
nowaki kana	autumn storm

—1768

sendō no	the ferryman's pole
sao toraretaru	seized—
nowaki kana	autumn storm

—1768

nishi fukeba	when it blows from the west
higashi ni tamaru	they gather in the east—
ochiba kana	fallen leaves

—1769

botan chirite	from the fallen peony
uchikasanarinu	lying on each other,
ni san pen	two or three petals

—1769

kusa karete	grasses withered
kitsune no hikyaku	a fox-messenger
tōrikeri	passes by

—1769

kanashisa ya	sadness—
tsuri no ito fuku	a fishing line blown
aki no kaze	in the autumn wind

—1774

Interestingly, Buson changed the first line of the final poem to "the river spreads out," but was advised by his student Takai Kitō (1741–89) at a poetry meeting to go back to "sadness."[13]

Winter brings its own violent weather as well as the irony of both flowers and a sandal lost to nature. The last of these three poems comes close to echoing the first line of Bashō's most famous haiku.

kogarashi ya	winter winds—
hita-to tsumazuku	suddenly stumbling,
modori kana	the returning horse

—1769

The Art of Haiku

fuyukawa ya	winter river—
hotoke no hana no	flowers once offered to Buddha
nagarekuru	come floating by

—1768

furu ike ni	in the old pond
zōri shizumite	a submerged straw sandal—
mizore kana	sleet

—1769

There is a sound-play between *ni zōri* and *mizore* in the Japanese that adds additional interest to the last of these poems.

The strong visual sense in these verses bolsters the idea that Buson's painting perceptivities carried over into haiku. Further support comes from the way Buson mentions colors, directly or indirectly, in a number of poems from these same two years.

byakuren wo	deciding
kiran to zo omou	to cut a white lotus—
sō no sama	a monk

—1768

kimi yuku ya	you are leaving—
yanagi midori ni	in the green of the willows
michi nagashi	the road is long

—1769

cha no hana ya	tea-plant flowers—
shiro ni mo ki ni mo	whether white or yellow
obotsu kana	is uncertain

—1768

noji no ume	plum blossoms along
shiroku mo akaku mo	the path through the fields
aranu kana	not quite red or white

—1769

asagao ya	morning glory—
ichirin fukaki	a single blossom the color
fuchi no iro	of a deep pool

—1768

tombo ya	dragonflies—
mura natsukashiki	in my longed-for village
kabe no iro	the color of walls

—1768

Even more closely tied in with Buson's paintings are three haiku relating directly to his art and its appurtenances.

kiku no tsuyu	receiving the dew
ukete suzuri no	from chrysanthemums—
inochi kana	the inkstone comes to life

—1769

asagiri ya	morning mist—
e ni kaku yume no	painting a dream
hitodōri	of people passing by

—1769

tesusabi no	just for fun
uchiwa egakan	I'll paint on a round fan
kusa no shiru	with the juice of grasses

—1768

The Art of Haiku

So far there seems to be ample evidence that Buson the painter had a strong influence upon Buson the poet. However, by careful selection of which haiku to include, almost anything can be suggested, if not proven. For example, although Buson was not known to have been a musician, a number of his haiku from the same two years are based upon listening rather than seeing. Several of these recall Bashō's famous frog poem, which Buson alluded to at various stages of his life.

furu ido ya
ka ni tobu io no
oto kurashi

old well—
the dark sound of a fish
jumping at mosquitoes

—1768

tori naite
mizuoto kureru
ajiro kana

as a bird calls out
the sound of water darkens—
wicker fish trap

—1768

sara wo fumu
nezumi no oto no
samusa kana

the sound of rats
walking on dishes—
the coldness

—1769

tori mare ni
mizu mata tōshi
semi no koe

birds rarely seen
waters also distant—
cicada voices

—1768

asagiri ya
kuize utsu oto
chō-chō tari

morning mist—
someone driving in a stake
"cho-cho"

—1769

samidare no	fifth-month rains
utsubobashira ya	falling down the drainpipe—
oi no mimi	my old ears

—1769

These six haiku could be used to establish that Buson as a poet was es-
pecially drawn to sounds rather than sights, but this is plainly false. It does
suggest, however, that critics should be very careful in drawing conclusions
from only a selection of haiku, and that as a great master, Buson did not
limit himself to the visual. The most one may say at this point is that he
was often more precise in his imagery than Bashō, who seems to have been
more content to suggest rather than define his experiences.

The 1770s

The 1770s marked the full maturation of Buson as poet and artist.[14] In 1770
he succeeded to a haiku studio called Yahantei, which had been idle since
the death of Hayano Hajin in 1742. Although Buson seemed to have been
somewhat reluctant to take on the added responsibility of heading the Ya-
hantei School, he used this name as a signature for some of his haiga, and it
marked another step in his career as a haiku master.

Buson made several rules for his school. He said that the stylistic mod-
els for the poets should be Kikaku, Ransetsu, Kyorai, and Sodō—all true
pupils of Bashō, whose tradition was being "altered and debased" by other
poets of the time. Haiku should spring from admiring the moon and en-
joying blossoms, thus causing the mind to move beyond the world of dust.
More specifically, when the poets met as a group, everyone should speak up
in discussions, without flattery, intimidation, or ridicule.[15]

This kind of democratic process was quite different from some other
haiku schools, where the leader was the primary (or only) judge. It also
reaffirmed Buson's central commitment to Bashō, which was to appear

in several manifestations during this decade. For example, Buson and his friends renovated a hermitage named Bashō-an (Bashō's Hut) in the hills of northeastern Kyoto, of which Buson wrote a short account in 1776. He gave the hut's history and described it as "a quiet, secluded place, where it is said that the green moss has buried the traces of human beings for some hundred years, but the deep bamboo grove seems like it is enveloped in the smoke of a tea fire. Streams flow, clouds linger, the trees are ancient, birds sleep, and the sense of the past is powerful . . . in the end I talked about it with like-minded friends and we rebuilt the hut."[16]

Several haiku by Buson were written at Bashō's Hut, including two that use the image of a cloud first spreading and then gone—do they refer to Bashō's influence on haiku poetry?

fuyu chikashi	winter is near
shigure no kumo mo	the shower-clouds also
koki yori zo	spread out from here
—1777	

hata utsu ya	tilling the field—
ugokanu kumo mo	the unmoving cloud
naku narinu	has disappeared
—1778	

ware mo shi shite	when I die
hi no hotori sen	put my tombstone next to his—
kare obana	dried pampas-grasses
—1777	

In addition, a few of Buson's other haiku from the 1770s make direct or indirect references to the master and his poetic legacy, some quite pessimistically.

furu ike no	the old pond's frog
kawazu oi yuku	has grown old—
ochiba kana	fallen leaves

—N.D.

hosomichi wo	the narrow road
uzumimi mo yaranu	almost completely covered
ochiba kana	by falling leaves

—1770(?)

Bashō satte	Bashō is gone
sono nochi imada	and since his time, the year
toshi kurezu	does not end well

—1776

Buson further commented, "Rushing along in the road to fame and riches, drowning in a sea of desire, people torture their ephemeral selves. Especially on New Year's, even their behavior is unspeakable. . . . Bashō once gone, we have no master to teach us, whether the year begins or ends."[17]

How close was Buson's style to Bashō's? It can be instructive to compare haiku by the two poets on a similar theme; the first is by Bashō.

shiogoshi ya	in the shallows
tsuru hagi nurete	the crane's legs are moistened
umi suzushi	by the cool sea

—BASHŌ, 1689

Eighty-five years later, Buson responded with a haiku that is by no means a copy.

yūkaze ya	evening breeze—
mizu aosagi no	waters splash up against
hagi wo utsu	the legs of a blue heron

—BUSON, 1774

What are the differences? Buson gives some context with his "evening breeze," while Bashō suggests the "cool sea." Buson presents a more dynamic scene; Bashō is gentle and peaceful in his imagery, and the crane also carries connotations of long life. The more one examines these haiku, the more differences appear, yet they are both evocative observations of quite similar moments. Which haiku is preferable is something for each reader to decide, or perhaps the two haiku can be equally appreciated as poetic expression.

In admiration for Bashō, Buson also wrote a haiku in which he borrowed the master's persona.

mon wo izureba	as I go out the gate
ware mo yukuhito	I too am a traveler—
aki no kure	autumn darkens

—1774

Of course Buson was not fundamentally a wanderer like Bashō, but rather a poet with a home and family. For example, he went to some effort to secure a good marriage for his daughter Kuno in the last month of 1776; unfortunately this did not work out, and he brought his daughter home the following year for a divorce. It may be that there was a difference in cultural norms; Kuno was a fine musician who played the koto, and perhaps expected a more cultivated family than the one into which she married.[18] In any case, being a daughter-in-law in traditional Japan could be very difficult. Buson wrote in a letter that "her aged father-in-law has turned out to be a man who thinks of nothing but making money and has no taste for the arts. . . . I felt so sorry for her that I took her back home at once."[19]

Meanwhile, Buson's renown as a painter had been growing. For example, in 1771 he was invited to share the painting of an album, *Jūben jūgi-jō* (Ten Pleasures and Ten Conveniences of Living in the Country), with the most famous literati artist of the day, Ike Taiga (1723–76).[20] During this decade, Buson further reaffirmed his admiration for and lineage from Bashō by writing and painting a number of versions of Bashō's travel records, particularly the *Oku no hosomichi*, with haiga-style paintings interspersed with the texts.

Buson created these paintings on various formats, including screens, a set of fans, and several hand-scrolls. It is always interesting to see what moments in a narrative that painters and illustrators choose to show, and in this case it seem to be the most significant moments plus the most picturesque. For example, one section from a Buson hand-scroll depicts the request by the two prostitutes to follow along with Bashō and Sora, and their reluctant reply that they will have many detours and side trips, and so they cannot be of help (Plate 6-1).

This painting demonstrates both Buson's confidence in depicting figures in various poses, and his skill and empathy in capturing the spirit of Bashō's prose and poetry. The seeming simplicity of the lines and light colors mask Buson's sure touch, and the composition establishes the relationships of the people without needing background details; the woman who is crying is not the only person in tears. Although the tone seems relaxed, there is an underlying sense of respect; the image is balanced with a sense that human feelings are part of the larger world through which we all travel.

Returning to Buson's haiku, he produced a great number during the 1770s, with a broader range of subjects than before. These can again be divided into groups based first on parallelism, second on which sense is primary, third by poems featuring colors or otherwise related to painting, and ending with a few that are more deeply personal. Some haiku are not datable, but these generally fit in with or relate to other haiku from this decade.

Parallelism is an extension of the repetitions found in a few Buson haiku from earlier in his career, but here they are mostly what might be called multidirectional.

uguisu no the warbler sings
naku ya achira-muki facing this way
 kochira-muki facing that way

—N.D.

This haiku has the cutting word *ya* in the middle of the second line, making an implied rhythmic counterpoint of 8–10 syllables. It could therefore be rendered in English:

the warbler sings—
facing this way, facing that way

The first poem of the next three has the unusual syllable pattern of 11–7–5, while the second adds repetition to parallelism, and the third substitutes time for direction.

gekkō nishi ni watareba as the moonlight moves to the west
hanakage higashi ni the flower-shadows
 ayumu kana move to the east

—1777

ume ochikochi plum flowers far and near
minami subeku splendid to the south
 kita subeku splendid to the north

—1777

kinō ini departing yesterday
kyō ini kari no departing today—
 naki yo kana no geese tonight

—N.D.

Moving on to haiku that are based on the experience of different senses, one poem follows the sense of touch, followed by one based on scent.

kangetsu ya	cold moon—
koishi no sawaru	feeling small pebbles
kutsu no soko	under my shoes

—N.D.

ono irete	when the ax strikes,
ka ni odoroku ya	a surprising fragrance—
fuyu kodachi	winter trees

—1773

Many more of Buson's poems from the 1770s are based on hearing. Some of these are at least partially the result of human activity, including one that also mentions an ax. The first two haiku each have two seemingly unconnected images—why the woodpecker in the first poem, and why the peonies in the second?

teono utsu	the sound of an ax
oto mo kobu kashi	in the forest depths—
keratsutsuki	and a woodpecker

—N.D.

jiguruma no	the heavy cart
todoro to hibiku	resounds with a roar—
botan kana	peonies

—1774

While the answer to the first question could be that the repeated sounds of the ax relate to the woodpecker either in similarity or in contrast, the second question is more difficult. A peony is not usually compared with a

cart, so readers must find a connection for themselves—is it that a peony is larger than most flowers? Another option is to simply enjoy the contrast.

More Buson haiku about sounds include both the vocal and the nonvocal.

kujira-uri	whale-meat market
ichi ni katana wo	sharp blades
narashi-keri	drumming

—N.D.

akikaze ya[21]	autumn wind—
shushi ni shi utau	in the wineshop, fishermen and woodcutters
gyosha shosha	chant poems

—1774

machibito no	the sound of footsteps
ashi oto tōki	of the awaited person—
ochiba kana	falling leaves

—1774

More common among Buson's haiku are poems in which the sounds are made by nature rather than by humans. In one of these, the autumn wind is more fearsome, if less poetic, than Bashō's voice of the cicada penetrating the rocks (see p. 108).

kogarashi ya	winter wind—
iwa ni sakeyuku	coming to split the rocks
mizu no koe	the voice of water

—1775

Frequently in Buson's haiku the voices come from living creatures, each with its own meaning and context. As for the voice of the deer in the second poem, it is, as noted, understood in Japan to mark the beginning of autumn.

yūgarasu	an evening crow
aki no aware	speaks up about
tsugenikeri	autumn melancholy

—N.D.

mitabi naite	it called three times
kikoezu narinu	then was not heard again—
shika no koe	the voice of the deer

—N.D.

ka no koe su	mosquito voices
nindō no hana no	every time honeysuckle
chiru tabi ni	petals fall

—1777

Buson also wrote two haiku about the sounds from a temple bell.

suzushisa ya	coolness—
kane wo hanaruru	leaving the bell,
kane no koe	the voice of the bell

—1777

kogarashi ya	winter wind—
kane ni koishi wo	blowing small stones
fukiateru	against the temple bell

—1777

What of Buson the painter as a poet? As before, there are many visual haiku, and color is mentioned from time to time. However, of the colors Buson specifies in his poems, the most common is white. This color is not very frequently seen in his paintings (except as the white of the paper, which sometimes represents snow), but it is more significant in his haiku.

kagerō ya	heat waves—
na mo shiranu mushi no	a nameless insect
shiroki tobu	flies whitely

—N.D.

yoru no ran	the orchid at evening
ka ni kakurete ya	hiding its fragrance—
hana shiroshi	white flowers

—1777

yama ari no	the mountain ant
akarasama nari	stands out clearly—
shiro-botan	white peony

—1777

shiragiku ni	white chrysanthemums—
shibashi tayutau	the scissors
hasami kana	hesitate

—N.D.

kaze ichijin	one gust of wind
mizutori shiroku	and the waterbirds
miyuru kana	look white

—N.D.

Other colors also appear in Buson's mature haiku, sometimes stated and sometimes implied.

kaya tsurite	hanging the mosquito net
suibi tsukuran	I create blue mountains
ie no uchi	inside my house

—1775

utsukushi ya	just beautiful
nowaki no ato no	after the autumn storm
tōgarashi	a red pepper

—1776

ishikiri no	the stonemason
yubi yaburitaru	has cut his finger—
tsutsuji kana	azaleas

—1778

yama kurete	mountains darken
momiji no ake wo	robbing the crimson
ubaikeri	from maple leaves

—N.D.

teshoku shite	when I pick up the hand-lantern
iro ushinaeru	they lose their color—
kigiku kana	yellow chrysanthemums

—1777

niji wo haite	breathing out a rainbow
hirakan to suru	as it blooms—
botan kana	the peony

—N.D.

otsuru hi no	the setting sun
kugurite somuru	passes through and dyes
soba no kuki	buckwheat stalks

—1778

Several further Buson haiku mention screens, a format on which he often painted, although usually on silk or paper formats rather than gold or

The Art of Haiku

silver leaf ones. At one point, a little earlier in his life, there even seems to have been a club of admirers who gathered funds to pay for his painting materials; members then received preferential treatment in acquiring his works.[22]

mijika yo ya	short nights—
makura ni chikaku	next to my pillow
ginbyōbu	silver screens

—1770

kinbyō no	whose gauze dress
usumono wa tare ka	is on the gold screen?
aki no kaze	autumn wind

—1776

A few of Buson's haiku from this decade mention works of art, or his own struggles with painting in the deep of winter. The references are to Ōtsu-e, folk paintings created in the town of Ōtsu outside of Kyoto, and to a portrait of Vimalakirti (Japanese: Yuima), a Buddhist layman who proved to be as wise or wiser than bodhisattvas.

Ōtsu-e ni	pooping on the
fun otoshi yuku	Ōtsu-e and flying away—
tsubame kana	a swallow

—1778

rofusagi ya	closing the hearth
toko wa Yuima ni	I change the scroll
kakekaeru	to Vimalakirti

—N.D.

yamadera no	at the mountain temple
suzuri ni hayashi	the first ice on the inkstone
hatsugōri	comes early

—N.D.

ha arawa ni	with a remaining tooth
fude no kōri wo	I bite off the ice from
kamu yo kana	my brush at night

—1774

As for Buson's primarily visual haiku, of course there are many from this era. Several of the most delightful mention living creatures, the first of which also suggests a farmer.

kamo tōku	distant wild ducks—
kuwa sosogu mizu no	when washing the hoe,
uneri kana	the water undulates

—1770

Once again we have a two-part haiku for which the reader must make the connection. Is the water stirred by the hoe undulating? Does the flight of the ducks also undulate? Perhaps the farmer washing the hoe is simply looking into the distance, where he sees the ducks? Or maybe his mind is undulating?

Haiku about insects show Buson's range as a poet, from observation and wonder to a sarcastic sense of humor.

asakaze no	we can see the morning breeze
ke wo fukare iru	blowing its hairs—
kemushi kana	the caterpillar

—N.D.

utsutsunaki	unreal—
tsumami-gokoro no	holding in my hand
kochō kana	a butterfly

—1773

gakumon wa	scholarly brilliance
shiri kara nukeru	comes forth from its bottom—
hotaru kana	the firefly

—1772

Other Buson haiku about living creatures reveal his dispassionate eye for nature, including one that may seem a little gruesome.

oborozuki	hazy moon—
kawazu ni nigoru	a frog muddies up
mizu ya sora	both water and sky

—1774

yūdachi ya	sudden shower—
kusaba wo tsukamu	clinging to the grasses
mura-suzumi	village sparrows

—1775

musasabi no	flying squirrel
kotori hami-iru	munching on a small bird—
kareno kana	withered fields

—1775

Beyond insects, birds, and animals, Buson came up with two haiku, four years apart, that share the same final line in presenting an almost living creature.

ine karete	in the drying rice fields
bake wo arawasu	it looks like a ghost—
kakashi kana	the scarecrow

—1770

mizu ochite	as the rice-field water drains
hosohagi takaki	its legs grow long—
kakashi kana	the scarecrow

—1774

Another case of repeating an image comes with two poems about summer. The first line, ending in the cutting word *ya,* was used several times by Buson, as in these two haiku written one year apart.

mijika yo ya	the night is short—
nami uchigiwa no	on the beach,
sute-bōki	a discarded broom

—1774

mijika yo ya	the night is short—
asase ni nokoru	remaining in the shoals,
tsuki ippen	a slice of moon

—1775

People feature in many of Buson's haiku from the 1770s, either directly or indirectly. Among the more unusual are several that suggest a scene for the reader to imagine, or present an image that implies a short narrative. The first of these uses the device of repetition.

shoku no hi wo	with one candle
shoku ni utsusu ya	lighting another candle—
haru no yū	spring evening

—N.D.

The next two present an anticipatory moment, and a visit not made.

seki to shite	in the silence
kyaku no taema no	before guests arrive—
botan kana	peonies

—1774

na no hana ya	hedge-flowers blossoming—
hōshi ga yado wa	not stopping at the monk's hut
towade sugi	I pass on by

—1776

Although Buson was becoming successful with his poetry, he was also proud of his haiga. He used them at times for income, writing to his pupil and agent Kitō, "My paintings in the haiga style are unequalled in Japan; don't sell them too cheaply."[23] Yet judging from the relatively small number that survive, Buson did not paint very many of them, and when he did, he usually added an introduction, another inscription, a line or two from a Chinese poem, or even another sketch.

Because Buson's haiga are almost never dated, it is difficult to know when he painted them, but probably he turned to this art at various points in his life. Some seem to be earlier than others, such as several that were probably created from the early to mid 1770s, while others are more likely from later that decade.

One of Buson's most influential works was an album of portraits of earlier haiku masters with representative poems; this was published as a woodblock book in 1799 and achieved wide circulation. One example from this

album is a portrait of Chigetsu (see page 136) with her autumn poem (Plate 6-2).

> *toshi yoreba* when it gets old
> *koe mo kanashiki* its voice becomes plaintive—
> *kirigirisu* katydid

One notable feature of this seemingly simple work is the integration of poem, calligraphy, and painting. The melancholy tone of the haiku is well expressed in both the slightly melancholy pose of the poet, and yet we are able to read any emotions that we wish into her face, which is made simply of three dots and a hooking stroke. The poem nestles against her, and its basic triangular form is repeated in the figure, but this time with the triangle's base at the bottom. The calligraphy itself, which is made up primarily of curving lines with subtle modulations in thickness, has exactly the same kind of brushwork seen in the figure. Echoing some of the lines in the image, the notable semicircle over Chigetsu's head is actually a repeat mark, indicating that the *kiri* syllables become *kirikiri,* or *kirigiri,* before the final *su.*

Another parallel occurs at the bottom of the calligraphy in the character for "moon" (月, *getsu* in the signature "Chigetsu"): the vertical line on the left ends with the same kind of small hook as the line that moves down to the left of the poet's face. To indicate how important the relation of calligraphy to image is here, we can make a collage that puts the signature to the left and the poem farther to the right (Plate 6-2a).[24] It is still an attractive image—but something is now lost.

One of Buson's most famous haiga depicts the figure of Matabei, a happy-go-lucky fellow who has been admiring the cherry-blossoms while drinking a little more than he should (Plate 6-3). The introduction and poem are somewhat complex, referring to the painter Tosa Mitsunobu (1434–1525), who often used layers of gesso under his bright colors, and to Omuro, a section of Kyoto well-known for its late-blooming cherry trees.

The falling of cherry-blossoms in the capital is like gesso flaking off a Mitsunobu painting.

Matabei ni	have I met Matabei?
au ya Omuro no	Omuro blossoms
hana zakari	at their finest

—C. 1777

Matabei is depicted with relaxed brushwork appropriate to the subject. His robe is slipping off his shoulders and his discarded wine gourd has fallen beneath him like a little chunk of gesso, while the red-orange of his cap relates to cherry-blossoms.

Although many of Buson's poems relate to what he has seen, heard, or sensed, there are a small number of Buson haiku from the 1770s that seem more personal to the poet, although one must always be careful about assuming autobiographical intent in haiku. Like other poets, haiku masters could and did take on different personae, and yet some of these verses seem to carry more internal emotions than usual.

Buson may have become infatuated with a woman, perhaps from the pleasure quarters. He wrote:

oi ga koi	if the old man
wasuren to sureba	could only forget his love—
shigure kana	winter showers

—N.D.

Another haiku may or may not also refer to this infatuation.

gu ni tae yo to	"endure your foolishness"—
mado wo kuraku su	darkening the window,
yuki no take	snowy bamboo

—1774

One well-known Buson haiku subtitled "In My Bedroom," however, mentions his wife, who was very much alive at the time.

mi ni shimu ya	it penetrates my being—
naki tsuma no kushi wo	stepping on the comb
neya ni fumu	of my dead wife

—1777

More attuned to Buson's moods are several haiku concerning the seasons of autumn or winter. Two of the former are sad, but the third contains an emotional turnabout while using the same final line as the previous haiku.

botan kitte	after cutting the peony
ki no otoroeshi	my spirit wanes—
yūbe kana	evening

—1776

kyonen yori	more lonely
mata sabishii zo	than last year—
aki no kure	autumn darkens

—1776

sabishisa no	in loneliness
ureshiku mo ari	there is also some joy—
aki no kure	autumn darkens

—1776

Three winter haiku are more emotionally chilly. The third, in the unusual form of 8–7–5 syllables, was composed on Bashō's death anniversary.

The Art of Haiku

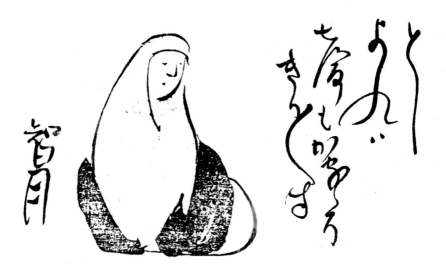

6-2a Buson, *The Poet Chigetsu* (rearranged).

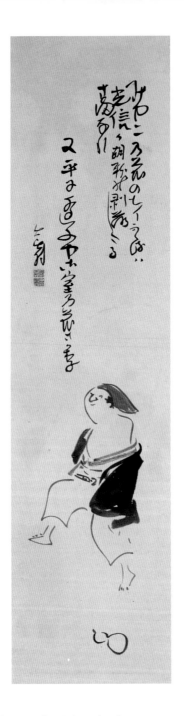

6-3 Yosa Buson (1716–84), *Matabei*. Ink and color on paper, 103.3 x 26.5 cm. Itsuo Art
Museum.

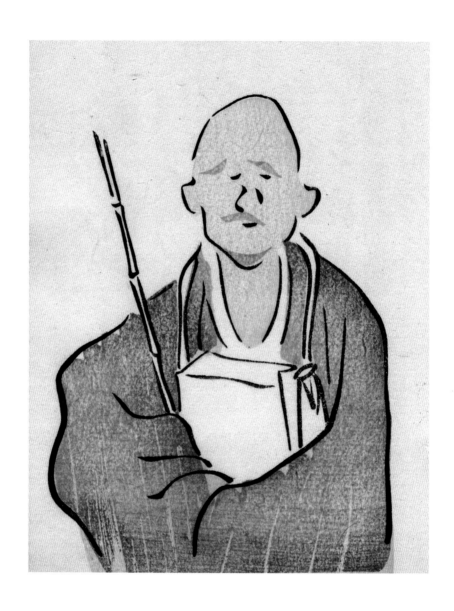

6-4　Matsumura Goshun (1752–1811), *Portrait of Buson*. Wood-block print from *Shin hana tsumi* (New Flower Picking, 1777). Ink and color on paper, 27.2 x 18 cm.

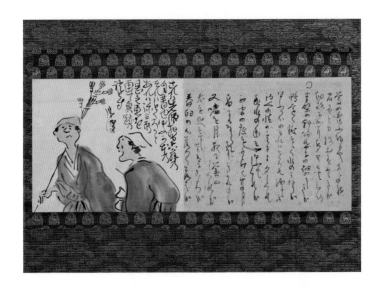

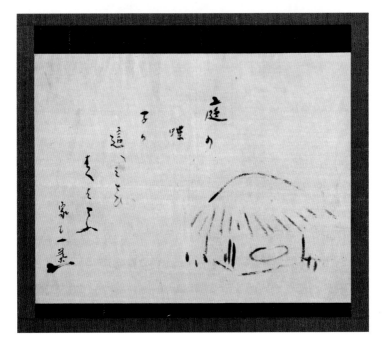

6-5 Matsumura Goshun (1752–1811) and Yosa Buson (1716–84), *Dowry Haiga* (*Yomeiride*). Ink and colors on paper, 15.8 x 39.3 cm.

7-1 Kobayashi Issa (1763–1827), *Garden Butterfly*. Ink on paper, 28.6 x 37.6 cm. Chikusei Collection.

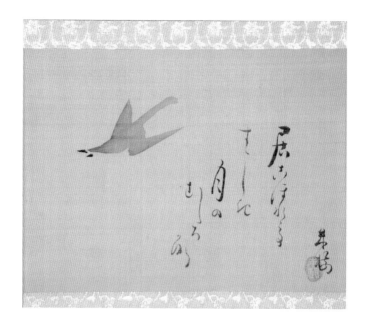

7-2 Inoue Shirō (1742–1812), *Cuckoo.* Ink on silk, 27 x 38 cm.

7-3 Inoue Shirō (1742–1812), *Moon and Mountain.* Ink on paper, 31 x 50 cm.

7-4 Takebe Sōchō (1761–1814), *Discussions Under a Mosquito Net.* Ink and colors on paper,
34 x 55.8 cm. Masuda Collection.

7-5 Takebe Sōchō (1761–1814), *Old Couple* (detail). Ink and colors on paper, 28 x 16.7 cm.

8-1 Masaoka Shiki (1867–1902), *Fruit*. Colors on paper, 26 x 33 cm. Shibunkaku Collection.

8-2　Kawahigashi Hekigotō (1873–1937), *Ōhara*. Ink on decorated paper, 36.3 x 6 cm.

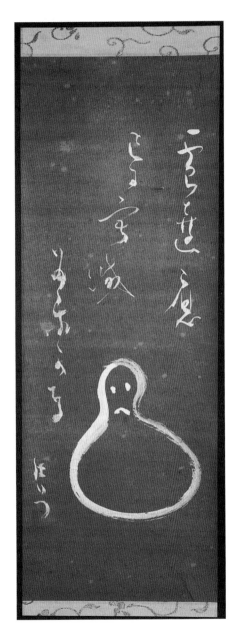

8-3 Fukuda Kodōjin (1865–1944), *Bamboo Shoot*. Ink on printed paper, 22.7 x 7.8 cm.

8-4 Fukuda Kodōjin (1865–1944), *Snow Daruma*. Ink on colored paper, 62 x 23.2 cm.

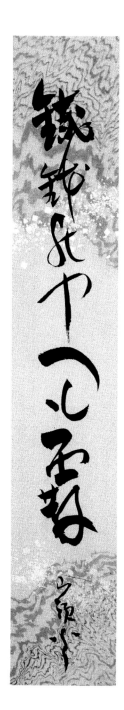

8-5 Taneda Santōka (1882–1940), *Hail.* Ink on colored paper *tanzaku,* 36 x 6 cm.

8-6 Taneda Santōka (1882–1940), *Alone, Silently.* Ink on decorated paper *tanzaku,* 36 x 6 cm.

8-7 Taneda Santōka (1882–1940), *No Money.* Ink on paper, 49.4 x 69.3 cm.

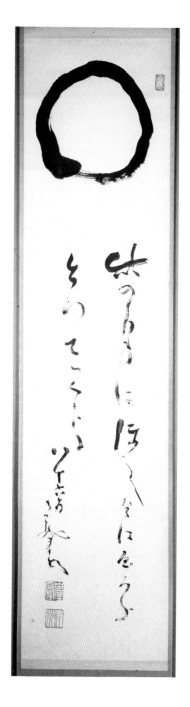

8-8 Nakahara Nantembō (1839–1925), *Moon Ensō* (1924). Ink on paper, 130.9 x 31.5 cm.

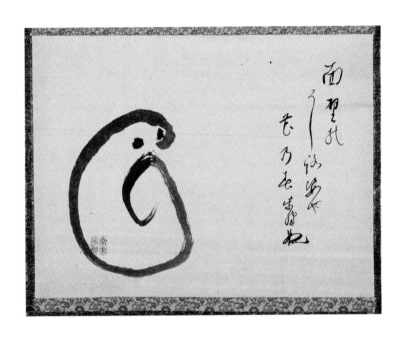

8-9 Sōhan Gempō (Shōun, 1848–1922), *Daruma Meditating.* Ink on paper, 39 x 52.2 cm.

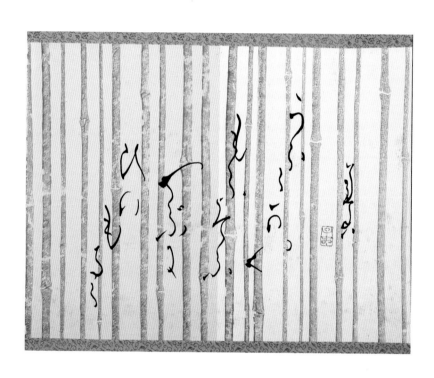

8-10 Tsuji Kakō (1870–1931), *Spring Haiga.* Ink on decorated paper, 33.8 x 45.3 cm.

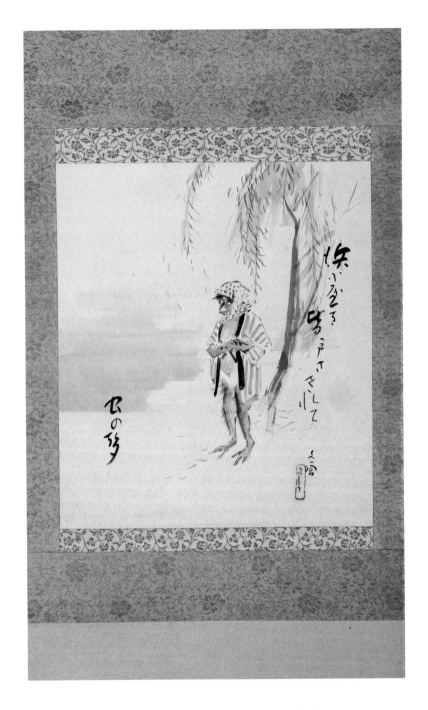

8-11 Hayashi Buntō (1882–1966), *Shops by the Beach*. Ink and colors on paper, 33 x 29.2 cm.

ineburite	going to sleep,
ware ni kakuren	I hide in myself—
fuyugoromi	winter seclusion

—1775

waga hone no	my bones
futon ni sawaru	touching the quilt—
shimoyo kana	frosty night

—1777

shigure oto nakute	winter shower
koke ni mukashi wo	soundless on the moss—
shinobu kana	thinking of the past

—N.D.

In 1777, Buson took on the self-imposed task of writing ten haiku a day for one hundred days, following an earlier example by Kikaku. He began on Buddha's birthday, the eighth day of the fourth month (which itself becomes the first line of the second haiku). The following haiku may have been written in memory of Buson's mother, and the first two are unusually emotional.

kanbutsu ya	Buddha's birthday—
motoyori hara wa	the womb is only
kari no yado	a brief shelter

—1777

uzuki yōka	fourth month, eighth day—
shinde umaruru	the baby born dead
ko wa hotoke	is a buddha

—1777

Buson became ill and did not finish the hundred-day task, but the haiku he did write were collected (along with prose stories of the fanciful and supernatural that he had collected) in *Shin hana tsumi* (New Flower Picking, 1777). One of the wood-block illustrations by his pupil Matsumura Goshun (1752–1811) shows Buson with his traveling pouch, much like pictures of Bashō (Plate 6-4). This is one more example of his sense of identification with the earlier master.

In a prose introduction written in 1777 for the "Shundei Poem Collection" (*Shundei kushū*), a compilation of verses by his friend Kuroyanagi Shōha (1727–71), Buson gave one of his rare comments on the art of composing haiku.[25] He refers to the important Japanese term *zoku* (mundane, common, plebian) and how it may be used in poetry.

Haiku values verses that detach themselves from the mundane while using mundane language, but such an art of detachment is very difficult to put into practice. A certain Zen monk [Hakuin Ekaku] said, "Listen to the sound of one hand." In his words, the Zen of haiku as well as the art of detachment from the mundane are contained.

The Final Years

Late in his life, Buson continued to produce exceptional work in both art forms. His literati landscape paintings achieved their height of expressiveness, adding a personal touch to the millennium-old Chinese poet-painter tradition. Perhaps his work in haiku made him even more receptive to the ever-changing aspects of nature that brushwork could evoke visually, and his scrolls from this time have a special warmth not always seen in his earlier works. In terms of haiku, Buson composed fewer than in the 1770s, but with no diminution of his powers of poetic observation.

As for style, in 1780 Buson wrote in a book preface that haiku "is an open-minded fellow. . . . It may seem there is a specific style of the day, but actually there is not. This can be compared to a line of people running

round a circular course. The runner heading the line looks as if he were following the last runner, who is lagging one lap behind. How can we tell which is the leading poetic style?"[26] This idea was later known in America as "lapping the track in sensibility," and it is interesting that Buson used the same image.

While one might expect autumn and winter poems to predominate in Buson's old age, some of his finest verses from these years are about spring.

wakakusa ni	in the young grasses
ne wo wasuretaru	its roots are forgotten—
yanagi kana	the willow

—1782

This poem is as much about what is not seen as about what is visible; might this show Buson at an advanced age still enjoying the emergence of new life in nature?

ike to kawa	pond and river
hitotsu ni narinu	have become one—
haru no ame	spring rain

—1782

It is tempting to imagine the pond as Bashō and the river as Buson, but this is probably reading too much into the poem. However, in the same year Buson wrote several more poems about spring rain, now using it as the first segment of the poems, each of which could have personal meanings.

harusame ya	spring rain—
kawazu no hara wo	the frog's belly
mada nurezu	not yet wet

—1782

harusame ya	spring rain—
kurenan to shite	almost evening
kyō mo ari	but today lingers

—1782

A third poem with the same first line is quite delightful.

harusame ya	spring rain—
monogatari yuku	telling stories as they go,
mino to kasa	straw coat and umbrella

—1782

Buson was certainly capable of haiku that tell (or suggest) stories within their brief span.

tobikawasu	fluttering about
yatake-gokoro ya	impatiently—
oyasuzumi	parent sparrows

—1780

fuyukawa ya	winter river—
ta ga hikisuteshi	pulled up and discarded,
akakabura	a red turnip

—1782

nokogiri no	the sound of a hand-saw
oto mazushisa ya	is poor and meager—
yowa no fuyu	winter midnight

—1780

Generally, Buson's late haiku do not suggest the infirmities or sadness of old age, but a few have a slightly melancholy tone.

The Art of Haiku

yuku haru ya	spring passing by—
shunjun to shite	reluctant, hesitating,
osozakura	the last cherry-blossoms

—1782

kagari aru	in this limited life
inochi no hima ya	a time of leisure—
aki no kure	autumn darkens

—1782

In Buson's final year, he took part in a special poetry festival in Kyoto honoring Bashō, perhaps the major event in the Bashō revival. That year he wrote haiku that can serve to represent his respect for earlier poets, his fresh observations of nature that incorporate humor, and his irrepressible spirit.

Saigyō no	Saigyō's quilt
yagu mo dete aru	has again appeared—
momiji kana	maple leaves

—1783

hasu karete	lotus leaves dried up,
ike asamashiki	the pond is pitiable—
shigure kana	early winter rain

—1783

hi wa hi kure yo	by day, "darken the day"
yo wa yo ake yo to	at night, "brighten the night"
naku kawazu	chant the frogs

—1783

ikada-shi no	the straw raincoats
mino ya arashi no	of raftsmen in the storm
hana-goromo	become flower-robes

—1783

Buson's health had been generally good until late 1783, when he began to have severe chest and stomach pains. At first he seemed to recover, but in the eleventh month, knowing his passing was near, Buson summoned to his side his two major painting pupils, Ki Baitei (1734–1810) and Matsumura Goshun. He asked that since his daughter's first attempt at marriage had not been successful, could they help raise a dowry so she could marry again?

After the master died the following month, the two young poet-artists searched among Buson's papers to find examples of his poems that he had written at various times in his life. To these poems they created and appended small paintings in haiga style that related to the themes or seasons of Buson's haiku. Thus they produced one of the most unusual forms of Japanese painting, *yomeiride* (dowry haiga), which seem to have been created only this once in history.

Several examples of *yomeiride* by both Baitei and Goshun still exist.[27] One that has only recently come to light includes thirteen Buson haiku (probably from 1770) with a delightful painting by Goshun showing two itinerants (Plate 6-5). One figure relates to the sixth poem by preaching Namu Amida Butsu (Hail to Amida Buddha) while striking a gong (all we can see is his thin mallet), while the other figure is selling whisks for the tea ceremony. Goshun notes on his painting that the calligraphy to the right is a genuine work of his master Buson, whose haiku celebrate several seasons, primarily late autumn and winter. These haiku are written in single columns from right to left.

uguisu no	the warbler
au tamaribi ya	finds a sun-drenched spot—
fuyu no eda	a winter branch

—N.D.

yadokase to	"Give me shelter!"
katana nagedasu	he throws down his sword—
fubuki kana	the blizzard

—1768

hosomichi ni	voices coming
nariyuku koe ya	into the narrow lane—
kan nembutsu	winter prayers

—1768

hanken no shayō	the setting sunlight
kamiko no sode no	on the paper kimono sleeve—
nishiki kana	brocade!

—1768

kamo samuku	even ducks are chilly—
suki susugu mizu no	the tool-washing water
uneri kana	shivers

—N.D.[28]

yūgao no	evening glories—
sore wa toguchi ka	is that a doorway?
kane tataki	he strikes the begging bell

—N.D.

machibito no	the person I'm waiting for
jō no kowasa yo	has no sympathy at all—
yū shigure	winter evening rain

—N.D.

nigemizu no	escaping water
nige soko nōte	twists and turns in its channel—
shigure kana	first winter rain

—1770

hatsuyuki no	when the first snow
soko wo tatakeba	strikes the lowest culms—
take no tsuki	bamboo in moonlight

—1770

hatake ni mo	even it couldn't
narade kanashiki	become a farm, it's sad—
kareno kana	withered field

—1770

mata uso wo	still telling lies
tsukiyo ni kama no	on the pot in the moonlight
shigure kana	early winter rain

—1770

koi wo yama e	even for one who
suteshi yo mo aru ni	renounced love in the mountains—
sakura kana	cherry-blossoms

—N.D.

haru usu no	harmonizing with
kokoro ochitsuku	the springtime mortar—
ochiba kana	falling leaves

—N.D.

These poems represent much of what made Buson a major haiku master. They include fresh observations of nature, along with some scenes

The Art of Haiku

of human nature, and also have both a sense of drama and a personal touch.

As far as we know, the dowry haiga were successful in raising funds. Baitei thereupon returned to Shiga Prefecture, outside of Kyoto, to become a successful *nanga* (literati) painter. Goshun remained in Kyoto, eventually switching from Buson's painting style to that of the more naturalistic Maruyama Ōkyo (1733–95), while helping to spread haiga as a painting genre for professional artists as well as poets.

Before he died, Buson called Goshun to his bedside to record a death poem. Worried that he might not come close to matching Bashō's death verse about dreams circling over withered fields, Buson actually wrote three. They each represent the early spring, which Buson did not live to see, and the one he chose is the third and finest:

shira ume ni among white plum blossoms
akuru yo bakari to what remains is the night
nari ni keri about to break into dawn

—1784

7

Issa and the Early Nineteenth Century

LTHOUGH BASHŌ and Buson are usually ranked above him, there is
no haiku poet as beloved as Kobayashi Issa (1763–1827). This is in
part due to his responses through haiku to a very difficult and
often tragic life, and in part to the empathy he shows in his poems for all
living creatures, from wolves to mosquito larvae.

A Short Biography

Issa was born as Kobayashi Yatarō to a farming family in Kashiwabara (Na-
gano Prefecture), a village of heavy snow.[1] Only two years later his mother
died, and despite care from his grandmother, he missed her for the rest of
his life.

naki haha ya	my lost mother—
umi miru tabi ni	every time I look at the sea,
miru tabi ni	every time I look . . .

—1812

Issa was sent to study with a local scholar and haiku poet named Na-
kamura Shimpo (n.d.), but he was a solitary child who spent a great deal
of time by himself in nature. When Issa was seven, his father remarried,
and his stepmother Satsu seems to have treated him badly, insisting that he
work at the farm rather than go to school. When she bore a son three years
later, the situation became worse, with Issa being given the responsibility of

looking after the baby, and later Issa wrote that he was frequently beaten. One of his later haiku may relate to this time:

hito no yo ya this human world—
konoha kaku sae scolded even for writing
shikaruru on a leaf

—1816

After his grandmother died in 1777, Issa was sent to Edo, where he barely made a living at several different jobs. A haiku written many years thereafter may carry some of his emotions from that time, with the understanding that "starling" was slang for "country bumpkin" or "ignorant migrant worker."

mukudori to "starling"
hito ni yobaruru is what people called me—
samusa kana the cold

—1819

Through these difficult years Issa continued his interest in poetry, and by 1787 he was able to study haiku with a poet named Chikua (1710–90), who followed the Bashō tradition. One of Issa's earliest haiku refers to a stone image in the countryside of the Buddhist guardian deity Jizō.

koke no ha moss flowering
kokizu ni saku ya on his little scars—
ishi Jizō stone Jizō

—1788

After Chikua died in 1790, Issa determined to become a wanderer, much like Bashō. Beginning in 1792, he spent the next decade traveling and visiting a number of poets in Edo and the Kyoto-Osaka area. That same year he took the name "Issa" (a single tea), as a later haiku explains.

haru tatsu ya	spring returns—
Yatarō aratame	Yatarō has become
Issa-bō	the monk-poet Issa

—1818

During these years, Issa also began to gather his haiku into collections.[2] One of his early poems is an observation of nature, the second could well refer to himself, and the third shows his sense of humor.

chiru botan	the falling peony
kinō no ame wo	spills
kobosu kana	yesterday's rain

—1792

aki no yo ya	autumn evening—
tabi no otoko no	a man on a journey
harishigoto	mending his clothes

—1793

shōben no	shivering as I piss—
miburui warae	and the smile
kirigirisu	of the katydid

—1795

In 1801 Issa's father died, and following his father's final wishes, Issa tried to settle in his home village. Unfortunately, arrangements with his stepmother and half brother went badly; they challenged his father's will, and so Issa alternated for some years between Kashiwabara and Edo, an existence he sometimes felt had no real purpose.

tsuki hana ya—	moon and cherry-blossoms—
shijū-ku nen no	forty-nine years of
muda aruki	walking uselessly

—1811

ikinokori	living on
ikinokoritaru	living on—
samusa kana	the cold

—1811

In 1813, Issa finally received half of the Kashiwabara home. Although family relationships were still not ideal, this seems to have cheered him up, and several of his haiku reflect his more relaxed state of mind.

hara no ue ni	practicing Chinese characters
ji wo kakinarau	on my belly—
yonaga kana	the long night

—1813

We can imagine the poet, on a winter evening, using perhaps his index finger to trace out some difficult characters on his stomach.

The following year, Issa married a twenty-seven-year-old woman named Kiku (chrysanthemum), and one of his more humorous haiku details his embarrassment at being a middle-aged groom.

gojū muko	the son-in-law over fifty
atama wo kakasu	hides his head with
ōgi kana	a folding fan

—1814

Issa seems to have been fond of Kiku, in part for her lack of pretension, which is apparent in a haiku.

The Art of Haiku



waga Kiku ya my Kiku—

nari ni mo furi ni mo what she wears and how she walks

kamawazu ni don't concern her



—1815

Issa and Kiku had four children, all of whom died in childhood, surely among the most difficult experiences that anyone may suffer. In particular, the loss of their baby daughter Sato at the age of four hundred days seems to have been especially heartrending, and led to this poem composed at the grave thirty-five days after her death.



akikaze ya autumn wind—

mushiritagarishi the red flowers

akai hana she loved to pick



—1819

Issa began to spend more and more time traveling and teaching; on one journey in 1820 he suffered his first stroke, from which he never fully recovered.

Kiku herself died in 1823, and one of Issa's haiku written the previous year, another soon after her death, and a third perhaps a little later (although undated) serve to express his changing feelings in everyday terms.



kotoshi koso this year there's

kogoto aite mo someone to complain to—

natsu zashiki our summer room



—1822



kogoto iu if she were only

aite mo araba here to complain to—

kyō no tsuki tonight's moon



—1823

shikararuru	envious even
hito urayamashi	of the one being scolded—
toshi no kure	the year ends

—N.D.

At age sixty, when one is supposed to be free of cares, Issa saw himself as nothing but foolish. He may have viewed the world the same way; although the following haiku does not indicate himself directly, the poem feels like a personal comment:

haru tatsu ya	spring returns—
gu no ue ni mata	on top of foolishness
gu ni kaeru	more foolishness

—1823

Issa married again in 1824, but this quickly ended in divorce. Two years later he married a third time, despite suffering from various health difficulties including partial paralysis from a second stroke. Unfortunately, the following year the main section of his house burned down. Issa and his pregnant third wife then lived in the storehouse without sufficient heat, and this proved too much; he died that same year.

Issa's life was certainly filled with sorrow, and yet Issa of all haiku poets seems to celebrate the world, not without a touch of irony, but generally with joy.

iso-iso to	cheerful cheerful
oiki mo wakaba	the old tree befriends
nakama kana	the young leaves

—1824

Pure Land Buddhism

Issa seems to have been a devout Buddhist, especially later in his life, but rather than Zen he followed Pure Land teachings.[3] These center upon faith; anyone who intones the *nembutsu* chant Namu Amida Butsu (Hail to Amida Buddha) with perfect sincerity will be reborn in Amida's Western Paradise after death. Pure Land Buddhism is generally seen as a devotional "outer directed" form of Buddhism in contrast with "inner directed" Zen, but it also could be practiced with an inner focus.

Although haiku do not usually deal with religion as such, some of Issa's poems over the years reflect various aspects of his beliefs. He was frequently able to combine a view of nature with the *nembutsu*, believing that the entire world could resound with the chant.

nembutsu wo	teaching us
sazukete yaran	the Buddhist chant,
kaeru kari	geese depart

—1810

suzume no ko	baby sparrows
ume ni kuchi aku	open their mouths to the plum tree—
nebutsu kana	a Buddhist chant

—1804

Issa also believed that this world is full of craving and grasping, which according to the Buddha are the cause of so much human suffering.

hana saku ya	cherry trees blossoming—
yoku no ukiyo no	desires fill the corners
katasumi ni	of the floating world

—1810

By Issa's day, the term "floating world" had become well-known as meaning a world of pleasure, but it retained a much older Buddhist meaning as a world of transience. Issa wrote that people lived seemingly unaware that they were not far from death and possible punishment.

yo no naka wa	in this world
jigoku no ue no	we are flower-viewing
hanami kana	over hell

—1812

Issa also had a sense of irony, as several haiku make clear, the latter two relating to forms of Buddhist paintings.

hae hitotsu	swatting a fly
utte wa Namu Amida	and chanting
Butsu kana	Hail to Amida Buddha

—1814

Ōtsu-e no	even the folk-art demon
oni mo mijito ya	can't look—a little bird
nukumedori	warms the hawk's nest

—1814

jigoku e no	in the painting of hell,
kaki ni kakarite	perched on the fence
naku hibari	a skylark is singing

—1815

Other Issa haiku with Pure Land themes range from a peaceful household scene to more irony.

yu mo abite	after a hot bath,
hotoke ogande	worshipping Buddha—
sakura kana	cherry-blossoms

—1815

nomi kanda	from the mouth
kuchi de Namu Amida	that crunched the flea,
Butsu kana	Hail to Amida Buddha

—1817

As Issa grew older, he became more convinced that Buddha does not only exist in paradise, an insight that is also important in Zen.

aki kinu to	the puppy not knowing
shiranu koinu ga	autumn has come—
hotoke kana	a buddha

—1820

hito areba	where there are people
hae ari hotoke	there are flies
arinikeri	there are buddhas

—1823

When Issa died, his family found the following poem under his pillow, so it may be his final verse, or even a death poem:

arigata ya	thankful—
fusuma no yuki mo	snow on the quilt also comes
Jōdo yori	from the Pure Land

—1829(?)

Snow

Living most of his life in a village with a high snowfall, Issa composed many po-
ems about snow, occasionally using onomatopoeia, and sometimes mention-
ing his interest in making a "snow-buddha" (snowman) with varying success.
As often with Issa, he has a range of attitudes toward the subject, frequently
depending upon whether or not he is including himself in the imagery.

beta-beta to	sticky-sticky
mono ni tsukitaru	it clings to everything—
haru no yuki	spring snow

—N.D.

tada oreba	when being here—
oru tote yuki no	just being here—
furi ni keri	snow falls

—1805

te no hira e	onto my open hands
hara-hara yuki no	fluttering-fluttering
furi ni keri	snow falls

—1812

waga sato no	our village's bell
kane ya kikuran	can't be heard—
yuki no niwa	a garden of snow

—1813

yoriatte	gathering sparrows
suzume ga hayasu	raise a cheer—
yuki-botoke	my snow-buddha

—1815

The Art of Haiku

waga kado ya	at my gate
itsumo mijime na	it's always pitiful—
yuki-botoke	my snow-buddha

—1817

monzen ya	before my gate
tsue de tsukurishi	I use a stick to make a river
yukige-gawa	from melted snow

—N.D.

massugu na	a straight hole
shōben ana ya	from pissing in the snow
kado no yuki	by my gate

—1820

Flowers, Grasses and Trees

Issa wrote about flowers, grasses, and trees somewhat less often than other poets, but he nonetheless composed some evocative haiku on these themes. For some poems he turned again to repetition and onomatopoeia.

nanigoto no	to what are you
kaburi-kaburi zo	nodding, nodding,
ominaeshi	maiden-flower?

—1811

yusa-yusa to	rustling, rustling,
haru ga yukuzo yo	as spring departs—
nobe no kusa	field grasses

—1811

yuku aki wo	to departing autumn
obana ga saraba	the pampas-grass waves
saraba kana	farewell, farewell

—1813

yase kusa no	the skinny plant
yoro-yoro hana to	has grown a wobbly-wobbly
nari ni keri	flower

—1813

Two haiku about kites have an opposite focus.

kyō mo kyō mo	today too, today too—
tako hikkakaru	the kite caught by
enoki kana	the nettle-tree[4]

—1807

utsukushiki	beautifully
tako agarikeri	a kite rises from
kojiki goya	the beggar's hut

—1820

Although haiku are seldom fully narrative, one of Issa's verses begins to tell a story, perhaps to chill the bones of listeners.

karesusuki	dry pampas-grass—
mukashi onibaba	once long ago they say
atta to sa	there was an ogress . . .

—N.D.

The Art of Haiku

The willow tree has always been a favored theme of haiku, but Issa found new ways to discuss it in terms of implicit or explicit human interactions, each time ending with the words *yanagi kana* (the willow).

iriguchi no	at the entrance gate
aiso ni nabiku	waving amiably—
yanagi kana	the willow
—1819	

hitogoe ni	buffeted by human voices
momarete aomu	it grows greener—
yanagi kana	the willow
—1820	

Several of Japan's favorite flowers were also among Issa's themes, but each time with meanings that stretch beyond the flowers themselves. Whether he was writing about the passing of time, nature expanding, or the wonder of a child, Issa was able to find fresh ways to create new haiku from traditional themes.

yūzakura	evening cherry-blossoms—
kyō mo mukashi ni	today has also become
nari ni keri	the past
—1810	

asagao no	morning glories
hana de fukitaru	thatch
iori kana	my cottage
—1812	

kore hodo no	"the peony was
botan to shikata	this big"—the child
suru ko kana	stretches her arms wide

—1810

More complex are the poems that Issa wrote about chrysanthemums. He may have raised these plants himself for the annual contests every fall, or he may have just observed reactions from other growers, but in any case he was keenly aware of the competitions.

kachi kiku ni	at the winning
horori to jiji ga	chrysanthemum, the old man
namida kana	sheds a tear

—1814

kata sumi ya	stuck in a corner—
saru nen kachitaru	last year's winning
kiku no hana	chrysanthemum

—1814

makegiku no	the losing chrysanthemum
shikararete iru	scolded—
kosumi kana	off in a corner

—1818

makegiku wo	examining again
jitto minaosu	the losing chrysanthemum—
hitori kana	alone

—1822

The Art of Haiku

Views of Nature

Issa did not write standard views of nature, but rather noticed the individual moments that often inspire fine haiku. For example, in two quite different poems he noticed how liquids reflect; one poem is more serene, and the other is a humorous take on the familiar theme of the autumn moon.

haru no hi ya	the spring sun remains
mizu sae areba	where there is water
kure nokori	at dusk

—1804

yamazato wa	mountain village—
shiru no naka made	all the way into our soup
meigetsu zo	the harvest moon

—1813

Similarly, Issa noticed how a hole in his paper door (*shōji*) could create music when the wind blows, but could also become a vantage point for gazing at the sky.

aki no yo ya	autumn evening—
shōji no ana no	a hole in the paper door
fue wo fuku	plays the flute

—1811

utsukushi ya	beautiful—
shōji no ana ga	through a hole in the paper door
ama-no-gawa	the Milky Way

—1813

Issa also used onomatopoeia to emphasize the poverty of his home province, as well as some unsteady shadows in the breeze.

ge-ge mo ge-ge	lowly lowly again lowly lowly
ge-ge no gekoku no	lowly lowly province—
suzushisa yo	coolness

—1813

akikaze ya	autumn wind—
hyoro-hyoro yama no	trembling, trembling
kagebōshi	mountain shadows

—1814

Issa and People

With this attitude toward nature, how did Issa write about people? It turns out that there is great variety in his human-centered haiku, including his sense of compassion, a slightly skeptical attitude that his experiences had fostered, a touch of humor, and sometimes almost pure observation.

One example of Issa's skeptical attitude is undated; it may have been composed during his difficulties with his family, but it may also reflect his view of the government.

hito wa iza	people?
sugu na kakashi mo	there's not even
nakarikeri	a straight scarecrow

—N.D.

Another poem, from relatively early in his career, expresses Issa's view of humans in constant motion (with repeated "k" sounds), observing how they try to gain something outside themselves.

mata hito ni	again someone
kakenukarekeri	rushes past me—
aki no kure	autumn dusk

—1806

Most of Issa's haiku about people, however, take a more gentle, if some-times ironic tone; we may even sense more empathy as well as humor in his verses as the years go by.

harusame ni	in the spring rain
ōakubi suru	giving a huge yawn—
bijin kana	the beautiful woman

—1811

daikonbiki	pulling up radishes
daikon de michi wo	he points the way
oshiekeri	with a radish

—1814

tabibito no	abusing
waruguchi su nari	the traveler—
hatsu shigure	first winter rain

—1818

kogarashi ya	late autumn storm—
niji-shi mon no	the twenty-four-cent
yūjo goya	prostitute shack

—1819

While Issa was clear-eyed about human faults as well as virtues, he had an abiding love of children. They inhabit his haiku with games and fun, oc-casionally take part in family outings, and are generally treated with fatherly

love. As with other groups of Issa poems, there seems to be an increase in compassion as the years go by.

u no mane wo
u yori kōsha na
kodomo kana

—1819

imitating cormorants
the children are more adroit
than cormorants

hatsu uri wo
hittoramaete
neta ko kana

—1819

clutching the season's
first melon—
a sleeping child

harusame ya
neko ni odori wo
oshieru ko

—1820

spring rain—
a child teaches a cat
how to dance

shibui toko
haha ga kuikeri
yama no kaki

—1820

their mother eats
the bitter parts—
mountain persimmon

sue no ko ya
ohaka mairi no
hōki-mochi

—N.D.

the youngest child
visiting family graves
holds the broom

Animals

The last of the above poems has its counterpart among Issa's haiku about animals.

furu inu ga	the old dog
saki ni tatsunari	leads the way—
haka-mairi	visiting family graves

—1823

Which is the better haiku? Which is more moving to the reader? This must depend on each individual, but while the former has the charm of youth, the latter has both a gentle smile and a sense of transience that mark it as exceptional.

Other Issa poems about canines were written a little earlier; they begin with charm, and end with a bow of the head.

inu no ko no	as he sleeps
kuaete netaru	the puppy gnaws
yanagi kana	on the willow

—1819[5]

kuchi akete	mouth open
hae wo ou nari	chasing a fly—
kado no inu	the dog at the gate

—1821

inudomo	the dogs
yokete kurekeri	kindly step aside—
yuki no michi	snowy path

—1822

The last of these poems is a fine example of singular-plural ambiguity in Japanese—is it one dog or several? Or can we choose, as readers, each time we encounter the poem? The same question is true for a poem about a wolf (or wolves); translators are forced to make a choice, losing the nice ambiguity.

ōkami mo	the wolf also
ana kara miru ya	watches from his cave—
aki no kure	autumn darkens

—1814

Issa saw cats quite differently, noticing particularly their romances.

yamadera ya	mountain temple—
sōshi no yurushi no	by the founder's permission,
neko no koi	affairs of the cat

—1817

kuraki yori	out from darkness
kuraki ni iru ya	back into darkness—
neko no koi	affairs of the cat

—1818

A more unusual subject for haiku was the bat, here in two different contexts:

kōmori ya	bats
tori naku sato no	in a village without birds
meshijibun	at dinnertime

—1820

kōmori ya	bats
niō no ude ni	hanging on the arms
burasagari	of guardian statues

—1824

Issa's haiku about horses change over time, as often in his work, from a smile to something more powerful.

uma no ko ga	the young horse
kuchi tsundasu ya	sticks out his mouth—
kakitsubata	irises

—N.D.

yūgiri ya	evening mist—
uma no oboeshi	the horse remembers
hashi no ana	the holes in the bridge

—1819

yūdachi ya	sudden evening shower—
hadaka de norishi	riding naked
hadaka uma	on a naked horse

—1825

Frogs and Snails

Two creatures that Issa seems to have much enjoyed are frogs and snails. The former subject immediately calls to mind Bashō's famous haiku, but Issa adds a connection between the amphibian and himself.

ware wo mite	looking at me
nigai-gao suru	with a sour face—
kawazu kana	the frog

—1808

ore to shite	locked
niramikura suru	in a staring contest with me—
kawazu kana	the frog

—1819

It's unknown how aware Issa may have been of paintings by Zen Master Hakuin (see chapter 5), but one haiku suggests a familiarity with Hakuin's depictions of blind men crossing a bridge, a visual metaphor for seeking enlightenment.[6] Another Issa haiku also has a Buddhist connection, as the frog naturally sits in what resembles a meditation position.

hashi wataru	crossing the bridge
mekura no ato no	after the blind men—
kawazu kana	the frog

—1812

yūzen to shite	viewing the mountain
yama wo miru	in deep contemplation—
kawazu kana	the frog

—1813

As for snails, the first of these four Issa haiku is entitled "Hell," while the last of them suggests the "just this" of Zen.

yū-tsuki ya	evening moon—
nabe no naka nite	calling out from the cooking pot
naku tanishi	pond snails

—N.D.

katatsumuri	hey snail
mi yo mi yo ono ga	look, look!
kagebōshi	it's your shadow

—1814

The Art of Haiku

shiba no to ya	brushwood gate—
jō no kawari no	instead of a lock,
katatsumuri	a snail

—1815

dedemushi no	the snail
sono mi sono mama	goes to sleep and wakes up
neoki kana	just as he is

—1821

Birds

Issa often wrote about the chirps, songs, murmurs, and squawks of birds, so rather than organizing the following haiku by species, they are presented by the different meanings their calls had for the poet. Moving from 1804 to 1817, these haiku sometimes compare sounds, occasionally imitate the birds' voices, and from time to time directly relate to Issa's life—but each vocalization is appropriate to the occasion.

misosazai	although the wren
chi-chi to iute mo	calls out "chi-chi"
hi ga kureru	the day darkens

—1804

uguisu ya	the young warbler
kiiro na koe de	with a yellow voice
oya wo yobu	calls for its parents

—1810

toshitoru ya
take ni suzume ga
nuku-nuku to

—1811

one year older—
sparrows in the bamboo
call "nuk-nuk"

kuina naku
hyōshi ni kumo ga
isogu zo yo

—1812

moor-hens call—
and to their rhythm
clouds hurry by

kari waya-waya
ore ga uwasa wo
itasu kana

—1812

geese murmur-murmur—
are they spreading
gossip about me?

naku na kari
dokko mo onaji
ukiyo zo ya

—1813

wild geese, don't cry out—
it's the same floating world
everywhere

harusame ya
kuwari-nokori no
kamo ga naku

—1813

spring rain—
the ducks not yet eaten
are quacking

uguisu ya
ame darake naru
asa no koe

—1815

the warbler—
its morning voice
covered with rain

The Art of Haiku

ko wo kakusu	circling the grove
yabu no meguri ya	where she hid her chicks
naku hibari	the skylark sings

—1815

senjū no	a mountain cuckoo's song—
tsuke-watari nari	left behind
kankodori	by the previous tenant

—1815

hai-wataru	as I creep across
hashi no shita yori	the hanging bridge—
hototogisu	from below, the cuckoo

—1817

The warbler is usually associated with spring and plum trees; perhaps because there were already so many tanka and haiku praising this bird, Issa often shows another side.

uguisu ya	the warbler
doro-ashi nuguu	wipes his muddy feet
ume no hana	on the plum blossoms

—1814

Issa also enjoyed the different habits of different species.

kitsutsuki ya	the woodpecker—
hitotsu tokoro ni	still in the same place
hi no kureru	as day ends

—1805

misosazai	the wren
kyoro-kyoro nan zo	looking busily busily—
otoshita ka	what have you dropped?

—N.D.

daibutsu no	flying out
hana kara detaru	from the Great Buddha's nose—
tsubame kana	a swallow

—1822

Three of Issa's haiku about crows give the sense that he respected them for their confidence and self-sufficiency; the first word of the third poem *kerorikan* (relaxed, nonchalant) may well have been coined by Issa himself.

hata uchi no	as though
mane shite aruku	plowing the field
karasu kana	walks the crow

—N.D.

nogarasu no	the field crow
jōzu ni tomaru	skillfully perches
bashō kana	on the banana-tree

—N.D.

kerorikan	nonchalant—
to shite karasu to	crow and
yanagi kana	willow

—N.D.

Perhaps Issa's favorite bird was the humble sparrow, and his haiku on this theme cover a wide gamut from observation to compassion to irony. In

The Art of Haiku

the first of these poems, it may be that the children are also sparrows weary-ing their mother.

ōzei no ko ni	tired out
tsukaretari	in a crowd of children—
suzume kana	a sparrow

—1811

oki yo oki yo	wake up, wake up!
suzume wo odoru	sparrows are dancing
chō wa mau	butterflies frolicking

—1812

cha no hana ni	among the tea flowers
kakurenbo suru	playing hide-and-seek—
suzume kana	sparrows

—1813

suzumera yo	sparrows,
shōben muyō	please don't piss
furu fusuma	on my old quilt

—1814

suzume no ko	sparrow chicks,
soko noke soko noke	look out, look out!
o-uma ga tōru	Mr. Horse is passing by

—1819

jihi sureba	when you are kind to them
fun wo suru nari	they poop on you—
suzume no ko	baby sparrows

—1824

One final Issa haiku about birds is unusually pessimistic.

kiru ki to wa	not knowing the tree
shirade ya tori no	will be felled—birds
su wo tsukuru	build a nest

—1824

Structurally speaking, this haiku has the cutting word *ya* in the middle of the second line, dividing the poem neatly in half.

Insects

naki nagara	singing as they go
mushi no nagaruru	insects float down the stream
ukigi kana	on a broken bough

—N.D.

If there is any haiku theme that Issa is most famous for, it is insects. Traditionally, the Japanese have not only admired butterflies, but have particularly enjoyed the voices of crickets, cicadas, and katydids, which are often sold in small cages. Issa, however, goes much further in also writing about flies, fleas, and mosquitoes. His ability to empathize is most apparent here, and it may well be that the struggles of his own life led him not only to compassion, but also to delight in all living creatures.

Beginning with the sound producers, we can note that not all the haiku are primarily concerned with vociferation—some also mention or imply human characteristics, not only in the insects but also in the world around

them. Also to be noted are the five "ah" sounds in the first line of the fifth poem.

yamabito ya
tamoto no naka no
semi no koe

—1810

mountain dweller—
from his sleeve
a cicada's voice

aonoke ni
ochite nakikeri
aki no semi

—1820

falling face-up
and still singing—
autumn cicada

kōrogi no
naki naki hairu
fusuma kana

—1812

calling "naki naki"
the cricket crawls into
the quilt

kōrogi no
shimo yo no koe
jiman kana

—1820

the cricket's voice
on a frosty night—
boasting

tamadana ya
jōza shite naku
kirigirisu

—1813

on the altar
in the place of honor
sings the katydid

negaeri wo
suru zo soko noke
kirigirisu

—1816

I'm turning over
so find another place,
katydid

kirigirisu	the katydid
mi wo urarete mo	even when being sold
naki ni keri	sings

—1820

hanachi yaru	nipping the hand
te wo kajirikeri	that sets it free—
kirigirisu	the katydid

—1825

ware shinaba	when I die
hakamori to nare	take care of my grave—
kirigirisu	katydid

—N.D.

Throughout his life, Issa wrote poems about butterflies. One of the first can be dated to 1788 and takes an appreciative tone, but as time went on his haiku tended to have other elements that make the expression somewhat more complex.

mau chō ni	dancing butterflies—
shibashi wa tabi mo	for a while my journey
wasurekeri	forgotten

—1788

tōri-nuke	where the temple
yurusu tera nari	allows me a short-cut—
haru no chō	a spring butterfly

—1804

The Art of Haiku

yo no naka ya	in this world
chō no kurashi mo	even butterflies keep busy
isogashiki	making a living

—1811

bettari to	blooming thickly
chō no sakitaru	with butterflies—
kareki kana	the withered tree

—1814

kago no tori	the caged bird
chō wo urayamu	looks with envy
metsuki kana	at the butterfly

—1823

The most celebrated of Issa's poems about a butterfly does not have a date, but certainly was composed during his mature years.

niwa no chō	garden butterfly—
ko ga haeba tobi	as the baby crawls, it flies,
haeba tobu	crawls closer, flies on

—N.D.

The scene of a baby trying in vain to reach the butterfly can be considered pure observation, but it can also have a Buddhist reading where we fail to grasp what we seek outside ourselves.

This poem became one of Issa's favorite haiga themes, as he added a painting several times when writing out the verse. Interestingly, he did not depict either the baby or the butterfly, but rather sketched a picture of a small hut (Plate 7-1). This is a case of visually adding to the poem, rather than illustrating it, but we may still ask: Why the hut? One answer might be found by examining the entire composition, in which there is a nice use

of space between the painting and the calligraphy. Is the image giving a sense of context? If so, might the meandering calligraphy suggest the fluttering path of the butterfly?

Issa's signature at the lower left says "hut also Issa." Perhaps he is merely stating that the painting is also by him, but more adventurously we can imagine that he himself is the hut, viewing the scene in the garden. In any case, the painting, like all those by Issa, is quite simple with very modest brushwork, far from the skillfulness of Buson and his followers. This haiga may seem childish at first glance, but the unassuming sincerity of the image, poem, and calligraphy all add together to offer viewers an experience that tends to deepen over time. Issa's haiga, like his haiku, have a unique touch that has made them especially admired in Japan.

Two other attractive insects that Issa clearly enjoyed are the firefly and the dragonfly. As is so often the case with Issa, the poems gain in depth as the years go by.

akatombo
kare mo yūbe ga
suki ja yara

—1810

red dragonfly—
it seems that you too
enjoy the evening

omatsuri no
akai dedachi no
tombo kana

—1817

going to the festival
dressed in red—
the dragonfly

tōyama ga
medama ni utsuru
tombo kana

—1820

distant mountains
reflected in his eyes—
the dragonfly

The Art of Haiku

waga yado ya	at my hermitage
nezumi to naka no	the mice are friendly
yoi hotaru	with the fireflies

—1813

hatsuhotaru	as the first firefly
tsui to soretaru	escapes—
tekaze kana	the breeze in my hand

—1818

ōbotaru	the large firefly
yurari-yurari to	staggering, staggering
tōrikeri	passes by

—1819

Issa's enjoyment of insects continues with some varieties that he wrote about less often; these insects tend to be missing from the work of earlier poets.

nigeru nari	the fleeing
shimi ga naku ni mo	silverfish include
oya yo ko yo	parents and children

—1813

oni mo iya	not a demon
bosatsu mo iya to	not a bodhisattva—
namako kana	a sea-slug

—1814

meigetsu ya	harvest moon—
funamushi hashiru	sea-lice run
ishi no ue	over the rocks

—N.D.

keshite yoi	coming just when
jibun wa kuru nari	I turn out the light—
hitorimushi	a tigermoth

—N.D.

kumo no ko wa	the spider's children
mina chiri-jiri no	all skitter-scatter
misugi kana	to make a living

—1822

Flies, Fleas, Lice, and Mosquitoes

To many people, the most surprising and yet ultimately the most character-istic of Issa's haiku are those about insects that humans tend to dislike most. They were parts of his life that he did not disdain, for as he noted:

naga iki no	flies, fleas, and mosquitoes
hae yo nomi ka yo	live long in my
bimbo mura	poor village

—1820

This did not mean that Issa always welcomed these insects, or that he ig-nored their obnoxious qualities, yet he was able not only to observe them, but also to see life from their point of view with rare empathy.

Flies

waga yado wa	at my inn
hae mo toshitoru	the flies too are a year older—
urabe kana	at the seacoast

—1804

hae uchi ni	when hitting the fly
hana saku kusa mo	I also hit
utarekeri	flowering grasses

—1816

hito hitori	one person
hae mo hitotsu ya	and one fly
ōzashiki	in the large room

—1819

yare utsu na	"don't hit me!"
hae ga te wo suri	the fly wrings its hands
ashi wo suru	and wrings its feet

—1821

utte-utte to	swat, swat—
nogarete warau	the escaping laughter
hae no koe	of the fly

—1822

Fleas

sakazuki ni	in my saké cup
nomi oyogu zo yo	the flea is swimming,
oyogu zo yo	swimming!

—1811

Issa and the Early Nineteenth Century

nomi hae ni	despised by fleas and flies
anadorare tsutsu	today too
kyō mo kurenu	comes to an end

—1813

tsujidō wo	borrowing the roadside shrine
nomi ka ni karite	from fleas and mosquitoes
netari keri	I take a nap

—1814

semaku tomo	although it's small,
iza tobinarae	you can practice jumping—
io no nomi	fleas in my hut

—1814

tobibeta no	the flea
nomi no kawaisa	least skilled at jumping
masarikeri	is the most charming

—1816

nomi no ato	while feeding her baby
kazoe nagara ni	she counts
soeji kana	the flea-bites

—1818

Lice

shirami-domo	also for lice
yonaga karō zo	is the night cold
sabishikaro	and lonely?

—1813[7]

onorera mo
hanami-jirami ni
sōrō yo

—1815

on us too
as we go flower-viewing—
lice

ōkawa e
shirami tobasuru
bijin kana

—1817

throwing her lice
into the broad river—
the beautiful woman

Mosquitoes

hiru no ka wo
ushiro ni kakusu
hotoke kana

—N.D.

noontime mosquitoes
hiding behind
a Buddha

hitotsu ka no
nodo e tobikomu
sawagi kana

—1812

a mosquito has
jumped down my throat—
what a commotion!

kabashira ya
kore mo nakereba
ko sabishiki

—1814

a column of mosquitoes—
but when they're not here
it's a little lonely

waga yado wa
kuchi de fuite mo
deru ka kana

—1816

in my hut
when I just whistle—
here come mosquitoes

abare-ka ni	swinging prayer beads
juzu wo furi-furi	whish-whish at fierce mosquitoes
ekō kana	during the memorial service

—1818

If these poems were not enough, Issa goes one step further, writing about mosquito larvae, surely the most unusual of all his haiku subjects.

bōfuri no	mosquito larvae
nebutsu-odori ya	dancing a Buddhist chant
haka no mizu	in the graveside puddle

—1821

kyō no hi mo	this day
bōfuri-mushi yo	along with mosquito larvae
kure ni keri	comes to an end

—N.D.

Dew and the Dewdrop World

One more subject was very important to Issa: the dew, with the evanescent world that dewdrops call to mind. Here his Pure Land Buddhist beliefs were combined with his observations of nature to create some remarkable haiku. Some of these can be seen as clear descriptions of moments in nature, but others make it clear that the image of dew was of special significance to the poet.

tsuyu no tama	pearls of dew
hitotsu-hitotsu ni	one by one—
furusato ari	my old village

—1806

The Art of Haiku

shiratsuyu to
shirade fue fuku
tonari kana

—N.D.

not knowing the white dew,
he plays his flute—
my neighbor

tsuyu no yo no
tsuyu no naka nite
kenka kana

—1810

a world of dew—
and with the dewdrops,
 quarrels

tsuyu no yo no
tsuyu wo naku nari
natsu no semi

—1811

in a world of dew
singing of the dew—
 summer cicadas

tsuyu chiru ya
sude ni onore mo
ano tōri

—1813

dewdrops fall—
I too will soon
 follow

asa tsuyu ni
jōdo mairi no
keiko kana

—1813

in the morning dew
there is a lesson about
 the Pure Land

tsuyu chiru ya
jigoku no tane wo
kyō mo maku

—1814

dewdrops fall—
the seeds of hell are
 planted again today

oku tsuyu ya	dew settling—
ware wa kusaki ni	when will I become
itsu naran	grasses or a tree?

—1826

The most quoted of all Issa haiku is also about the dew, and was written after his infant daughter Sato died. It perfectly captures the moment when sincere religious understanding meets the deepest feelings of the heart.

tsuyu no yo wa	this world of dew
tsuyu no yo nagara	is just a world of dew
sarinagara	and yet . . . and yet . . .

—1819

Inoue Shirō

Two haiku friends of Issa were noted not only for their verses but for their excellent haiga. The first of these was Inoue Shirō (1742–1812), a doctor from Nagoya who followed his family profession, specializing in obstetrics. Despite achieving fame in this field, he devoted much of his life to literature and the arts. Studying "National Learning" (referring to classic works in the Japanese tradition, such as *The Tale of Genji*) with the celebrated Motoori Norinaga (1730–1801), he also became known for painting, narrative chant, and playing the *biwa* lute.

Living almost his entire life in Nagoya, Shirō achieved his greatest renown as a haiku poet and haiga master, and frequently met with other poets and literati. To some extent he followed the Buson tradition in haiku, but his paintings tend to be much simpler and almost always feature varied ink tones rather than colors. Like Issa, he also liked onomatopoeia in his haiku, as the following two verses make clear:

tō-tō to	"tō-tō" gushes
taki no ochikomu	the waterfall—
shigeri kana	lush vegetation

sasatake ni	falling "saya-saya"
saya-saya to furu	on the bamboo—
shigure kana	late autumn rain

Two more haiku depict winter; there is a pun in the first poem, where *kazahana* can mean "stuffy nose" but can also mean "snowflakes" (which of course have no color or scent).

iro mo ka mo	no color or scent
nakute hanamiru	when flower-viewing—
kazahana kana	stuffy nose[8]

akebono ya	break of day—
arashi wa yuki ni	the storm is buried
uzumorete	in snow

Shirō's view of spring can be represented by another pair of haiku, where he finds new uses for the familiar symbols of plums and warblers.

takusan na	many months and days
tsuki hi ga dekite	have made possible
ume no hana	plum blossoms

dokoyara de	somewhere
uguisu nakinu	a warbler sang—
hiru no tsuki	the moon at midday

Since the cuckoo is a harbinger of summer, some people (not only lovers) might stay out for much or all of the night to hear its first calls. One of Shirō's most evocative haiga, where the image is not specifically stated in the poem, shows a cuckoo, beak open as it sings (Plate 7-2). The bird flies down to the left, the calligraphy follows the same diagonal, and only the signature and seal at the lower right balance this sense of movement, like a visual anchor. The poem sets the scene rather than fully describing it.

kyo koborete	instead of home
suzushiki tsuki no	the cool moon's
mushiro kana	straw mat

The painting is unusual for a haiga in using silk rather than paper as its medium, but this is perfect for the tones of gray in the cuckoo, as though one could almost see right through the bird in the moonlight. And although the painting and poem do not share the same image, one might interpret the character for "moon" (月, originally a pictograph of the crescent moon) as the moon itself, written near the center of the scroll.

If this interpretation seems questionable, it is reinforced by another haiga by Shirō in which the character for "moon" is larger and slightly separated from the calligraphy as it shines over a mountain (Plate 7-3). Here the haiku is very straightforward:

yorozu yo ya	through the ages
yama no ue yori	over the mountains—
kyō no tsuki	tonight's moon

Amazingly, this haiga is composed of a single line. The brush was dipped in gray ink, then just the tip in darker ink, and as the line rises to the right and then descends to the lower right, tones of gray appear that give this single stroke life and energy. Always pliant, the line continues to slightly curl and bend as it moves confidently across the paper. The primary diagonal

The Art of Haiku

that this line describes is countered by the slightly tilting "moon" above it, and here it would be difficult not to agree that Shirō was aware of the moon as a pictographic form as well as a written character.

Three more haiku by Shirō demonstrate some of the range of his poetry, from broadscale views of nature to an indoor observation during the summer.




aki no yo no
akete mo shibashi
tsukiyo kana




the autumn evening ends
but for a moment longer
the moonlit night[9]







izuru hi no
hoka ni mononashi
kiri no umi




the rising sun—
otherwise nothing
but misty ocean







ōari no
tatami wo aruku
atsusa kana




a large ant walks
over the tatami mat—
the heat!




Takebe Sōchō

Even more immersed in painting than Shirō was the poet Takebe Sōchō (1761–1814), who came closer to the Buson tradition by adding color to many of his haiga. Sōchō painted in other styles as well, but his most significant works are his haiku-paintings, which appear on screens as well as scrolls.

Sōchō's family had accompanied the shogun Tokugawa Ieyasu (1542–1616) to Edo when the new capital was being established.[10] Sōchō's father was a well-known calligrapher named Yamamoto Ryūsai (n.d.), leading to a haiku when Sōchō was visiting Takasago (Hyōgo Prefecture).




Takasago ni
oya no sho mo ari
fude hajime




at Takasago
my father's calligraphy—
his first brush-strokes of the year




As well as learning calligraphy from his father, Sōchō studied haiku with Kaya Shirao (1738–91), a follower of the Bashō tradition, and practiced painting under several teachers. Leading an artistic life, he also excelled at flower arrangement and the tea ceremony, and was close friends with a number of artists and poets including his brother-in-law Kameda Bōsai (1752–1826), a scholar-calligrapher-poet-painter in the Chinese style, who noted that Sōchō "loved saké and loved guests."[11]

Like Shirō, Sōchō had a wide range of subjects and moods in his haiku, often abetted by paintings to form haiga. One of his most delightful for both image and poem is *Discussions Under a Mosquito Net* (Plate 7-4). Although travel was restricted by the government, going on pilgrimage was often a good excuse to see the country and meet people, and we can imagine such a case at this country inn. The poem itself sounds like a complaint:

susuki kara	from the pampas-grass
ka no deru yado ni	mosquitoes came into the inn
tomarikeri	where I stayed

What kind of painting might one expect with this haiku? The figures are huddled to the left, while semicircles indicate a rump, a lamp, and a sedge hat, with the poem to the right. Indeed, Sōchō has taken a positive view toward the scene: the guests are huddled under a single mosquito net, giving them the opportunity to chat among themselves. In the back, a woman seems to be asleep, but a baby looks on wonderingly as several old geezers smoke, wave a fan, and gossip. The painting has offered a new interpretation of the poem: the usually obnoxious mosquitoes seem to have done the travelers a favor.

Sōchō also painted a pair of screens with haiku and images from the twelve months, in which this haiku appears in the sixth month.[12] Other notable poems included on this screen were also written when traveling.

The Art of Haiku

asa no ma ni	through the morning
sakura mite kite	I watched cherry-blossoms
oinikeri	become old

—SECOND MONTH

nemu saku ya	seeming to desire
tsuge no kokushi mo	a small boxwood comb—
hoshige ni te	the blooming silk-tree

—SIXTH MONTH

ro ni yoreba	leaning on the hearth
kamo ga matarete	waiting for the duck to roast—
kamo no koe	voices of wild geese

—EIGHTH MONTH

keisei wa	the courtesan
mino mo tashiname	scolds even the straw coat—
hatsu shigure	first winter rain

—ELEVENTH MONTH

Sōchō's haiku for the twelfth month has a headnote: "Coming to Ikuta Forest, where winter cherry trees are planted by the side of the beach, and since this is a shrine with ancient ceremonies":

koyuki seyo	let the light snow fall
kasa kite mawan	I'll dance with my hat
kami no mae	in front of the god

—TWELFTH MONTH

Another twelfth-month poem comes on a hand-scroll by Sōchō dated 1799.[13]

toshi kurete	at year's end
hi wo taku ni sae	even making a fire
omoshiromi	is delightful

We might imagine that once a poet-painter has combined a haiku and an image, that is how it will be combined from that time on, but Sōchō proves this is not always true. He painted two distinctly different images for the same verse:

dore kara to	where did it come from?
ogi no tonari ya	next to waterside reeds—
nochi no tsuki	late autumn moon

One image simply shows the reeds in a rather literal rendering of the image, but another shows two elderly people sitting and conversing (Plate 7-5).[14] What relation does this have to the haiku? Because moon-viewing is a favorite activity in Japan, we might assume that the couple has gone out for this purpose, but it seems they are enjoying their conversation, and perhaps the moon is just beginning to appear. In any event, the overlapping figures created with relaxed brushwork may give us something of the same pleasure that they are feeling.

There were of course many other fine poets contemporary with Issa. While none of them achieved his range of subject matter and depth of feeling, they did create some fine haiku, and especially in the cases of Shirō and Sōchō, added a great deal to the haiga tradition.

By the first half of the nineteenth century, haiku painting and haiku poetry were thoroughly established as important elements in Japanese culture, practiced by a great number of people from all walks of society. However, when Japan opened to the West in 1868, all the traditional arts faced new challenges. The following chapter will explore different responses to this challenge, which included the flourishing of both traditional and new forms of haiku and haiga.

The Art of Haiku

8

Shiki and the Modern Age

THE OPENING OF JAPAN to the West in 1868 had consequences for almost every aspect of Japanese life. Caught in the turmoil between Westernization and traditional values, haiku writers continued, but in different directions. Some poets accepted the guidelines from the past, while others found new freedoms, including abandoning the 5–7–5 structure that had been followed more or less rigorously for several hundred years.[1]

Masaoka Shiki

At the turn of the twentieth century, the leading haiku poet, who was also a theorist and tanka master, was Masaoka Shiki (1867–1902). If Bashō, Buson, and Issa have been accepted as the three greatest haiku poets, Shiki is often considered the fourth; despite his short life and other literary activities, his influence was profound.[2]

Shiki was born in Matsuyama, a city on the island of Shikoku, to a modest samurai-class family. His father was an alcoholic who died when Shiki was five, and his mother taught sewing to support the family. After studying the Chinese classics with his grandfather and spending three years at the Matsuyama Middle School, Shiki moved to Tokyo (no longer called Edo in the new Meiji era) for further studies in 1883. Some of his earliest haiku date from this time, but they do not yet show the special touch that marks his later works.

ki wo tsumite	the tree cut down,
yo no akeyasuki	dawn comes early
ko-mado kana	through the little window

—1885

In Tokyo, Shiki first attended a preparatory college and then Tokyo Imperial University, focusing on classic Japanese literature and haiku (in 1888 he also became fascinated with baseball). However, his interest in formal education declined just as the health difficulties that were to eventually cost him his life began to appear. He left college after failing his examinations in 1892; he later wrote that when he studied the exam questions, new haiku flew into his mind.[3] Shiki thereupon decided to focus his life on poetry; he began to write a haiku column for the newspaper *Nippon,* and soon became its poetry editor, a position that put him at the forefront of the haiku world.

Over the next decade Shiki published hundreds of poems of his own and by his young friends, as well as articles and essays. He became the voice of the new haiku movement that soon became a strong force in Japanese literature. In fact, it was Shiki's insistence that haiku was indeed a form of literature that helped to give it significant intellectual standing in the unsettled cultural times before and at the turn of the century. He himself wrote about eighteen thousand haiku, an amazing total considering that they were mainly composed over a twelve-year span between 1891 and his death in 1902.

The early 1890s were an especially fertile period for Shiki's poetry, and he poured forth haiku that can be divided into two general categories. The first is a large group of poems that do not directly mention elements of the newly Westernizing Japan. Some of these seem as though they could have been written a hundred years earlier, while others begin to show a different tone and voice.

The Art of Haiku

iwa-iwa no	cliff after cliff
wareme-wareme ya	crevice after crevice—
yama tsutsuji	mountain azaleas
—1891	

te no uchi ni	in my hands
hotaru tsumetaki	emitting a cold light—
hikari kana	the firefly
—1892	

kogarashi ya	cold winds—
jizai ni kama no	the squeak of the kettle
kishiru oto	hanging free
—1892	

getabako no	from the back
oku ni narikeri	of the shoe closet
kirigirisu	a katydid sings
—1892	

hadakami no	pressing my naked body
kabe ni hittsuku	against the wall—
atsusa kana	the heat!
—1893	

suzushisa ya	coolness—
kami to hotoke no	gods and buddhas
tonaridoshi	are neighbors
—1893	

This last haiku suggests the close relationship that had developed over centuries between the native Shinto religion and Buddhism, whose deities were often

seen as manifestations of each other. However, this relationship was officially severed at the Meiji Restoration of 1868, when the new government promoted Shintoism and denigrated Buddhism. In a popular anti-Buddhist frenzy, many monks returned to lay life, and a number of temples were abandoned or even destroyed, forming the background for two other haiku by Shiki.

mujūji no	at the closed temple
kane nusumarete	with its bell stolen—
hatsuzakura	first cherry-blossoms

—1893

yare tsukusu	at the poverty-stricken
bimbō-dera no	broken-down temple—
bashō kana	a plantain

—N.D.

Three more haiku bring new Westernized elements into the poem.

hasu no hana	lotus flowers
saku ya sabishiki	blooming at the lonely
teishajō	railroad station

—1893

kisha sugite	a train passes by
kemuri uzumaku	its smoke swirling
wakaba kana	in the new leaves

—1895

hitori iru	alone in
henshūkyoku ya	the newspaper office—
satsuki ame	fifth-month rains

—N.D.

The Art of Haiku

Shiki was ambiguous about how much of the new industrializing Japan to allow into haiku. On one hand, he recognized that the modern world was now part of people's experience and therefore appropriate to include in poems, but he also felt that many of the new images had little poetic content. In his *Talks on Haiku from the Otter's Den* of 1892, he wrote, "What mental reaction does the word 'steam engine' evoke? . . . or try listening to such words as 'election,' 'competition,' 'disciplinary punishment,' 'court,' and the like, and see what images they call up."[4]

Shiki's own solution to this problem was to be very judicious in the use of new Westernizing words and concepts. Nevertheless, he was definitely influenced by the events of his own day; for example, despite having developed the early stages of tuberculosis, he insisted upon traveling to China as a war correspondent in the spring of 1895. To his disappointment, the war had ended before he arrived, but during his time there he composed a few tanka and haiku, including these verses written in Chin-chou.

nagaki hi ya	days lengthen—
roba wo oiyuku	a donkey chased by
muchi no kage	the shadow of a whip[5]

—1895

nashi saku ya	pear trees blooming—
ikusa no ato no	after the war,
kuzure-ie	destroyed houses

—1895

On his way back to Japan that summer, Shiki suffered a lung hemorrhage that was so serious he was not expected to live. He slowly recovered, however, convalescing at the house of his friend Natsume Sōseki (1867–1916) in Matsuyama. Sōseki had focused on haiku before becoming one of Japan's most successful novelists, and we can compare verses with the same final line.

soko no ishi	stones at the bottom
ugoite miyuru	look like they're moving—
shimizu kana	clear waters

—SŌSEKI

kanemochi mo	rich people and bears
kuma mo kite nomu	both come to drink—
shimizu kana	clear waters

—SHIKI

Judging from these two examples, Shiki was the more adventurous poet, but they each offered a fresh view of an otherwise familiar scene.

While in Matsuyama, Shiki introduced his haiku style to a group of young poets and wrote *Haikai taiyō* (Elements of Haiku), one of a series of works in which he discussed the past and the future of haiku. Feeling that the form was being stultified by too many rules and regulations, he began to search out new guidelines that were not entirely revolutionary but would allow some freedoms from past tradition.

Parting from Sōseki in fall of 1895 in order to return to Tokyo, Shiki wrote:

yuku ware ni	for me going
todomaru nare ni	and you staying—
aki futatsu	two autumns

—1895[6]

Back in the metropolis, Shiki's outlook had changed; despite his growing circle of friends and admirers, a sense of solitary selfhood sometimes prevailed, no doubt increased by his growing illness. Two years after his haiku about gods and buddhas as neighbors, he wrote:

The Art of Haiku

yuku aki no	autumn passing—
ware ni kami nashi	for me no gods
hotoke nashi	no buddhas

—1895

More haiku from 1895 also have a somewhat pessimistic tone.

keshi saite	poppies bloom
sono hi no kaze ni	and the same day
chirinikeri	scatter in the wind

—1895

buke machi no	where samurai once lived
hatake ni narinu	now there are fields—
aki nasubi	autumn eggplants

—1895

kumo korosu	after killing the spider
ato no sabishiki	it gets lonely—
yosamu kana	cold evening

—1895

That same year Shiki wrote what was to become his most famous haiku.

kaki kueba	as I eat a persimmon
kane ga narunari	a temple bell resounds—
Hōryū-ji	Hōryū-ji

—1895

Interestingly, it was not the bell of Hōryū-ji that Shiki actually heard, but that of Tōdai-ji; he decided that mentioning the earlier temple (which had persimmon orchards nearby) would have more resonance. This is despite

Shiki's claim that haiku should follow the conception of *shasei,* or "painting from life." Perhaps the most important element of Shiki's theories, this term originally came from Chinese painting, and was opposed to the more idealistic conception of *sha-i* (painting the idea), which was so important for literati art. *Shasei* could be equated with naturalism, and was strongly influenced during Shiki's time by Western-style painting; Shiki's idea was that *shasei* could equally apply to haiku poetry.

In some respects, stressing *shasei* was one means to get away from poems written in familiar ways on familiar themes, or poems based on other poems. Shiki loved persimmons, and just as he was biting into one, he heard the temple bell. While there was no actual connection between the two events, they nevertheless seemed to relate to each other beyond logic. Somehow the concurrence of the immediate with the seemingly timeless, of the two different senses of tasting and hearing, and of the personal with the traditional, all worked together to create a poem that is still taught in Japanese schools today.

Shiki and Bashō

Although Shiki is sometimes considered a harsh critic of Bashō, the truth is much more complex, especially since Shiki wrote about Bashō often and not always consistently. On the negative side, he complained in his 1893 essay "Some Remarks about Bashō" that the admiration of the master had become almost a religion in which he was venerated like a saint. To counter this trend, Shiki wrote that 90 percent of Bashō's haiku were not very good, although he believed that the other 10 percent were marvelous. What he admired in these successful haiku was a sense of grandeur combined with natural observation about the life around him. On the other hand, he felt that Bashō "discarded scenes which arise from imagination."[7] With his admonition to follow *shasei,* one might not expect Shiki to favor haiku stemming from imagination, but that was just what he admired in the poems of Buson, whose reputation Shiki did much to foster.

Shiki realized that he and Bashō were very different in their choice of lifestyles, and wrote a haiku with the title "Viewing a Portrait of Bashō."

ware wa kotatsu	I by the little stove,
kimi wa angya no	you portrayed on your
sugata kana	pilgrimage

—1894

Realizing that the wandering of Bashō was not something he could emulate, Shiki nevertheless traveled when given the chance, but his health problems cut short any possibilities of larger journeys. Instead, he worked on his art theories and criticism, publishing many articles in *Nippon*.

In 1898, Shiki wrote a significant essay entitled *Furu ike ya* (Old Pond) in which he traced the entire history of renga and haiku up to the time of Bashō. Shiki basically felt that earlier haiku suffered from lack of depth and not enough natural observation, too often opting for humor or reworking past themes. In contrast, he wrote that when Bashō came up with his "old pond" poem in 1686, "That's it! At this time, Bashō got enlightened. . . . He found that an ordinary thing can be immediately a verse . . . and rejected unpoetical, intellectual, made-up verses. . . . It is clear that he reached a hitherto unknown region. . . . Bashō opened his living eyes to the frog; that meant he opened his eyes to nature. . . . The meaning of this verse is just what is said; it has no other . . . he heard the sound of a frog jumping into an old pond—nothing should be added to that."[8]

Shiki had earlier written that he doubted if this poem marked the Zen experience of *satori*, but in common with Zen, the haiku "truly 'describes as is'—the 'as is' became a poem."[9] Whether or not the poem was an enlightenment experience for Bashō has been debated, but for Shiki it marked the beginning of true haiku and the quintessence of what he considered *shasei*, painting from life.

As time went on, Shiki elaborated his views on haiku, and sometimes changed them. In his 1897 book on Buson, for example, he wrote that

Buson's haiku were the equal of Bashō's, with more "positive beauty" and pictorial qualities. In an extension of (if not opposition to) *shasei,* Shiki insisted that "literature should not be based upon actuality alone. . . . The writing of an author of ordinary experience will ultimately be unable to avoid triteness. . . . [An author's] imagination ranges from beyond his country's borders throughout the universe and seeks beauty in absolute freedom. . . . In haiku there is only one poet like this: Buson."[10] On the other hand, in his final year of 1902, Shiki wrote, "It is imagination which is shallow and has nowhere near the variety of the sketch from life. I do not say that a work based on the imaginative method is always bad, but it is a fact that many of the works which rely on it are often bad."[11]

What are we to make of these seeming contradictions? First, poets are certainly allowed to change their minds as the process of creation and evaluation matures, but there are other factors in the case of Shiki. His own state of health limited his experiential world as his final years went by; this gave him a different view of the importance of imagination than one might expect, since he could now focus his attention on the smallest of themes. In addition, he realized that everyday experience can be the basis of fine haiku, but finding the extraordinary in the ordinary is what makes them sing. Perhaps he would have agreed that the imagination in the service of the everyday is what the finest haiku have to offer—the sound of water after the frog's jump energizes our own imaginations, and Bashō did not need to elaborate any further.

Shiki's Final Years

Although he had basically recovered from his major lung hemorrhage of 1895, Shiki became more and more of an invalid over the next months and years. By November, he was experiencing pains in his pelvis that made it difficult to walk. In 1896 he was confined to bed for a time, and he continued his ideas of *shasei* by writing of his life, now limited to house and garden.

yuki furu yo	it's snowing—
shōji no ana wo	I can see it through a hole
mite areba	in the paper window
—1896	

yuki no ie ni	in this snow-covered house
nete iru to omou	all I can think of is that
bakari nite	I'm just lying here
—1896	

furu niwa ya	old garden—
tsuki ni tampo no	emptying a hot-water bottle
yu wo kobosu	into the moon
—1896	

Despite the new elements in these poems, we can see traces of the past as well. The hole in the paper window was an image used by Issa, and the first line of the third poem suggests Bashō's "old pond."

In 1897, Shiki and his close followers began to edit *Hototogisu,* which was to become the most influential journal in the new haiku world, drawing huge numbers of submissions. Of course, this also increased the work Shiki had to do, but he kept up a frenetic pace despite his illness, sometimes allowing himself the reward of his favorite fruit.

sanzen no	after inspecting
haiku wo kemishi	three thousand haiku—
kaki futatsu	two persimmons
—N.D.	

After I Die

kaki kui no	you can report
haiku konomishi to	I ate persimmons
tsutau beshi	and loved haiku

—1897

That year, Kawahigashi Hekigotō (also spelled "Hekigodō," 1873–1937), whom Shiki made haiku editor of *Hototogisu,* became ill with smallpox. Shiki was sympathetic:

samukarō	probably cold
kayukarō hito ni	probably itching
aitakarō	probably wanting visitors

—1897

For Shiki, as each season passed his world became smaller. Nevertheless, he could focus his attention on both beauty and the less enjoyable aspects of nature.

Furansu no	in the French
ichirinzashi ya	single-bud vase—
fuyu no bara	a winter rose

—1897

hae nikushi	hateful fly—
utsu ki ni nareba	when I want to swat it
yoritsukazu	it won't come near

—N.D.

Shiki became very fond of roses, and as he became more and more confined to his room, he liked to paint them in *shasei* style.

bara wo kaku	painting roses—
hana wa yasashiku	the flowers are easy,
ha wa kataki	the leaves difficult

—N.D.

He also made a number of watercolor sketches of such subjects as fruit (Plate 8-1). There is a definite influence here from Western art, but Shiki's haiku-style focus is also apparent.

One of Shiki's earlier enthusiasms was now reduced from watching to just listening.

natsugusa ya	summer grasses—
besu-bōru no	people in the distance
hito tōshi	playing baseball

—1898

Unfortunately, Shiki's tuberculosis settled in his spine and became both debilitating and very painful. He tried to work on reforming tanka the way he had with haiku and achieved some success, but his energy was limited. As the seasons passed, he found that he couldn't walk without a cane, then couldn't walk at all, then could just sit up, and finally had to spend his time lying down.

After Buying My First Cane

tsue ni yorite	due to my cane
tachi agarikeri	I could stand up!
hagi no hana	bush-clover blossoms

—1899

In December of 1899, Shiki's friend and follower Takahama Kyoshi (1874–1959) arranged to have a glass door installed between Shiki's room and his garden.

garasu goshi ni	winter sun shines
fuyu no hi ataru	through the glass door—
byōma kana	sickroom

—1899

ringo kūte	eating an apple
botan no mae ni	in front of peonies
shinan kana	is how I'll die

—1899

In 1900 there was a great fire at Takaoka, and Shiki responded from his sickbed.

ie no naki	twenty thousand people
hito ni-man nin	homeless—
natsu no tsuki	the summer moon

—1900

This haiku can have various interpretations. One might feel Shiki was somewhat heartless to invoke the moon when people had lost their homes, or one might imagine that he was making an ironic contrast. But for people without dwellings, the moon might also be their companion; as good haiku can do, this one invites the reader's participation to bring forth its meaning or meanings.

Most of Shiki's later haiku, however, center on the experience of his room and the garden just outside.

akaki ringo	a red apple
aoki ringo ya	and a green apple
taku no ue	on the table

—1900

Facing the Garden

keitō no	cockscombs—
jūshi-go hon mo	there must be about
arinu beshi	fourteen or fifteen

—1900

These poems, especially in translation, may seem too simple, but they have become quite famous. The poems highlight the sheer experience of looking at apples of different colors, or at brilliantly red autumn cockscombs—any further responses and associations are left to us.

In his final two years, Shiki found his life even further reduced.

kaki kuu mo	also for eating persimmons
kotoshi bakari to	I think I have only
omoikeri	this year

—1901

mainichi wa	every day
budō mo kuwazu	not even eating grapes—
mizu-gusuri	just drinking medicine

—N.D.

kusuri nomu	cold season—
ato no mikan ya	after swallowing medicine,
kan no uchi	the tangerine!

—1902

Shiki was now taking morphine several times a day, and after each dose he could read, write, or sketch for a little while. He still found Zen texts difficult, such as the Chinese koan collection the *Blue Cliff Record,* but he could enjoy the flowers, fruits, and vegetables that were in his garden or brought to him.

kai shikanuru	still impenetrable
Hekiganshū ya	the *Blue Cliff Record*—
zōni-bara	my stomach full of soup

—1902

kubi agete	stretching my neck
ori-ori miru ya	I can sometimes take a look—
niwa no hagi	garden bush-clover

—1902

kobocha yori	eggplants are
nasu muzukashiki	more difficult than pumpkins
shasei kana	to paint from life

—1902

kōbai no	red plum blossoms
chirinu sabishiki	scattered in loneliness
makura moto	by my pillow

—1902

kuroki made ni	a purple deep
murasaki fukaki	to the point of blackness—
budō kana	grapes

—1902

At the end, Shiki could still dictate haiku to his followers. Here, in a poem spoken only hours before he died, the final word *hotoke*, which means "Buddha," is also used for a body at death.

The Art of Haiku

hechima saite	snake-gourd in bloom—
tan no tsumarishi	my lungs clogged with phlegm—
hotoke kana	*hotoke*

—1902

Takahama Kyoshi

The two major followers of Shiki took different paths in moving haiku into the new world of twentieth-century Japan. Takahama Kyoshi (1874–1959), born near Shiki's original home in Matsuyama, was more conservative than Hekigotō, maintaining tradition without being stultified by it. He met Shiki in 1891, and soon became his follower and friend. After Shiki's death, Kyoshi became editor of *Hototogisu,* while Hekigotō took over the daily haiku column for *Nippon.* Kyoshi soon opened his journal to other forms of writing, and for a few years starting in 1909 he stopped composing poetry himself, but returned with a haiku column in *Hototogisu* beginning in 1912.

Over the course of his long life Kyoshi insisted upon simplicity, but was ready to accept other rhythms than 5–7–5 while still favoring seasonal associations. A few of his early haiku give a sense of his general style.

fuyugare no	winter decay—
michi futasuji ni	the road divides
wakarekeri	in two

—1894

akikaze ya	autumn wind—
ganchū no mono	in my eyes,
mina haiku	everything is haiku

—1903

kiri hito-ha	a single paulownia leaf
hiatari nagara	catching the light
ochinikeri	as it falls

—1906

Admirers of Kyoshi point to his evocative and unpretentious lucidity; critics sometimes complain that his poems lack the layers of meaning one can sometimes find in the haiku of Shiki. Kyoshi's best poems from his middle years, however, can evoke a sense of mystery.

hebi nigete	the snake has fled
ware wo mishi me no	but the eyes that looked at me
kusa ni nokoru	remain in the grasses

fumite sugu	as soon as
daisy no hana	I walk on it,
okiagaru	the daisy rises up

akikaze ni	in the autumn breeze
kusa no hito-ha no	one blade of grass
uchi-furuu	oscillates

sankaku no	the triangular face
tokage no kao no	of the lizard—is it
sukoshi nobu ka	getting longer?

Other haiku of Kyoshi contain touches of humor that are very welcome.

hana no ue ni	with a fallen leaf
ochiba wo nosete	on his nose—
higoi uku	a golden carp

The Art of Haiku

nusundaru	on the hat
kakashi no kasa ni	stolen from the scarecrow
ame kyū nari	sudden rain
yorokobi ni	when she's happy
tsuke uki ni tsuke	or when she's miserable
kami arau	she washes her hair

Two of Kyoshi's later haiku, from 1936 and 1938 respectively, show on the one hand his ability to find a nice contrast of images when traveling, and also his *shasei*-style observation.

London no	treading on London's
shunsō wo fumu	spring grasses—
waga zōri	my Japanese sandals
ware omou	just as I thought—
mama ni bōfura	mosquito larvae
uki shizumi	rise and sink

Kawahigashi Hekigotō

Although equally a follower and friend of Shiki, Hekigotō was very different from Kyoshi in temperament and poetic style. He too was born in Matsuyama and met Shiki in 1890 or 1891, soon becoming a believer in *shasei*. After he became haiku editor of *Nippon* in 1902, however, Hekigotō did his best to revolutionize haiku and cast away what he considered stifling regulations, such as the 5–7–5 syllable count.[12] Although his early verses had been more or less traditional, he became the voice of "new haiku" through his column in *Nippon*, through traveling and proselytizing from 1907–1911, and especially through his own haiku. A comparison of his verses from

1906 and 1918 makes this clear, not only in the syllable count of 5–7–5 versus 6–7–10, but also in theme and expression.

omowazu mo	unexpectedly
hiyoko umarenu	little chicks are born—
fuyu sōbi	winter roses

ringo wo tsumami	picking up an apple—
iitsukushite mo	even if I've said it all
kurikaesaneba naranu	I must definitely say it again

Another Hekigotō haiku with unusual rhythms has a total of twenty-six syllables compared to the traditional seventeen.

konogoro tsuma naki yaoya	nowadays the widowed grocer
na wo tsumu negi wo tsumu	loads the greens, loads the onions
aruji musume	with his daughter

Hekigotō believed that haiku should simply be short poems rather than rhythmically rigid, so he also thought fewer syllables could be effective.

onna wo soba e	a woman next to me
sode fururu	our sleeves touch
momo	peaches

tō hanabi	the sound of
oto shite	distant fireworks—
nani mo nakarikeri	nothing else

Since in Japan haiku are usually written or printed in a single column, this latter poem might be translated into a single line:

the sound of distant fireworks—nothing else

Nevertheless, why did Hekigotō usually add words and syllables to his poems rather than reducing them? This may have been partially for the extra meanings he could include, but it could also have been intended to make the reader or listener pay attention to the new expanded rhythms. It also allowed more contrast to the nature images that frequently end his poems.

kojō no tachi	sounds of expanding the factory—
hirogaru oto mo	today again is clear
kyō mo seifū no hare	with a west wind

waga kao ni iro shita koto	no one has commented that
tare mo iwananda	my face is the color of the dead—
yoru no mushi no ne	insect voices at night

In addition to his experiments with rhythms, Hekigotō tried to use words the way impressionist painters used colors.

yama made	as far as the mountains
mikan irozukinu	tangerines paint their hue
kabe wo iru nuru	coloring the walls of the house

Hekigotō's calligraphy was also eccentric. To some degree he followed a late-nineteenth-century Japanese interest in early styles of Chinese scripts, but he did so with his own spirit, somehow achieving a balance between bold exuberance and childlike simplicity. He frequently wrote on *tanzaku*, especially when decorated paper could contrast with his blocky characters to create an effect of dramatic innocence. In one such example, he praises a natural scene just outside of Kyoto (Plate 8-2).

Ōhara nara	if it's Ōhara
Yamabe no taki ya	then at the Yamabe Waterfall
den tsukuri	building a shrine

The calligraphy is typical for Hekigotō, with thick wet lines, simple Chinese character forms in loose standard script, a few equally bold Japanese syllables, and a slightly irregular rhythm in the sizing and spacing of the forms. As one examines this work, the seemingly spontaneous calligraphy begins to take on more subtleties. Although Hekigotō used the pause sound *ya* at the end of the second line, the calligraphy itself pauses after the first line. Along with the more strongly brushed forms, this creates a contrapuntal rhythm that might be expressed as:

ŌHARA nara	If it's ŌHARA,
Yamabe no TAKI ya	then at the Yamabe WATERFALL—
DEN TSUKURI	BUILDING a SHRINE

In this manner, calligraphy is able to enhance and add shades of meaning to its texts. The double patterns of clouds on the *tanzaku,* in blue, purple, and gold, also convey a hint of natural splendor to the scene being described in the poem. While the haiku at first may seem to be of no great interest, its formulation in this small work of art shows how calligraphic presentation can add a great deal to any written text.

For some years Hekigotō's innovations swept the day, and he was considered the leading poet of the new haiku movement. Eventually, however, much of the public found him too strange, while other poets found him difficult to emulate, and as a result his influence waned. When Kyoshi wrote in 1927 that haiku should sing of birds and flowers, this more traditional goal found many followers. As a kind of epitaph, Kyoshi commented about Hekigotō that "the path he took led in the end to failure, but I would like to think of it as a brilliant failure."[13]

The Art of Haiku

Fukuda Kodōjin

Another friend and follower of Shiki who created interesting haiku was Fukuda Kodōjin (1865–1944). Born in Shingū in Wakayama, he was a precocious child who wrote his first haiku at the age of five by Japanese count (we would consider him four).

tsurube kara	from the bucket
yo ni tobidetaru	jumping into the world—
i no kawazu	frog in the well

This could well describe the young Kodōjin himself: he was eagerly learning all that he could, including both Japanese and Chinese literature, and while still in school began to compose his own Chinese-style poems.[14] He moved first to Kyoto, for further study in poetry and also painting, then in the early 1890s to Tokyo, where he focused his attention on Chinese-style poetry. However, after meeting Shiki, Kodōjin became part of his haiku group, and by 1894 he was being praised and published in *Nippon* under his haiku name of "Haritsu."

Several verses from 1898 show Kodōjin's ability to give new life to familiar imagery as well as bring in new themes.

haru no kasa	spring river—
chasana geta no	a tiny wooden clog
nagareyuku	floats by
ganjitsu no	New Year's
shimbun ōki	newspaper—
tsukue kana	a big deskful!

fune ni kite	arriving at the boat
Nankin no hito	a Chinese from Nanking
uchiwa uru	sells round fans

In 1899 Kodōjin joined the staff at *Nippon* and soon became its editor for Chinese-style poetry. In 1901, however, he moved back to Kyoto, where he spent the rest of his life.

Rather than a haiku poet per se, Kodōjin was a literatus who followed the Chinese tradition of self-cultivation through the practice of several arts, including poetry, calligraphy, and painting. His temperament seems to have been modest; he did not seek fame or publicity for his work, so he did not become as celebrated during his lifetime as did Shiki, Kyoshi, and Hekigotō. Yet Kodōjin's poems in both Japanese and Chinese, as well as his paintings, have attracted favorable attention for their combination of skill and personal expression.

Kodōjin made a very modest living teaching Chinese and Japanese poetry; his haiku remain important as a way of expressing themes from the past as well as those of his own day.

waga hin wa	poverty
hone ni tesshite	penetrates my bones—
kamiko kana	paper clothes
gunkan no	next to the battleship
soba ni bora tsuru	a small boat
kobune kana	casting for mullet
yakeato no	by the burned-out campfire
furu ike kōru	the old pond is frozen—
ashita kana	dawn

The last of these poems is especially interesting as it offers a new context for

Bashō's old pond, perhaps suggesting that the haiku world was not flowing freely.

Kodōjin's haiku do not tend to break new ground technically, but he did experiment with some of the new ideas, composing this poem in an 8-8-2 syllable count while on a 1906 visit to his hometown in Wakayama:

naruko kashimashi	the noise of the clappers
kakashi shizuka nari	the silence of the scarecrow—
yū	evening

Although most of his paintings were in Chinese literati style, Kodōjin also created some unusual haiga. In one case he wrote out a poem on a printed design of bamboo, chrysanthemums, and orchids on Chinese paper (Plate 8-3). The calligraphy of the haiku parallels the long bamboo tube, while the signature "Haritsu" is over the shorter tube on the lower left.

take no ko ni	a bamboo shoot
tsumazuku ware wo	causes me to trip—
waraikeri	I laugh at myself

Writing haiku and creating haiga no doubt gave Kodōjin an enjoyable change from his more elaborate Chinese-style poems and landscapes. One of his most delightful visual works is a haiga called *Snow Daruma* (Plate 8-4). Since Daruma (Bodhidharma) was the First Patriarch of East Asian Zen, one might not expect humor, but Daruma was so well accepted by the Japanese populace that satirical or comic renditions of this famous monk were common. According to folklore, when Daruma meditated in front of a wall without moving for nine years, his legs withered and fell off. What we call a snowman therefore in Japan is called a "snow-daruma" or "snow-buddha" (see chapter 7 on Issa). Here Kodōjin's brushwork in white on the red paper is extremely simple—a single curving line for the figure, with two

dots and a dash for his humorously sad face—while the poem nestles above and to one side of the figure.

yuki daruma	snow Daruma—
sude ni jakumetsu	already entering
itaru kana	nirvana

Since entering nirvana has been described as moving beyond and extinguishing all traces of this world, the melting of a snowman could be seen as an everyday symbol of this spiritual goal.

Kodōjin died in 1944 at the height of the Second World War, perhaps in part from poverty and a lack of nourishment, but he never gave up his ideal of a literati lifestyle. His haiku, as well as his Chinese-style poems, calligraphy, and paintings, all attest to the personal spirit that motivated him; far from the search for fame and influence, he was able to appreciate nature, including human nature, with a calm heart and mind.

momiji fukashi	so deep the autumn leaves
ishi kumo wo	that rocks
haku tokoro	exhale the clouds

kohara hi sashite	Indian summer sunlight
shokan mabayuki	pierces the books on the
tsukue kana	bedazzled desk

ka no naka	taking a bath
gyōzui yaru ya	with the mosquitoes—
tera otoko	the temple sexton

ame mitsubu	three drops of rain
fureba kochi fuki	east wind
umi aruru	ocean

The Art of Haiku

Taneda Santōka

If Kodōjin was basically traditional in his approach to haiku, Taneda Santōka (1882–1940) was unique. Originally a follower of a poet in the Shiki circle named Ogiwara Seisensui (1884–1976), Santōka soon found his own style. His haiku are perhaps the most basic and unadorned of any Japanese poet, yet they so clearly and honestly express his often difficult life that they seem to reach directly to the heart. Of all Japanese haiku masters of the twentieth century, he has most intrigued the West, with several books of his verses now available in English.[15]

Santōka was born in a small village; his father was a landowner, heavy drinker, and womanizer, and his mother committed suicide by jumping down a well when Santōka was eleven years old. His older brother died two years later, and these traumatic events foreshadowed Santōka's troubled and often dissolute life. He entered Waseda University in 1901, but partly due to concern about his family, he suffered a nervous breakdown in 1904 and left Waseda. His father opened a saké brewery in 1906, but neither father nor son was a good businessman, and both were too fond of the product they were trying to sell.

By this time, Santōka had renewed his childhood interest in haiku and become a disciple of Seisensui, publishing seven haiku in his teacher's magazine *Sōun* (Layered Clouds) in 1913. Kodōjin was even made an associate editor of *Sōun* in 1915, but the Taneda family business went bankrupt in 1916 after their entire stock of saké was ruined. Santōka then opened a secondhand bookstore, but this business also failed. If these troubles were not enough, in 1918 his younger brother committed suicide, and the following year the grandmother who had raised him died. Santōka then moved to Tokyo and took on several jobs, eventually working in a library, but after his father's death he suffered another nervous breakdown in 1922, and quit his position.

In 1924, Santōka attempted suicide by standing in the tracks before an approaching train, but he was rescued and taken to a Zen temple. There he

learned to meditate, to go on begging pilgrimages, and to control, at least for some days and weeks at a time, his alcoholism. He took the tonsure in 1925, and spent the rest of his life as a monk, starting his first pilgrimage the following year.

Many of Santōka's poems were composed during his extensive walking and begging trips, including one of his most famous haiku, written in 1926.

wakeittemo	still walking into
wakeittemo	still walking into
aoi yama	green mountains

This kind of simplicity and repetition is characteristic of his poems, following the cadences of his life.

As Santōka made his begging rounds, he also made notes into a diary-journal, commenting at one point that "words express the subject, but what gives life to the words is rhythm. What transmits a particular poet, time, place, aroma, tone color, and reverberation is this rhythm, and a poem's rhythm—only its rhythm—is what makes it good. . . . I dislike haiku crafted by a knife, yes, by a razor—what I want to make are bold, decisive works."[16]

ichinichi ni	every day
oni to hotoke ni	coming to meet
ai ni keri	buddhas and demons

Santōka further noted in 1932, "As for haiku, if it is a true haiku it must be a poem of the spirit, because when not expressing the heart and mind, the essence of haiku is gone. . . . When you've forgotten any sense of purpose or intentionality, that is the fundamental existence of art." His own poems reflect this everyday sense of naturalness, but not all his verses were simply spontaneous utterances that remained as they first appeared. Santōka also wrote in 1938, "Today I've composed ten haiku—of course they're about as

good as broken pieces of tile—but they may shine as much as a piece of tile can, so my job is to polish, polish, polish them until they shine." Much of his achievement was to create poems that seem totally natural, even if he worked on them over time.

The first main theme found in Santōka's haiku relates to his begging rounds and pilgrimages.

ko no ha chiru	leaves fall from the trees—
aruki-tsumeru	I keep on walking

dare ni mo awanai	no one to meet—
michi ga dekoboko	the path worsens

kasa e pottori tsubaki datta
on my straw hat—plop—a camellia

dō shiyō mo nai	can't do anything else—
watashi ga aruite iru	I just keep walking

As he wandered from place to place, Santōka was especially aware of the heat, cold, wind, rain, and snow, all of which he seems to have accepted and even embraced.

samui kumo ga…	chilly clouds
isogu	hurrying

oto wa shigure ka	is that sound a rain shower?

ishi ni shiku-shiku	soaking into the rocks
shimitōru	sobbing, sobbing
aki no yo no ame nari	autumn evening rain

shigurete	persimmon leaves
kaki no ha no	in early winter rain—
iyoiyo utsukushiku	even more beautiful

amadare no oto mo toshitotta
the sound of raindrops—also grown old

yama no shizukasa e	to the mountain quiet
shizukanaru ame	the quieting rain

yasuka yasuka	peaceful, peaceful
samuka samuka	chilly, chilly
yuki yuki	snow, snow

yuki e yuki furu	snow falls on snow
shizukesa ni oru—	silence

On his travels Santōka occasionally encountered other living creatures, and he could certainly empathize with them.

yama no ichinichi	all day in the mountains
ari mo aruite uru	ants are also walking

ishi ni tombo wa	the dragonfly on a rock
mahiru no yume miru	looks at noontime dreams

ichiwa kite . . .	a bird comes once
nakanai tori de aru	and does not sing

tereba naite	braying when it's clear
kumoreba	braying when it's cloudy—
yagi ippiki	one goat

The Art of Haiku

kawazu ni nari kitte	becoming a frog
tobu	and jumping

The simplicity of these haiku almost takes them beyond the usual definitions of poetry, which was fine with Santōka. He commented in 1936: "Haiku that don't seem at all like haiku, that's what I'm after." He noted that his verses had been like wine, not even the best wine, but from now on they would be like water—clear, bright, and rippling without overflowing—or so he hoped. He also felt that poets must honestly express every aspect of their experience, as he declared in a prose passage that is close to poetry:

When an art becomes intense,
loneliness comes forth,
 clarity comes forth,
strangeness comes forth—
 if it doesn't go that far,
it's a lie.

This use of repetition can also be seen in one of Santōka's most moving haiku, written on Obon, the Japanese Memorial Day.

tomato wo tanagokoro ni	offering a tomato
mihotoke no mae ni	in front of the Buddha
chichi haha no mae ni	in front of my father and mother

At the request of some of the few friends who came to visit him, Santōka occasionally wrote out his haiku as calligraphy. He often chose the narrow *tanzaku* form on decorated paper, but he usually considered his writing as "ugly characters."[17] This judgment has not been echoed by others, and his works are now assiduously collected by those who can feel a sense of his presence in the calligraphy.

One of Santōka's most admired poems that he would occasionally write out on a poem-card deals with his begging rounds (Plate 8-5).

> *. . . teppatsu no naka e mo* . . . even into my begging bowl—
> *arare* hailstones

Santōka does not offer his reactions to the hail; he simply accepts it. Similarly, his writing has no pretensions, but an inner strength is apparent. Here he stresses the first character, and then reinks his brush for the final four forms, adding his signature in a smaller size below.

In comparison, a haiku by Santōka on another *tanzaku* has its strongest graphs at the beginning of each of the two columns (Plate 8-6).

> *hitori hissori* alone, silently
> *take no ko* the bamboo shoot
> *take ni naru* becomes a bamboo

The cursively written elements that begin the lower column on the left are the somewhat pictographic forms for "bamboo shoot" (*take no ko*, 竹の子). *Take* occurs again halfway below, with the brush almost running out of ink as it descends toward the three smaller forms at the bottom. Comparing the calligraphy of *take no ko* with the same characters written by Kodōjin (Plate 8-3), we can see greater force and continuity of the brush in Santōka's version, but more control and elegance by Kodōjin.

Santōka's attitude toward both poetry and calligraphy was summed up in his diary when discussing his admiration for children's writing: "For me, more than anything, I love artlessness. I hate skill, but even more I hate primped-up unskillfulness." This means that one should not get too involved in technique, but also avoid pretending to be "amateurish." Simply put, integrity is the most important quality.

An unusually large scroll by Santōka has some of his most dramatic cal-

ligraphy (Plate 8-7). The haiku makes full use of repetition, echoed in the columns of writing.

kane ga nai	money, none
mono ga nai	things, none
ha ga nai	teeth, none
hitori	—alone

Santōka starts on the top right with a strongly brushed character for "money" (金), followed by three Japanese syllables for *ga nai* (don't have). He then continues the pattern for the next three lines, ending with his signature at the lower left. Although haiku are usually written in a single column, here the poet has four columns, with the final two characters literally meaning "one person" (一人). By his spontaneous brushwork within the irregular placement of the columns, Santōka has given this work a sense of life and motion. It is not only the calligraphy itself, but also the spaces within and around it that create the unique rhythm that becomes an honest expression of his spirit.

As a begging monk, Santōka was equally honest with himself. For example, he seems to have struggled with the Buddhist ideal of nonattachment, writing: "Setting oneself free from desires and attachment is the purpose of Zen training, and through this training one can finally become free of passions—but this tragic kind of feeling is part of human nature. In other words, if you can finally extinguish human passions, it feels like you have extinguished human life and human feelings, so I admit to having a weak spirit that would like to free itself, but would also not like to free itself."

Similarly, Santōka could control his alcoholism for periods of time, but never completely.

tamasaka ni	occasionally
nomu sake no oto	the sound of drinking saké
sabishikari	is lonely

He was best at staying sober when out on pilgrimage, making his motto not to get angry, not to chatter, not to be greedy, but only to walk slowly and steadily onward. In his diary he wrote, "This life of walking and begging is, for me, the only peace." In this regard, he must have felt a kinship with the wandering monk Hotei, and wrote a poem upon encountering a weather-beaten image of the deity along the road.

sukkari hagete	Hotei
Hotei wa	his paint rubbed off
waraitsuzukeru	keeps smiling

A few haiku by Santōka express his attitude toward other people, whom he could sometimes enjoy as friends—but he ultimately understood himself as solitary.

otoko onna	men and women
to sono kage mo	along with their shadows—
odoru	dancing

. . . *hitori sumeba*	when you live alone
ao-ao wo shite kusa	green green are the grasses

In his final year of 1940, Santōka felt that even grasses might be too luxuriant and positive an image to express his life. He wrote that "people who don't understand the meaning of weeds cannot know the mind of nature itself. Weeds hold its essence and express its truth."

shinde shimaeba	when I finally die—
zassō	weeds
ame furu	falling rain

Haiga by Zen Masters

Although not primarily haiku poets, several leading Zen masters of Santōka's era occasionally added haiku to their paintings, creating haiga that generally followed the tradition of Hakuin (see chapter 5). Perhaps the most dynamic of these Zen masters was Nakahara Nantembō (Tōjū Zenchū, 1839–1925).[18] He received his nickname "Nantembō" from his habit of carrying a thick staff (*bō*) made from the nandina (*nanten*) bush. After serving in other temples, he eventually settled down at Kaisei-ji, near Kobe, where he spent his later years.

Like many prestigious abbots, Nantembō received numerous requests for his brushwork from monks and lay followers, especially during his last two decades, and he turned out over one thousand works of painting and calligraphy, as well as writing several books. One of his favorite painting themes was the Zen *ensō,* the circle that can mean the universe, everything, nothing, or even a rice cake. In some cases Nantembō added a haiku to his circle and created a haiga, with the circle now suggesting the moon (itself a Zen symbol). Yet these are quite different from other haiga on the moon, such as those by Shirō (see page 294), in large part due to their different purpose. Zen works of art are basically teachings, and tend to be more bold and perhaps less subtle than other haiga.

In one moon haiga created by Nantembō at the age of eighty-six, he deliberately wavered his powerful brush-stroke of the circle at the top, as though to create a moving pulse (Plate 8-8). Below it he has written a Zen message in haiku form.



kono tsuki ga if you want this moon
hoshikuba yarō I'll give it to you—
totte miyo try to catch it!



This is a nice Zen paradox: nothing can really be given to followers, since they must find their own inner Buddha-nature, yet the presence of the mas-

ters is vital to encourage, test, and ultimately sanction their successors. Furthermore, the moon can represent what people seek outside of themselves, always in vain, and yet it can also symbolize enlightenment. So Nantembō presents us with a conundrum: Here is the moon, but can we catch it?

Sōhan Gempō, often known by the name of Shōun (1848–1922), was another leading Zen master in the late nineteenth and early twentieth centuries. Born as the eldest son of a Shinto priest, he became a Buddhist monk at the age of twelve, and then spent some years studying and traveling, working under different Zen teachers including Nantembō.

In 1898 Sōhan returned to Empuku-ji, where he had studied in 1880, to run the monk's training center, at which time he took on the name "Shōun." He raised funds to repair the temple, and then in 1901 he visited China for a year and a half, observing local religious practices. Seven years later, he was appointed chief abbot of Kyoto's Daitoku-ji, one of the major temples in Japan, where he served until the year of his death.

Shōun was regarded as a friendly and unpretentious person, treating all people equally, and his personality comes through in his paintings and calligraphy. He often painted the most common and important Zen subject, Daruma, but he was unusual in adding a haiku (Plate 8-9).

mempeki no	the wall-gazer's form
ushiro sugata ya	seen from behind—
hana no haru	a springtime of flowers

The theme of Daruma meditating in front of a wall for nine years is most often inscribed with a couplet attributed to the First Patriarch himself:

Pointing directly to the human heart-mind
See your own nature and become Buddha.

This is a fundamental Zen message, so why did Shōun turn this subject into

The Art of Haiku

a haiga?[19] Perhaps he wanted to take the formality out of this kind of visual Zen teaching and reach people more directly. The figure, made of a simple curving line and two dots, is certainly charming, with a seal just where he is sitting, and the three-column poem is placed so the patriarch seems to be looking directly at it. Does the meditating Daruma represent the flowering of Zen?

Nakagawa Soen

Although Zen masters such as Nantembō and Shōun occasionally inscribed haiku on their paintings, thereby creating zenga and haiga simultaneously, it was Nakagawa Soen (1907–84) who was the most assiduous writer of haiku, composing poems throughout his life.[20] His father, a medical officer in the army, died in 1917, and Soen's younger brother died shortly thereafter, leaving the family to struggle. His mother educated her children herself until high school, where Soen read both Western philosophers and a book by Hakuin, which developed his interest in Zen. Soen entered Tokyo Imperial University in 1927 and studied literature; he especially admired Bashō, and wrote his thesis on him. It would be these two themes, Zen and haiku, that were to dominate Soen's life.

Upon graduating in 1931, Soen became a monk in the Rinzai Zen sect. He also did solitary meditation retreats at Mount Dai Bosatsu, and continued to write and occasionally publish haiku. Three verses from this time show his interest in combining a poetic sense of nature with his Zen vision.

> *arigata ya* thankfulness—
> *namida ni tokasu* tears dissolve
> *yama no yuki* into mountain snow
>
> —1931

mottaina ya	marvelous—
kusamura goto ni	every group of grasses
teru tsukiyo	shines in moonlight

—1932

tera ni kite	entering the temple
tsuyu yori chiisaki	I realize that I am
hito nari shi	less than a dewdrop

—1932

Starting in 1935, Soen's primary teacher became Yamamoto Gempō (1866–1961), the Zen master of Ryūtaku-ji, a temple founded by Hakuin (see chapter 5) and his disciple Tōrei Enji (1721–92). Two years later, Soen wrote two haiku at Hakuin's stupa (memorial stone) at Ryūtaku-ji.

aozora ni	under the blue sky
waga gan tsuki zu	my vow is endless
aki tsuki zu	autumn is endless

—1937

Hakuin-tō no	may one maple leaf
momiji hitohira	from Hakuin's stupa
umi koete	cross over the ocean

This latter haiku shows Soen's interest in taking Zen abroad, and although the Second World War intervened, he was finally able to make his first trip to California in 1949. This visit to San Francisco was the first of many such long journeys that Soen would undertake during his life. In the meantime, he continued to write haiku.

ama mo kite	a nun is visiting—
tsurara zukiyo to	icicles sparkle
nari-nikeri	in the moonlight

—1938

haru shigure	spring drizzle—
itsu yori sō to	since when have I
yobareken	been called a monk?

—1939

ume no mi no ko to	little plums
tsuyu no ko to	and small beads of dew
umare au	born together

—1946

In 1950, Gempō decided to retire as abbot of Ryūtaku-ji and asked Soen to be his successor. After some hesitation, Soen agreed, although he continued to make journeys both within Japan for further training and to the United States to assist Zen monks there. Soen proved to be somewhat unorthodox as an abbot; he wore an ordinary monk's robe, and played classical music records and composed haiku during his free time.

Zendō no	even in the Zen Hall
naka ni mo mainu	evening maple leaves
yū-momiji	are dancing

—1952

yama no oto	mountain sounds
umi no oto	ocean sounds
mina haru shigure	all in the spring drizzle

—1957

Shiki and the Modern Age

Yamamoto Gempō died at the age of ninety-six in 1961, and Soen's mother passed away the following year. Soen was very close to both of them, and to shake his depression he made several solitary retreats to Mount Dai Bosatsu, followed in 1963 by a trip to India, Israel, Egypt, and Europe, visiting various Zen centers along the way.

While surveying the grounds at Ryūtaku-ji in 1967, Soen fell from a tree, and he was not found for three days. Although he gradually recovered from his head injury, Soen was never fully healthy from then on. After traveling to America in 1968, 1971, and 1972, he retired as abbot in 1973, freeing him for more journeys until his final trip to the United States in 1982. He lived his final years on the Ryūtaku-ji grounds as a recluse.

Three of his late haiku sum up Soen's Zen approach to poetry. The first refers to a famous koan about a dog having or not having Buddha-nature, and the third is Soen's death poem.

ima zo hito	right now
kushi busshō no	the Buddha-nature of
hanazakari	dogs and people, flowering
—1970	

na-no-hana ya	mustard flowers!
sara ni nageutsu	nothing left
mono mo nashi	to throw away
—1984	

haru no yama	walking
yukeba michi ari	in the spring mountains
doko made mo	the path never ends
—1984	

Two Professional Painters: Tsuji Kakō and Hayashi Buntō

Haiku and haiga were certainly not the sole province of poets and Zen monks, and in the twentieth century, professional painters sometimes turned to haiga as a form of visual expression. Among the number of fine artists who occasionally created haiga, two of them painted works that were unusual in their medium or word-image relationships.

Tsuji Kakō (1870–1931) was one of the masters of *nihonga* (Japanese-style painting) in the first third of the twentieth century; in contrast to artists who tried Western media such as oil on canvas, he remained faithful to Japanese traditions. Born in Kyoto, he was trained in the Maruyama-Shijo school of naturalistic painting. He also undertook some Zen study beginning in 1899, and remained friends with the Zen master Takeda Mokurai (1854–1930) thereafter. Kakō did not follow trendy fashions in painting; he was an individualist, but not an iconoclast.

In 1920, Kakō traveled with painter friends to Korea to see the famous Diamond Mountains, which inspired many of his subsequent landscapes. The following year he organized a personal exhibition of these themes in Osaka and stopped participating in government-organized shows, although three years later he was made a judge for certain official exhibitions. Kakō developed stomach cancer in 1928, while still at the height of his artistic powers, and died in 1931.

Kakō's work shows a large amount of variety in subject, style, and scale. Some of his most appealing scrolls are modest, such as *Spring Haiga,* which utilizes a silver-leaf design on two-toned paper (Plate 8-10). His poem is celebratory:

uraraka ya	a splendid spring day—
mōsō yabu ni	sunlight seeps
hiimoruru	into the bamboo grove

The calligraphy is divided into shifting columns, beginning on the right with the signature and seal, and then dividing into a diagonal column for the first section of the haiku, two columns for the second section, and another diagonal column for the third section. This creates a subtle counterpoint with the straight verticals of the silver bamboo, which extend on every side of the calligraphy. In addition, the white paper on the right conveys brightness, and as the calligraphy moves to the left, it enters a gold-yellow tone of paper that suggests suffused light.

Calligraphy on decorated paper had already been familiar in Japan for a millennium, both for poetry and for the narration of such novels as *The Tale of Genji*. Its use was revived for tanka poetry by decorative-style artists in the seventeenth century, who featured silver and gold paper. Kakō's scroll is unusual because it is combined with a haiku, usually considered a more plebian form of art than court poetry. Kakō demonstrates here that elegance of style and richness of expression can work splendidly with an appropriate haiku—the light seeps both into and out from this scroll.

Hayashi Buntō (1882–1966) was also an artist trained in the naturalist Maruyama-Shijo tradition, and he traveled to China several times to widen his artistic scope. His works are very Japanese in spirit, however, such as a small haiga (Plate 8-11) in which the poem suggests autumn melancholy.

hamagoya wo	shops by the beach
mina tozasarete	all closed and boarded up—
mushi no koe	insect voices

The mood is clearly expressed: summer fun is over, families have headed back to their homes, the beach is empty.

What kind of painting might one expect for this haiku? A lonely seashore? The closed-up shops? Insects? Buntō comes up with a surprise that totally changes the mood of the poem. He paints a *kappa,* a troublemaker from Japanese folklore that does all kinds of mischief, including stealing

The Art of Haiku

children and vandalizing travelers. Kappa gain their powers from water and so they always live near streams, rivers, or the ocean, and they frequently hide under bridges. In addition, since the tops of their heads are concave, they keep a supply of water there for strength.

Here the kappa is ready to make trouble. Disguised in a jacket and head scarf in order to fool people, his beak and clawlike toes give him away. But wait—what can he do, whom can he harass? Suddenly the poem takes on a new meaning; now it is the kappa who is alone, and he seems clearly unhappy that there is no one to provoke or afflict. Are we to feel sorry for him, or glad that he can't torment us?

Perhaps both Buntō's composition of both the painting and the calligraphy adds greatly to his bittersweet theme. The kappa stands before a willow that acts as a vertical complement to his form. Behind him are the first two lines of the haiku in two columns, plus the artist's signature and seal. In contrast, there is nothing before the kappa but a light gray wash that may represent a lake or the ocean, and the final line of the haiku, "insect voices" (虫の声). In fact, all the creature can look forward to is the sound of autumn insects, so often admired by Japanese people, but of no use to this trickster. It is a case of "all dressed up but nowhere to go," and our own melancholy as summer ends is diverted to the kappa.

Although Buntō never became a particularly famous painter in Japan, this work shows how even a lesser-known artist could create a multilevel haiga of great charm.

Conclusion

There are a great many other poets and artists who might have been included in this volume, although the major names in haiku and haiga are well represented. One might also wish to continue to the present day, when haiku and haiku painting are more popular than ever, but that would take another volume at least.

Perhaps the most significant fact about haiku in the past one hundred

years is how it has become a worldwide phenomenon, even if it is often misunderstood to the point where almost any doggerel in a 5–7–5 syllable pattern is called a haiku. Yet in Russia, India, France, Brazil, Croatia, Ghana—all over the globe—people are composing haiku seriously, usually adjusting the syllable count to their own languages, and expressing new and fresh views of nature (and human nature) with both skill and empathy. Some of these have been writers known for other work, such as Langston Hughes and Jack Kerouac, while many others have concentrated on haiku, or haiku and tanka.

Books and journals on haiku have also flourished, giving a voice to poets from many countries, and various haiku societies also sponsor meetings for public readings, information, and interaction. Some poets and critics have attempted to define what a haiku has now become, but in general there is a welcome openness within the basic guideline of a short poem that suggests more than it defines, usually allied to nature.

A certain number of haiku poets are also painting haiga, or joining with painters to create combined haiga. These cover a range of styles and media, sometimes utilizing Western watercolor techniques and other times working with the East Asian brush-and-ink method, or even going further into collage and photography. As in traditional Japanese examples, the relationship between the verbal and the visual might be a portrait of the poet, an image that repeats in both text and painting, or different and seemingly unconnected elements that add new meanings or contexts, such as the kappa in Buntō's haiga.

As haiku and haiga continue to spread through the world, and as more and more poets and artists devote themselves to these art forms, the future is indeed bright. If there were to be a new *Art of Haiku* book fifty years from now, who knows what wonders it might include!

Appendix

Translating Haiku

Someone once said that when translating poetry, what you lose is the poetry. More specifically, you tend to lose the sound and rhythm that give poems their music. This leaves the verbal meanings, and since haiku often have multiple meanings with overtones beyond the words, translating becomes a difficult task indeed.

Japanese and English are very different languages in several important aspects. One is sentence structure; as noted earlier, in Japanese the verb tends to come last.

Second, Japanese nouns are generally not clearly singular or plural, and one must depend on context. As noted earlier, this means that in Bashō's famous poem, there could be one pond or several, one frog or many. In this case, one pond and one frog seem to carry the most meaning, so that is the way this verse has been rendered into English. Other times, it is not so clear whether singular or plural is better, and the translator is forced to make a choice. This becomes one of many occasions where interpretation must creep in, even for the most literal version of a poem. As noted earlier when discussing Bashō's "crow on a withered branch" verse (see page 86), the poet may have wished for the kind of ambiguity that is much more possible in Japanese than in English.

Third, since English tends to be more compact than Japanese, translating into 5–7–5 syllables often necessitates "padding" the poem in a way that destroys its appealing brevity. We can again take the most famous of all haiku as an example.

furu (old) *ike* (pond/ponds) *ya* (pause signal)
kawazu (frog/frogs) *tobikomu* (jumps in)
mizu (water) *no* (possessive) *oto* (sound)

Using the singular rather than the plural, in English this literally becomes 2–4–5 rather than 5–7–5.

old pond—
a frog jumps in
the sound of water

One could try to add words to reach the Japanese 5–7–5 rhythm.

there is an old pond—
suddenly a frog jumps in
the sound of water

The problems are the wordy first line and the addition of "suddenly" that is not in the original. Similar difficulties appear when trying to translate most haiku into 5–7–5 structures. As a result, translators have generally had to give up trying to match the Japanese rhythms and word orders, and must create what in some ways become new haiku in English. The main meanings (and sometimes possible additional meanings) of the originals can be given, but only at the cost of losing much of their music.

A final Japanese haiku can allow you, the reader, a chance to translate for yourself. The poem is by Chiyo, with a word-for-word equivalent.

tsuki no yo ya
ishi ni dete naku
kirigirisu

tsuki (moon) *no* (possessive) *yo* (evening/evenings/night/nights) *ya* (pause signal)

ishi (stone/stones/rock/rocks) *ni* (from) *dete* (come out) *naku* (sing/cry/chirp)

kirigirisu (katydid/katydids)

Now it is up to you: Will you try to make this a 5–7–5 poem in English? Will you change the line order? Will you use any plurals? What words and rhythms in English do you think can convey this scene best?

Some translators write what they think the haiku must mean, rather than what it actually says, but this implies knowing what the poet intended beyond the actual verse. Instead, the translations in this book are as close to the Japanese sources as possible. One can only trust that they retain enough of the perception and expression of the original poems to convey their wonder and delight.

Notes

Introduction

1. Strictly speaking, haiku usually have 5–7–5 *onji* (also called *morae*). The word "syllables" is not quite an exact match for *onji*, which can be less than a syllable when combining sounds. For example, the word *atta* is counted as three *onji* in Japanese (*a-tsu-ta*, but pronounced *atta*), which we would consider two syllables.

2. For more discussion of such seasonal indicators and their Westernization, see William J. Higginson, *Haiku World: An International Poetry Almanac* (Tokyo: Kodansha International, 1996).

3. For a full translation of the *Rōei-shū*, see J. Thomas Rimer and Jonathan Chaves, *Japanese and Chinese Poems to Sing: The* Wakan Rōei Shū (New York: Columbia University Press, 1997).

Chapter 1. Background: The Tanka (Waka) Tradition

1. For translations of these poems, as well as a great many from the *Man'yōshū*, see Edwin A. Cranston, trans., *A Waka Anthology: Volume One: The Gem-Glistening Cup* (Stanford, Calif.: Stanford University Press, 1993).

2. Scholars are divided on how to translate this title.

3. "Tangled hair" as a metaphor for passion extended into the early twentieth century, when Yosa no Akiko (1878–1942) wrote dramatically bold love poems in tanka form; her seminal 1901 collection was called *Midaregami* (Tangled Hair).

4. Translation by the author.

5. Ivan Morris, trans., *The Pillow Book of Sei Shōnagon* (New York: Columbia University Press, 1967), 122.

6. Ibid., 36–37.

7. Tanka, like the later haiku, were only seldom given titles.

8. For a thorough study of this anthology and its later interpretations, see Joshua S. Mostow, *Pictures of the Heart: The* Hyakunin Isshu *in Word and Image* (Honolulu: University of Hawaii Press, 1996).

9. See ibid., 12–17, for a discussion of this and other poetic techniques in tanka.

10. See William R. LaFleur, *Awesome Nightfall: The Life, Times, and Poetry of Saigyō* (Boston: Wisdom, 2003), 1.

11. Quoted in William LaFleur, trans., *Mirror for the Moon: A Selection of Poems by Saigyō (1118–1190)* (New York: New Directions, 1978), xiii.

Chapter 2. Renga, Hokku, Haikai, and Haiga

1. Quoted from Makoto Ueda, *Literary and Art Theories in Japan* (Cleveland, Ohio: Press of Western Reserve University, 1967), 38, 42–43, and 44.

2. See ibid., 40–41, for further enumerations.

3. For a more complete list, see Donald Keene, *Seeds in the Heart: Japanese Literature from Earliest Times to the Late Sixteenth Century* (New York: Henry Holt, 1993), 929.

4. Howard S. Hibbett, "The Japanese Comic Linked-Verse Tradition," *Harvard Journal of Asiatic Studies* 23 (1960–61): 82.

5. For an extended discussion of the rules of renga, see Hiroaki Sato, *One Hundred Frogs: From Renga to Haiku in English* (New York: Weatherhill, 1983), 18–36.

6. See Ueda, *Literary and Art Theories*, 49.

7. For a complete translation of this renga, see Steven D. Carter, *Traditional Japanese Poetry: An Anthology* (Stanford, Calif.: Stanford University Press, 1991), 303–26.

8. For more information on Teitoku and his place in Japanese literature, see Donald Keene, *Landscapes and Portraits: Appreciations of Japanese Culture* (Tokyo: Kodansha International, 1971), 71–93.

9. On a painting of Lady Murasaki, Ryūho noted that "from about the age of sixteen I started a new kind of painting." Some people have taken this to mean that he believed that he invented haiga, but the comment is too ambiguous to be sure. See Leon M. Zolbrod, *Haiku Painting* (Tokyo: Kodansha International, 1982), 6.

10. For more illustrations of Ryūho haiga, see the exhibition catalogue *Ryūho kara Bashō* [From Ryūho to Bashō] (Itami: Kakimori Bunka, 1995).

11. For a thorough discussion of this renga and a translation of its first hundred links, see Christopher Drake, "The Collision of Traditions in Saikaku's Haikai," *Harvard Journal of Asiatic Studies* 52, no. 1 (June 1992): 5–75, and "Saikaku's Haikai Requiem: *A Thousand Haikai Alone in a Single Day:* The First Hundred Verses," *Harvard Journal of Asiatic Studies* 52, no. 2 (December 1992): 481–588.

12. See Cheryl Crowley, "Putting *Makoto* into Practice: Onitsura's *Hitorigoto*," *Monumenta Nipponica* 50, no. 1 (1990): 1.

13. Torches bring fish to the surface, then the cormorants dive in after them; however, the birds have rings around their neck so they cannot swallow the fish whole. The fishermen pull the cormorants back to the boat with light ropes, and then give them small pieces of fish as a reward.

Chapter 3. Bashō

1. Interestingly enough, Shiki, who was generally ranked fourth among haiku poets, seems to have particularly admired Buson and was sometimes critical of Bashō (see page 306), but this is a rare exception.

2. See Robert Aitken, *A Zen Wave: Bashō's Haiku & Zen* (New York: Weatherhill, 1978).

3. Ibid., 53.

4. For this quote and further information, see Makoto Ueda, *Bashō and His Interpreters: Selected Hokku with Commentary* (Stanford, Calif.: Stanford University Press, 1991), 53.

5. Ibid., 59.

6. Ibid., 76–77.

7. Ibid., 80.

8. See previous chapter, p. 73.

9. See Ueda, *Bashō and His Interpreters*, 85.

10. For translations of Bashō's four major travel journals plus a generous number of his haiku, see Sam Hamill, trans., *The Essential Bashō* (Boston: Shambhala, 1999).

11. Hakuin Ekaku (1685–1768, see chapter 5) often gave both his monk and lay pupils the question "What is the sound of one hand" upon which to meditate.

12. These three comments, plus others, are given in Ueda, *Bashō and His Interpreters*, 140.

13. Aitken, *Zen Wave*, 27–28.

14. From *The Platform Sutra* of the Sixth Patriarch Hui-neng.

15. The comments in this paragraph come from Ueda, *Literary and Art Theories*.

16. Ibid., 159.

17. Ibid., 156. Dohō took the phrase "learn from the pine" to mean casting off desire and intention.

18. Ibid., 164.

19. This first line was inspired by the preface to "Peach Blossom Banquet" by the Chinese master Li Po.

20. For examples of Basho's *renku* (he favored thirty-six verses), see Makoto Ueda, *Matsuo Bashō: The Master Haiku Poet* (Tokyo: Kodansha International, 1982), 69–111. For discussion and analysis of Bashō's verse-linking techniques, see Haruo Shirane, "Matsuo Bashō and the Poetics of Scent," *Harvard Journal of Asiatic Studies* 52, no. 1 (1992): 77–110.

21. For a discussion of influences from Chinese poetry in Bashō's aesthetic, see Stuart H. Sargent, "Echoes of Chinese Poetry in Bashō," *Delos* 10, nos. 1–2 (1997): 47–57.

22. In earlier versions of this poem, the verbs were *shimitsuku* (sticking to) and *shimikomu* (seep into), but the final verb *shimiiru* (penetrating) is the strongest.

23. See Ueda, *Bashō and His Interpreters*, 300.

24. Ibid., 361.

25. Aitken, *Zen Wave*, 87.

26. See Ueda, *Bashō and His Interpreters*, 370.

27. Ibid.

28. Aitken, *Zen Wave*, 67.

Chapter 4. Followers of Bashō

1. It is significant that during his lifetime Bashō never published a book of just his own haiku; he always published with his pupils as a group.

2. Translation based upon that of Makoto Ueda, *Traces of Dreams: Landscape, Cultural Memory, and the Poetry of Bashō* (Stanford, Calif.: Stanford University Press, 1998), 105.

3. Donald Keene, ed., *Anthology of Japanese Literature* (New York: Grove Press, 1955), 379.

4. For women haiku poets, see Seiga Yokoyama, *Josei haika-shi* [Women haiku poets], (Tokyo: Gai-i Insatsujo, 1947), and Makoto Ueda, *Far Beyond the Field: Haiku by Japanese Women* (New York: Columbia University Press, 2003).

5. For a more extensive biography, haiga, and poems, see Patricia Donegan and Yoshie Ishibashi, *Chiyo-ni: Woman Haiku Master* (Rutland, Vt.: Tuttle, 1998).

6. Ibid., 30.

7. I am grateful to Fumiko Yamamoto for her assistance in translating this text.

8. For several Yayu haiga including one with this poem, see Ron Manheim, *Haiku & Haiga: Moments in Word and Image* (Amsterdam: Hotei, 2006).

Chapter 5. Senryu and Zen

1. For more information and many poems, see R. H. Blyth, *Japanese Life and Character in Senryu* (Tokyo: Hokuseido Press, 1960).

2. See R. H. Blyth, *Edo Satirical Verse Anthologies* (Tokyo: Hokuseido Press, 1961), 237.

3. The American haiku poet James W. Hackett also believed in the strong influence of Zen on haiku, although his views have been criticized by later haiku experts. See Charles Trumbull, "Shangri-La: James W. Hackett's Life in Haiku," pt. 1, *Frogpond* 33, no. 1 (2010): 80–92.

4. Aitken, *Zen Wave*.

5. See David Lewis Barnhill, "Of Bashōs and Buddhisms," *Eastern Buddhist* 32, no. 2 (2000): 177.

6. For a discussion, see ibid., 170–201.

7. This is a reference to the flute-playing Taira Atsumori, who was executed at the age of seventeen in Japan's great civil war between the Taira and Minamoto clans in the twelfth century.

8. This was supposed to have been Bashō's response when being criticized by his Zen teacher Butchō for writing poetry. Adapted from R. H. Blyth, *Haiku: Volume 4: Autumn-Winter* (Tokyo: Hokuseido Press, 1982), 1,080.

9. Quoted in Ueda, *Literary and Art Theories*, 148.

10. For further information, see Audrey Yoshiko Seo and Stephen Addiss, *The Sound of One Hand: Paintings & Calligraphy by Zen Master Hakuin* (Boston: Shambhala, 2010).

11. *Hakuin Oshō shigasanshū* [A collection of the monk Hakuin's painting and calligraphy], (Kyoto: Zenka Shorin, colophon dated 1759).

12. My thanks to Norman Waddell and Yoshizawa Katsuhiro for their help in understanding this haiku.

13. D. T. Suzuki, *Sengai: The Zen of Ink and Paper* (Boston: Shambhala, 1999), 177.

14. Ibid.

Chapter 6. Buson

1. His mother may have died in 1728, and his father at the same time or earlier. See Makoto Ueda, *The Path of Flowering Thorn: The Life and Poetry of Yosa Buson* (Stanford, Calif.: The Stanford University Press, 1998), 3.

2. Ibid.

3. Ibid., 5.

4. Cheryl A. Crowley, *Haikai Poet Yosa Buson and the Bashō Revival* (Leiden: Brill, 2007), 275.

5. Calvin French, *Poet-Painters: Buson and His Followers* (Ann Arbor: University of Michigan Museum of Art, 1974), 6.

6. Since New Year's Day usually arrived in February or early March, it represented the beginning of spring.

7. *Sakuragawa* literally means "Cherry-Blossom River" and is a poetic place name associated with the blossoms. There is also a reference here to a Noh play *Sakuragawa* in which the word *akuta* (rubbish) appears; see Crowley, *Haiku Poet Buson*, 64. Instead of praising cherry-blossoms floating down the river in this haiku, Buson turns the romantic scene upside down. This may recall Kikaku's melon-skin haiga discussed on page 147.

8. Another reading of this final line could be "melon-shaped eggplants."

9. Dates for Buson's haiku are taken from Tsutomu Ogata and Kazuhiko Maruyama, eds., *Buson zenshū* [Complete works of Buson], vol. 3 (Tokyo: Kōdansha International, 1992). There are 2,849 haiku in this "complete collection," of which 2,376 have been dated.

10. This scene was later made into a Noh drama.

11. Ueda, *Path of Flowering Thorn*, 34.

12. In ibid., v, Ueda comments that Buson "took delight in the natural

beauty of colors and forms as well as the artistic beauty of forms." See also Crowley, *Haiku Poet Buson*, 9–10.

13. Ueda, *Bashō and His Interpreters*, 88.

14. In 1777, he wrote 451 haiku, the most for any year. See Leon Zolbrod, "The Busy Years: Buson's Life and Work, 1777," *Transactions of the Asiatic Society of Japan*, 4th ser., 3 (1988): 53–81.

15. For the full rules, see Crowley, *Haiku Poet Buson*, 96–97.

16. Ibid., 259–61.

17. Quoted from Blyth, *Haiku: Volume 4*, 1159–60.

18. In one of his letters of 1776, Buson had complained that "she practices so much that it gets on my nerves, but it is a pleasure to see her grow up without mishap." See Zolbrod, "The Busy Year," 59.

19. Ueda, *Bashō and His Interpreters*, 114.

20. This album has now been registered as a National Treasure by the Japanese government.

21. Another reading for this first line is *shufū ya*, with the same meaning.

22. Ueda, *Bashō and His Interpreters*, 37.

23. Translation based on ibid., 95.

24. My thanks to Audrey Yoshiko Seo for this idea and image.

25. This was originally written for the now-lost *Yahantei meiwa* [Chats by Yahantei].

26. Ueda, *Bashō and His Interpreters*, 131–32.

27. Two are printed in the book-catalogue by Calvin French, *Poet-Painters*, 70–71.

28. This is a variant of a 1770 haiku found on page 220.

Chapter 7. Issa and the Early Nineteenth Century

1. For a full biography of Issa, see Makoto Ueda, *Dew on the Grass: The Life and Poetry of Kobayashi Issa* (Leiden: Brill, 2004).

2. See Ohashi Raboku, ed., *Issa haiku zenshū* [Issa's complete haiku], (Tokyo: Shunshūsha, 1929).

3. See David G. Lanoue, "The Haiku Mind: Issa and Pure Land Buddhism," *The Eastern Buddhist* 39, no. 2 (2008): 159–76.

4. Shades of Charlie Brown in the *Peanuts* cartoons!

5. In another undated version of this poem, the puppy paws, rather than gnaws, on the willow. See the excellent website Haiku of Kobayashi Issa, http://haikuguy.com/issa/index.html.

6. See Stephen Addiss, *The Art of Zen* (New York: Harry N. Abrams, 1989), 111.

7. This poem also exists in a variant for fleas.

8. For a Shirō haiga with this poem, see Stephen Addiss, *Haiga: Takebe Sōchō and the Haiku-Painting Tradition* (Honolulu: Marsh Art Gallery, University of Richmond, in association with University of Hawaii Press, 1995), 98–99.

9. For a Shirō haiga with this poem, see Manheim, *Haiku & Haiga*, 115.

10. For more information, see Fumiko Y. Yamamoto, "Takebe Sōchō (1761–1814)" in Addiss, *Haiga: Takebe Sōchō*, 20–26. The translations of these Sōchō haiku were done with her expert help.

11. Ibid., 21.

12. These screens are illustrated and discussed in Stephen Addiss, *Haiga: Takebe Sōchō*, 62–67.

13. For the image, see ibid., 79.

14. For both images, see ibid., 76–77.

Chapter 8. Shiki and the Modern Age

1. There are a number of successful haiku groups in Japan representing different points of view, including the Nihon Dento Haiku Kyōkai (Traditional Japanese Haiku Association), the Haijin Kyōkai (Haiku Poets Association), and the Gendai Haiku Kyōkai (Modern Haiku Association), each with thousands of members.

2. For a thorough study of Shiki's life and work, see Janine Beichman, *Ma-*

saoka Shiki (Tokyo: Kodansha International, 1986). More of Shiki's haiku, tanka, and a few of his Chinese poems can be found in Burton Watson, trans., *Masaoka Shiki: Selected Poems* (New York: Columbia University Press, 1997).

3. Beichman, *Masaoka Shiki,* 16.

4. Quoted in ibid., 34.

5. This haiku recalls Case 32 of the Zen koan collection *Mumonkan,* where the Buddha comments that "a first-class horse moves at even the shadow of the whip." See Stephen Addiss, Stanley Lombardo, and Judith Roitman, *Zen Sourcebook: Traditional Documents from China, Korea, and Japan* (Indianapolis, Ind.: Hackett, 2008), 105.

6. This haiku has also been attributed to Buson. See Blyth, *Haiku: Volume Four,* 1,004.

7. From Shiki's *Bashō no ikkyō* [Some remarks on Bashō], (1893). See Beichman, *Masaoka Shiki,* 37 and 39–40.

8. Translated by R. H. Blyth, *A History of Haiku,* vol. 2 (Tokyo: Hokuseido Press, 1964), 66, 75, and 46–47.

9. From Shiki's *Bashō no ikkyō.* See Beichman, *Masaoka Shiki,* 47.

10. From Shiki's *Haijin Buson* [The haiku poet Buson], 1897, as translated by Beichman, ibid., 59.

11. From Shiki's *Byōshō rokushaku* [A six-foot sickbed], 1902, as translated by Beichman, ibid., 59.

12. As noted, adding extra syllables had been done by the Danrin school of poets, and other masters did not feel absolutely confined to 5–7–5, but Hekigotō went much further in his freedom from syllabic constraints.

13. Translated by Donald Keene, *Dawn to the West* (New York: Henry Holt, 1984), 113

14. For a biography of Kodōjin plus many of his Chinese-style and Japanese poems, see Stephen Addiss and Jonathan Chaves, *Old Taoist: The Life, Art, and Poetry of Kodōjin (1865–1944),* (New York: Columbia University Press, 2000).

15. See the selected bibliography for books of translations by Sato Hiroaki, John Stevens, Burton Watson, and Scott Watson.

16. Translations from Santōka's journals and diaries are by the author.

17. For a publication on Santōka's calligraphy, see *Santōka ibokushū* [A collection of Santōka's remaining ink works], (Kyoto: Shibunkaku, 1993).

18. For more on Nantembō and Shōun, including illustrations of their works, see Audrey Yoshiko Seo with Stephen Addiss, *The Art of Twentieth-Century Zen: Paintings and Calligraphy by Japanese Masters* (Boston: Shambhala, 1999).

19. For a larger version of the same theme by Shōun without the dots for eyes, see ibid., 88.

20. For more on Soen's life and poetry, see Kazuaki Tanahashi and Roko Sherry Chayat, eds., *Endless Vow: The Zen Path of Soen Nakagawa* (Boston: Shambhala, 1996).

Glossary

haibun. Prose mixed with haiku poems.

haikai. Originally a comic verse in a linked series, later standing alone in 5–7–5 syllables (now called haiku).

haikai no renga. Humorous linked verses.

haiku. A term popularized by Shiki around 1900 for a 5–7–5-syllable poem previously called haikai or hokku.

hokku. Originally, the first 5–7–5 syllable verse in a series; later it could stand alone as what is now called a haiku.

kireji. "Cutting words" such as *ya* or *kana* that help to emphasize an image or create sections in a haiku, often without any particular meaning.

renga. A series of linked verses with 5–7–5 syllables alternating with 7–7 syllables.

renku. A series of linked haiku-style verses, also called *haikai no renga.*

tanka. A court-style 5–7–5–7–7-syllable poem, also called *waka* or *uta.*

uta. Another name for tanka, a 5–7–5–7–7-syllable court-style poem.

waka. Another name for tanka, a 5–7–5–7–7-syllable court-style poem.

Selected Bibliography

Addiss, Stephen. *The Art of Zen*. New York: Harry N. Abrams, 1989.

―――. *Haiga: Takebe Sōchō and the Haiku-Painting Tradition*. Honolulu: Marsh Art Gallery, University of Richmond, in association with University of Hawaii Press, 1995.

―――. *A Haiku Garden: The Four Seasons in Poems and Prints*. New York: Weatherhill, 1996.

―――. *Haiku Humor: Wit and Folly in Japanese Poems and Prints*. Boston: Weatherhill, 2007.

―――. *Haiku Landscapes: In Sun, Wind, Rain, and Snow*. New York: Weatherhill, 2002.

―――. *A Haiku Menagerie: Living Creatures in Poems and Prints*. New York: Weatherhill, 1992.

―――. *Haiku People: Big and Small in Poems and Prints*. New York: Weatherhill, 1998.

Addiss, Stephen and Jonathan Chaves. *Old Taoist: The Life, Art, and Poetry of Kodōjin (1865–1944)*. New York: Columbia University Press, 2000.

Addiss, Stephen, Gerald Groemer, and J. Thomas Rimer, eds. *Traditional Japanese Arts and Culture: An Illustrated Sourcebook*. Honolulu: University of Hawaii Press, 2006.

Addiss, Stephen, Fumiko Yamamoto, and Akira Yamamoto. *Haiku: An Anthology of Japanese Poems*. Boston: Weatherhill, 2009.

Aitken, Robert. *A Zen Wave: Bashō's Haiku & Zen*. New York: Weatherhill, 1978.

Barnhill, David Landis. "Of Bashōs and Buddhisms." *Eastern Buddhist* 32, no. 2 (2000): 170–201.

Bashō, Matsuo. *The Essential Bashō.* Translated by Sam Hamill. Boston: Shambhala, 1998.

Bashō-ten [Bashō exhibition]. Tokyo: Keizai Shinbunsha, 1993.

Bashō to Ōmi no monjin-tachi [Bashō and his pupils from Ōmi]. Otsu: Otsu-shi Rekishi Hakubutsukan, 1994.

Beichman, Janine. *Masaoka Shiki.* Tokyo: Kodansha International, 1986.

Blyth, R. H. *Edo Satirical Verse Anthologies.* Tokyo: Hokuseido Press, 1961.

———. *Haiku.* 4 vols. Tokyo: Hokuseido Press, 1981–82.

———. *A History of Haiku.* 2 vols. Tokyo: Hokuseido Press, 1963–64.

———. *Japanese Life and Character in Senryu.* Tokyo: Hokuseido Press, 1960.

Brower, Robert H. and Earl Miner. *Japanese Court Poetry.* Stanford, Calif.: Stanford University Press, 1961.

Carter, Steven. *Traditional Japanese Poetry: An Anthology.* Stanford, Calif.: Stanford University Press, 1991.

———. *Waiting for the Wind: Thirty-Six Poets of Japan's Late Medieval Age.* New York: Columbia University Press, 1989.

Codrescu, Ion. *Imagine Si Text in Haiga* [Image and text in haiga]. Bucharest: Editura Herald, 2002.

Cranston, Edwin. "Shinkei's 1467 *Dokugin hyakuin.*" *Harvard Journal of Asiatic Studies* 54, no. 2 (December 1994): 461–507.

———, trans. *A Waka Anthology: Volume One: The Gem-Glistening Cup.* Stanford, Calif.: Stanford University Press, 1993.

Crowley, Cheryl A. *Haikai Poet Yosa Buson and the Bashō Revival.* Leiden: Brill, 2007.

———. "Putting *Makoto* into Practice: Onitsura's *Hitorigoto.*" *Monumenta Nipponica* 50, no. 1 (1990).

de Bary, William Theodore, ed., and Seiichi Taki, trans. *The Manyōshū: The Nippon Gakujtsu Shinkokai Translation of One Thousand Poems, with the*

Texts in Romaji. New York: Columbia University Press, 1965.

Donegan, Patricia and Yoshie Ishibashi. *Chiyo-ni: Woman Haiku Master.* Rutland, Vt.: Tuttle, 1998.

Drake, Christopher. "The Collision of Traditions in Saikaku's Haikai." *Harvard Journal of Asiatic Studies* 52, no. 1 (June 1992): 5–75.

————. "Saikaku's Haikai Requiem: *A Thousand Haikai Alone in a Single Day:* The First Hundred Verses." *Harvard Journal of Asiatic Studies* 52, no. 2 (December 1992): 481–588.

Eiri haisho to sono gakatachi [Illustrated haiku books and their artists]. Itami: Kakimori Bunko, 1992.

Enrich, Jeanne, ed. *Reeds: Contemporary Haiga.* Nos. 1–5. Edina, Minn.: Lone Egret Press, 2003–07.

French, Calvin. *The Poet-Painters: Buson and His Followers.* Ann Arbor, Mich.: University of Michigan Museum of Art, 1974.

"Haiku." *Taiyō* no. 16 (Autumn 1976): 3–106.

Haiku shirizu: Hito to sakuhin. 18 vols. [Haiku series: poets and their works]. Tokyo: Ōfusha, 1963–67.

Hall, John Whitney and Toyoda Takeshi, eds. *Japan in the Muromachi Age.* Berkeley: University of California Press, 1977.

————, trans. *The Sound of Water: Haiku by Bashō, Buson, Issa, and Other Poets.* Boston: Shambhala, 1995.

Hass, Robert. *The Essential Haiku: Versions of Bashō, Buson, & Issa.* Hopewell, N.J.: Ecco Press, 1994.

Henderson, Harold. *An Introduction to Haiku: An Anthology of Poems and Poets from Bashō to Shiki.* Garden City, N.Y.: Anchor, 1958.

Hibbett, Howard. "The Japanese Comic Linked-Verse Tradition." *Harvard Journal of Asiatic Studies* 23 (1960–61): 76–92.

Higginson, William J. *Haiku World: An International Poetry Almanac.* Tokyo: Kodansha International, 1996.

Hisamatsu, Sen-ichi. *Biographical Dictionary of Japanese Literature.* Tokyo: Kodansha International, 1976.

Hoffmann, Yoel. *Japanese Death Poems: Written by Zen Monks and Haiku Poets on the Verge of Death.* Rutland, Vt.: Tuttle, 1986.

Ichiji, Tetsuo, ed. *Haiku jiten: Kinsei* [Dictionary of early modern haiku]. Tokyo: Ōfusha, 1982.

Inui, Norio. *Bashō-ō no shōzō hyakuei* [One hundred portraits of Bashō]. Tokyo: Kōrinsha, 1984.

Ishida, Motozue, ed. *Haijin shinseki zenshū.* 11 vols. [Collection of genuine painting and calligraphy by haiku poets]. Tokyo: Heibonsha, 1930–39.

Issa, Kobayashi. *The Autumn Wind: A Selection from the Poems of Issa.* Translated by Lewis Mackenzie. Tokyo: Kodansha International, 1984.

———. *Issa: Cup of Tea Poems: Selected Haiku of Kobayashi Issa.* Translated by David G. Lanoue. Berkeley, Calif.: Asian Humanities Series, 1991.

———. *Issa haiku zenshū* [Issa's complete haiku]. Edited by Ohashi Raboku. Tokyo: Shunshūsha, 1929.

———. *The Spring of My Life and Selected Haiku: Kobayashi Issa.* Translated by Sam Hamill. Boston: Shambhala, 1997.

Jambor, Kinuko. *Haikaishi sonojo no shōgai* [The lives of women haikai masters]. Tokyo: Nagata Shoten, 2000.

Kakimori seishō [Prize works from the Kakimori Bunko]. Itami: Kakimori Bunko, 1984–87.

Kato, Shuichi. *A History of Japanese Literature: The Years of Isolation.* Vol. 2. Translated by Don Sanderson. Tokyo: Kodansha International, 1979.

Keene, Donald, ed. *Anthology of Japanese Literature.* New York: Grove Press, 1955.

Keene, Donald. *Dawn to the West.* New York: Henry Holt, 1984.

———. *Landscapes and Portraits: Appreciations of Japanese Culture.* Tokyo: Kodansha International, 1971.

———. *Seeds in the Heart: Japanese Literature from Earliest Times to the Late Sixteenth Century.* New York: Henry Holt, 1993.

———. *Travelers of a Hundred Ages: The Japanese Revealed through 1,000 Years of Diaries.* New York: Henry Holt, 1989.

————. *World Within Walls: Japanese Literature of the Pre-modern Era 1600–1867*. New York: Holt, Rinehart, and Winston, 1976.

Kerkham, Eleanor, ed. *Matsuo Bashō's Poetic Spaces: Exploring Haikai Intersections*. New York: Palgrave MacMillan, 2006.

Kikusha. *Kikusha zenshū* [Complete poems of Kikusha]. Tokyo: Sara Shoten, 1937.

Kon Eizo, ed. *Bashō kushū* [Bashō's poem collection]. Tokyo: Shinchōsha, 1982.

LaFleur, William R. *Awesome Nightfall: The Life, Times, and Poetry of Saigyō*. Boston: Wisdom, 2003.

Lanoue, David G. "The Haiku Mind: Issa and Pure Land Buddhism," *Eastern Buddhist* 39, no. 2 (2008): 159–76.

————, ed. Haiku of Kobayashi Issa. http://haikuguy.com/issa/index.html.

Manheim, Ron. *Haiku & Haiga: Moments in Word and Image*. Amsterdam: Hotei, 2006.

Matsuo, Yasuaki, ed. *Haiku daijiten* [Large dictionary of haiku]. Tokyo: Meiji Shoin, 1957.

Me de miru haikai no rekishiten [An exhibition for viewing the history of haiku]. Kōchi: Kenritsu Kyōdo Bunka Kaikan, 1976.

Miner, Earl. *An Introduction to Japanese Court Poetry*. Stanford, Calif.: Stanford University Press, 1968.

Miyake, Chōsaku. *Haiga no kanshō* [The appreciation of haiga]. Tokyo: Gashōsha, 1931.

Morikawa, Akira, ed. *Haijin no shoga bijutsu* [Calligraphy and paintings by haiku poets]. 12 vols. Tokyo: Shūeisha, 1968–80.

Mostow, Joshua S. *Pictures of the Heart: The Hyakunin Isshu in Word and Image*. Honolulu: University of Hawaii Press, 1996.

Murasaki, Lady. *The Tale of Genji*. Translated by Arthur Waley. New York: Literary Guild, 1935.

Murasaki, Shikibu. *The Tale of Genji*. Translated by Edward G. Seidensticker. New York: Knopf, 1976.

Nihon haisho taikei [Japanese haiku-calligraphy series]. Tokyo: Shunjōsha Insatsujo, 1926.

Ogata Tsusomu. "Five Methods for Appreciating Bashō's Haiku." *Acta Asiatica* 28, (1975): 42–61.

———, ed. *Bashō shinseki* [Genuine works by Bashō]. Tokyo: Gakken, 1993.

Okada Rihei. *Bashō Buson.* Tokyo: Benseisha, 1976.

———. *Haiga no bi: Buson Gekkei* [The beauty of haiga: Buson and Gekkei]. Kyoto: Hōshobō, 1973.

———. *Haiga no sekai* [The world of haiga]. Kyoto: Tankōsha, 1966.

O'Mara, Joan Herzog. *The Haiga Genre and the Art of Yosa Buson (1716–1784).* Ann Arbor, Mich.: University Microfilms, 1989.

Peinture a l'encre du Japan (nanga et haiga). Exhibition catalog. Geneva: Collections Baur, 1968.

Ramirez-Christiansen, Esperanza. *Heart's Flower: The Life and Poetry of Shinkei.* Stanford, Calif.: Stanford University Press, 1994.

Rexroth, Kenneth, trans. *One Hundred Poems from the Japanese.* New York: New Directions, 1956.

Rimer, J. Thomas and Jonathan Chaves, eds. and trans. *Japanese and Chinese Poems to Sing: The* Wakan Rōei Shū. New York: Columbia University Press, 1997.

Ryūho kara Bashō [From Ryūho to Bashō]. Itami: Kakimori Bunka, 1995.

Saigyō. *Mirror for the Moon: A Selection of Poems by Saigyō (1118–1190).* Translated by William R. LaFleur. New York: New Directions, 1978.

———. *Saigyō: Poems of a Mountain Home.* Translated by Burton Watson. New York: Columbia University Press, 1991.

Saikaku. Itami: Kakimori Bunko, 1992.

Sansom, G. B. *Japan: A Short Cultural History.* Stanford, Calif.: Stanford University Press, 1952.

Santōka ibokushū [A collection of Santōka's remaining ink works]. Kyoto: Shibunkaku, 1993.

Santōka, Taneda. *For All My Walking: Free-Verse Haiku of Taneda Santōka.* Translated by Burton Watson. New York: Columbia University Press, 2003.

———. *Mountain Tasting: Zen Haiku by Santōka Taneda.* Translated by John Stevens. New York: Weatherhill, 1980.

————. *Santoka: Grass and Tree Cairn.* Translated by Sato Hiroaki. Winchester, Va.: Red Moon Press, 2002.

Sato Hiroaki. *One Hundred Frogs: From Renga to Haiku in English.* New York: Weatherhill, 1983.

Sato Hiroaki and Burton Watson, eds. *From the Country of Eight Islands: An Anthology of Japanese Poetry.* Garden City, N.Y.: Anchor, 1981.

Sawa Yuki and Edith Marcombe Shiffert. *Haiku Master Buson.* Buffalo, N.Y.: White Pine Press, 2007. First published 1978 by Heian International.

Schertsend Geschest: haiku-schilderigen. Belgium: Europalia, 1989.

Sei Shōnagon. *The Pillow Book of Sei Shōnagon.* Translated by Ivan Morris. New York: Columbia University Press, 1967.

Seo, Audrey Yoshiko, with Stephen Addiss. *The Art of Twentieth-Century Zen: Paintings and Calligraphy by Japanese Masters.* Boston: Shambhala, 1999.

Seo, Audrey Yoshiko and Stephen Addiss. *The Sound of One Hand: Paintings & Calligraphy by Zen Master Hakuin.* Boston: Shambhala, 2010.

Shiki, Masaoka. *Masaoka Shiki: Selected Poems.* Translated by Burton Watson. New York: Columbia University Press, 1997.

Shirane, Haruo. "Matsuo Bashō and the Poetics of Scent." *Harvard Journal of Asiatic Studies* 52, no. 1 (June 1992): 77–110.

————. *Traces of Dreams: Landscape, Cultural Memory, and the Poetry of Bashō.* Stanford, Calif.: Stanford University Press, 1998.

Sōseki, Natsume. *Zen Haiku: Poems and Letters of Natsume Sōseki.* Edited and translated by Shigematsu Sōiku. New York: Weatherhill, 1994.

Special issue, *Sumi* no. 42 (May 1983).

Suzuki, D. T. *Sengai: The Zen of Ink and Paper.* Boston: Shambhala, 1999.

Takagi, Sōgo. *Haikai jimmei jiten* [Dictionary of haiku poets]. Tokyo: Ganandō Shoten, 1987.

Takiguchi, Susumu. *Kyoshi: A Haiku Master.* Rousham: Ami-Net International Press, 1997.

Tanahashi, Kazuaki and Roko Sherry Chayat, eds. *Endless Vow: The Zen Path of Soen Nakagawa.* Boston: Shambhala, 1996.

Tsunoda, Ryusake, William Theodore de Bary, and Donald Keene. *Sources of Japanese Tradition*. New York: Columbia University Press, 1958.

Tsutsomu, Ogata and Kazuhiko Maruyama, eds. *Buson zenshū* [Complete works of Buson]. Vol. 3. Tokyo: Kōdansha, 1992.

Ueda, Makoto. *Bashō and His Interpreters: Selected Hokku with Commentary*. Stanford, Calif.: Stanford University Press, 1992.

―――. *Dew on the Grass: The Life and Poetry of Kobayashi Issa*. Leiden: Brill, 2004.

―――. *Far Beyond the Field: Haiku by Japanese Women*. New York: Columbia University Press, 2003.

―――. *Light Verse from the Floating World*. New York: Columbia University Press, 1999.

―――. *Literary and Art Theories in Japan*. Cleveland, Ohio: Press of Western Reserve University, 1967.

―――. *Matsuo Bashō: The Master Haiku Poet*. Tokyo: Kodansha International, 1982.

―――. *The Path of Flowering Thorn: The Life and Poetry of Yosa Buson*. Stanford, Calif.: Stanford University Press, 1998.

Waley, Arthur. *Japanese Poetry: The Uta*. Honolulu: University Press of Hawaii, 1976.

Watson, Scott. *The Santoka*. Sendai: Bookgirl Press, 2005.

Yaba, Katsuyuki and Joy Norton. *Five Feet of Snow: Issa's Haiku Life*. Nagano: Shinano Mainichi Shimbunsha, 1994.

Yasuda, Kenneth. *The Japanese Haiku*. Rutland, Vt.: Tuttle, 1957.

―――, trans. *Land of the Reed Plains: Ancient Japanese Lyrics from the Manyoshu*. Rutland, Vt.: Tuttle, 1960.

Yokoyama, Seiga. *Josei haika-shi* [Women haiku poets]. Tokyo: Gai-i Insatsujo, 1947.

Zolbrod, Leon M. "The Busy Years: Buson's Life and Work, 1777." *Transactions of the Asiatic Society of Japan*, 4th ser., 3 (1988): 53–81.

―――. *Haiku Painting*. Tokyo: Kodansha International, 1982.

Index

Aitken, Robert, 79–80,
 118, 168
Akazome Emon, 32
Ashikaga Yoshihisa, 58
aware, 42
 Baitei, Ki, 216
 Bankei Yōtaku, 138
 baseball, 268, 279
 Bashō, Matsuo, 56,
 68, 156, 181–82, 193,
 195, 199, 212–13,
 215, 221, 274–77,
 303
 life and poetry of,
 72–126
 kireji in, 5
 followers of, 127–52
 old pond, 12, 56, 80,
 95–97, 172, 191,
 275, 290–91
 rhythm in, 8–9
 structure in, 5–7

Blue Cliff Record, 281
Blyth, R. H., 168
Bonchō, Nozawa, 113
Bōsai, Kameda, 264
Buddha Shakyamuni, 40
Buddhist influences

on Saigyō, 34–36,
 38–41
in tanka, 22, 27
Buntō, Hayashi, 14,
 307–9
Bunya, Yasuhide, 23
Buson, Yosa, 9–11, 221,
 260, 275
 life and poetry of, 12,
 179–219
 Saigyō, admiration
 for, 34
Butchō, 83, 97

Chigetsu, Kawai, 136–37,
 208
Chikua, 222
Chin-chou, 271
Chine, 135, 148
Chinese poetry
 tanka and, 16–17, 29
Chiri, Naemura, 91
Chiyo, Kaga no, 143–47
Chronicles of Japan. See
 Nihonshoki
Chuang-tzu, 110–11
Collection of Ten Thou-
 sand Leaves. See
 Man'yōshū

courtly society, 27–29
 romantic love, impor-
 tance in, 25–27
 tanka in, 16–17
cutting words. See *kireji*

Daitoku-ji, 302
Danrin (school), 59,
 68–69, 73, 79, 81,
 83, 86, 124, 127
Daruma, 171, 291–92,
 302–3
Den Sute-jo, 9, 137–8
Dohō, Hattori, 103–4,
 170
Dokugin hyakuin (Solo
 100 Links), 49
dowry haiga. See *yomeiride*

Einstein, Albert, 105
Empuku-ji, 302
Etsujin, Ochi, 142–3
exchanged poems. See
 zōtōka
extra characters. See *ji-
 amari*

floating world (*ukiyo*), 20
Fujiwara no Atsutada, 33

Fujiwara no Teika, 30
fushimoto, 46

Gempō, Yamamoto,
 304–6
gigaku, 55
Goshun, Matsumura,
 212, 216, 219
Go-toba, Emperor, 50–51

haibun, 80, 91, 95, 100
haikai no renga, 58–9, 61,
 63, 68, 153
Haikai taiyō (Talks on
 haiku), 272
Hajin, Hayano, 179–80,
 192
Hakuin Ekaku, 96,
 171–73, 212. 242,
 301, 303
heart-mind. See *kokoro*
Heian jimbutsushi (Who's
 Who in Kyoto),
 183
Hekigotō, Kawahigashi,
 278, 283, 285–88,
 290
Hibbett, Howard S., 47
Hokushi, Tachibana, 142
Hōryū-ji, 273
Hotei, 66, 171–72, 300
Hototogisu, 277–78, 283
Hsiang-yen Chih-hsien,
 96
Hughes, Langston, 310
Hyakunin isshū (One
 Hundred Poems
 by One Hundred
 Poets), 30–34

Ieyasu, Tokugawa, 263
Ikkyū Sōjun, 57
Inu-tsukuba-shū (Mon-
 grel Collection), 58
Ise, 41
Ise, Lady, 23–24, 31
Issa, Kobayashi
 life and poetry of,
 221–60
 past references in, 9–11
 and Pure Land Bud-
 dhism, 258–59
Itchō, Hanabusa, 132
Izumo, 15, 16

Jakuren, 33–34
Japanese and Chinese
 Poems to Sing. See
 Wakan rōei-shū
ji-amari (extra charac-
 ters), 31
Jizō, 222
Jōso, 141–42
Journal of a Weather-
 Beaten Skeleton.
 See *Nozarashi kikō*
Jūben jūgi-jō (Ten Plea-
 sures and Ten Con-
 veniences), 196

Kakō, Tsuji, 307–8
kakekotoba (pivot word),
 64
kami, 41, 60
Kana-jo, 134–35
Kanō Yasunobu, 140
kappa, 308–9
karumi (lightness), 119,
 121, 124, 127

Kenshō-ji, 182
Kerouac, Jack, 310
Kigin, Kitamura, 148
kigo (seasonal references),
 2–3, 48
Kiitsu, Kei, 154
Kikaku, Enomoto, 96,
 118–32, 139, 179–
 80, 192, 211
Kiku, 224–25
Ki no Tomonori, 22
Ki no Tsurayuki, 22,
 29–30, 33
kireji (cutting words),
 4–5, 7
Kitō, Takai, 188, 207
Kodōjin (Haritsu), Fu-
 kuda, 289–92, 298
Kojiki (Record of Ancient
 Matters), 15
Kokin[waka]shū (Old
 and New Waka
 Collection), 21–24,
 28–29, 43, 55
kokoro (heart-mind),
 35, 42
Kōsai, 129
Kōsei-ji, 141
Kuno, 183, 195
Kyorai, Mukai, 112–13,
 125, 129, 134–35, 192
Kyoroku (Kyoriku), Mor-
 ikawa, 139–41, 148
Kyoshi, Takahama, 279–
 83, 288, 290

Layered Clouds. See *Sōun*
Li Po, 89
Lotus Sutra, 38, 165

maeku, 64

Man'yōshū (Collection of Ten Thousand Leaves), 16–21, 29, 45, 314–2

and *Kokinshū,* comparison, 24

Maruyama-Shijo, 307–8

Mibu no Tadamine, 32

Mikata no Sami, 20

Minashiguri (Shriveled Chestnuts), 89

Modern Old and New Collection. See *Shinkokinshū*

Mokurai, Takeda, 307

Mongrel Collection. See *Inu-tsukuba-shū*

Monkey's Raincoat. See *Sarumino*

Moritake, Arakida, 61–63, 66, 68

Murasaki, Lady, 24

mushin renga, 46, 58

Mutomagawa (Mutomagawa River), 153, 156

Mutomagawa River. See *Mutomagawa*

Nankaku, Hattori, 179

Nantembō, Nakahara, 301–3

Narrow Road to the North. See *Oku no hosomichi*

nembutsu, 169, 227

New Flower Picking. See *Shin hana tsumi*

nihonga, 307

Nihonshoki (Chronicles of Japan), 15

Nijō Yoshimoto, 46–48

Nippon, 268, 275, 283, 285, 289–90

Norinaga, Motoori, 260

Notes for my Knapsack. See *Oi no kabumi*

Nozarashi kikō (Journal of a Weather-Beaten Skeleton), 91–95

Ōe no Chisato, 32

Oi no kabumi (Notes for my Knapsack), 100–3

Oku no hosomichi (Narrow Road to the North), 104–9, 181

Ōkyo, Maruyama, 219

Old and New Waka Collection. See *Kokin[waka]shū*

Omi Ikuha, Daughter of, 20

Onakatomi no Toshinobu, 151

One Hundred Poems by One Hundred Poets. See *Hyakunin isshū*

Onitsura, Ueshima, 73–77

onji (syllables), 314–1

Ono no Komachi, 23, 30–31

Otokuni, 136

Ōtomo Clan, Elder Maiden of, 16

Ōtomo no Tabito, 16

Ōtomo no Yakamochi, 21

Ōtomo no Yotsuna, 21

Ōtomo of Sakanoue, Lady, 18

Otsu-e, 203

Otsuyū (Bakurin), Nakagawa, 150–52, 179–80

Patchwork Robe. See *Uzuragoromo*

Pillow Book of Sei Shōnagon, 27–29

pillow words, 16

pivot word. See *kakekotoba*

Po Chu-I, 84

poems, exchanged. See *zōtōka*

Premier Willow Cask. See *Yanagidaru shui*

Ransetsu, Hattori, 6, 132–33, 179, 192

Razan, Hayashi, 64

readers, role of, 3–4

Record of Ancient Matters. See *Kojiki*

Reigen, Etō, 173

rhythm, 8–9

riddle poems, 6, 59, 62

Ryūho, Nonoguchi (Hinaya Ryūho), 66–67

Ryōkan Daigu, 175–76

Ryūsai, Yamamoto, 263–64

Ryūtaku-ji, 304–6

Saigyō Hōshi, 9–11, 91,
181–82
biographical informa-
tion, 34–37, 41–43
legacy of, 43, 97, 100,
104, 107, 215
Saikaku, Ihara, 69–73
Saiun Hōjo, 132
Sampu, Sugiyama, 142
samurai era, 38, 43
Santōka, Taneda
life and poetry of,
293–300
Sarashina kikō (Visit to
Sarashina), 104
Sarumino (Monkey's
Raincoat), 113
Sato, 225
satori, 38, 40, 71, 275
seasonal references. See
kigo
Seisensui, Ogiwara, 293
Sei Shōnagon, 27–28
Sengai Gibon, 174–75
Sen no Rikyū, 100
Senryū, Karai, 155–56
Sesshū, Tōyō, 100
sha-i, 274
shasei, 274–6, 278, 285
Shidō, 110
Shiki, Matsuoka, 289–90
life and poetry of,
267–85
past references in,
10–11
comments on Bashō,
86, 274–76
Shikō, Kagami, 96,
142–43

Shimpo, Nakamura, 221
Shingon, 34
Shin hana tsumi (New
Flower Picking),
212
Shinkei, 48–50
Shinkokinshū (Modern
Old and New Col-
lection), 43
Shinten'ō Nobutane, 96
Shinto, 41, 60–2, 106, 168,
187, 269–70, 302
Shirao, Kaya, 264
Shirō, Inoue, 260–64
Shōha, Kuroyanagi, 212
Shōhaku, 50–57
Shriveled Chestnuts. See
Minashiguri
Shundei kushū (Shundei
Poem Collection),
212
Shundei Poem Collec-
tion. See *Shundei
kushū*
Sōchō, Saiokuken, 50–55,
57–58
Sōchō, Takebe, 263–66
Sodō, 99, 192
Soen, Nakagawa, 303–6
Sōgi, 50–53, 55–57, 61,
100, 124
Sōha, 97
Sōhan Gempō (Shōun),
302–3
Sōin, Nishiyama, 67–71,
73, 83
Sokan, 57–61, 68
Solo 100 Links. See *Do-
kugin hyakuin*

Sono-jo, 139
Sora, Kawai, 97, 105–9
Sosei Hōshi, 31
Sōseki, Natsume, 271–72
Sōun (Layered Clouds), 293
Suiō Genro, 173–74
Su Shih, 182
Suzuki, D. T., 174–75
syllable patterns
variants among lan-
guages, 1–2, 4–5,
314–1
syllables. See *onji*

Taiga, Ike, 196
Taikenmon-in no Hori-
kawa, 33
Tale of Genji, The, 24–27,
260
Talks on haiku. See *Hai-
kai taiyō*
*Talks on Haiku from the
Otter's Den*, 271
tan-renga, 45, 62
tanzaku, 65, 96, 287, 298
Teitoku, Matsunaga, 61,
63–66, 73
Teimon (school), 68–69,
79, 124, 127, 148
Ten Pleasures and Ten
Conveniences. See
Jūben jūgi-jō
Toba, Emperor, 34–35, 37
Tōdai-ji, 42, 273
Tōdō Yoshikiyo, 81
Tōdō Yoshitada, 81–82
Tokyo Imperial Univer-
sity, 268
Tomo, 183

Tōrei Enji, 304
Tosa Mitsunobu, 208–9
Toyotomi Hideyoshi, 64
tsukeku, 59, 61–62
Tu Fu, 89, 107

Ueda, Makoto, 87
Ungo Kiyō, 107
ushin-renga, 46, 58
Uzuragoromo (Patchwork
 Robe), 148

Vimalakirti (Yuima), 203
Visit to Sarashina. See
 Sarashina kikō

Vulture Peak, 40

Wakan rōei-shū (Japanese
 and Chinese Poems
 to Sing), 29–30
Who's Who in Kyoto.
 See *Heian jimbut-
 sushi*
Willow Cask. See *Yanagi-
 daru*

Yaha, Shida, 143
Yahantei, 179, 192
Yanagidaru (Willow
 Cask), 155

Yanagidaru shui (Pre-
 mier Willow
 Cask), 156
Yayu, Yokoi, 148–50
yomeiride (dowry haiga),
 216
Yoshino Mountain, 41–42

Zen influences
 in Bashō, 4, 80, 124,
 169–71
Zenkō-ji, 104
zōtōka (exchanged po-
 ems), 19–20, 25–27
Zuigan-ji, 107

Index